MATHEW BRADY'S PORTRAIT OF AN ERA

BOOKS BY ROY MEREDITH

Empress Carlotta of Mexico, circa 1856.
One of the most beautiful women of her time, Carlotta
was the wife of Emperor Maximilian of Mexico,
puppet of Napoleon III. Her husband died by firing
squad, and news of his death drove her insane.
From a photograph by Mathew Brady.

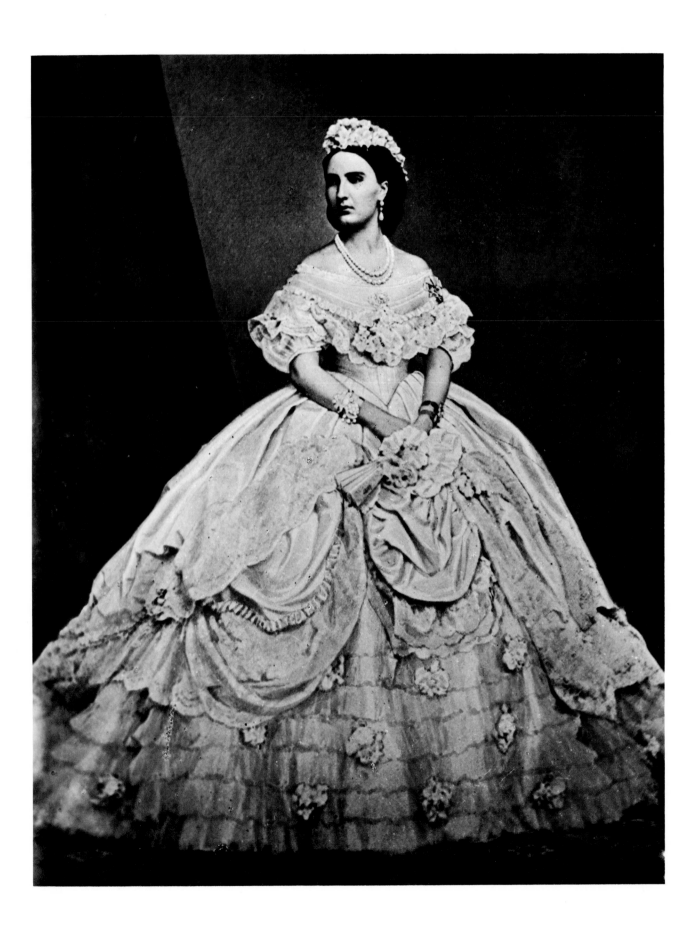

MATHEW BRADY'S

By Roy Meredith

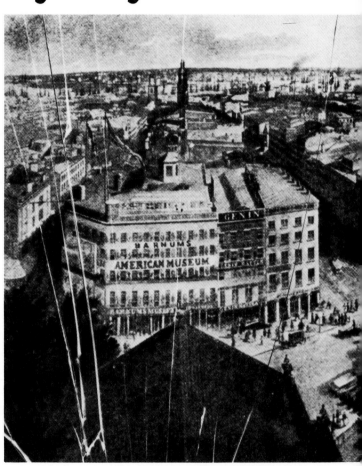

View of New York from the Steeple of St. Paul's Church, 1848.

In New York's principal business district, Brady's Miniature Daguerrean Gallery was established in 1844.

Drawn by J. W. Hill and engraved by Henry Papprel,
Courtesy New York Public Library.

W·W·NORTON & COMPANY

PORTRAIT OFANERA

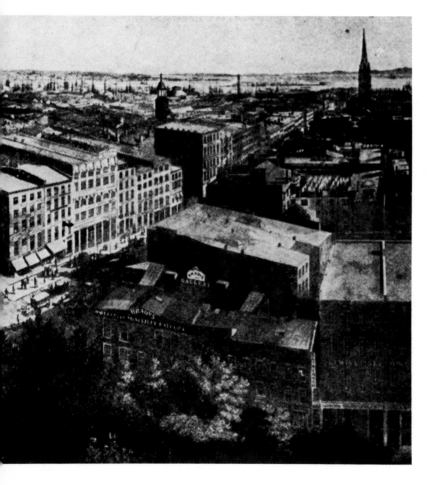

NEW YORK · LONDON

The text of this book is composed in Caledonia, with
display type set in Benguiat. Composition by Spartan
Typographers. Printing and Binding by the Murray Printing
Company. Book design by Winston Potter

First Edition

Library of Congress Cataloging in Publication Data

Meredith, Roy,
 Mathew Brady's portrait of an era.

 Includes index.
 1. United States—History—1849–1877—Pictorial
works. 2. United States—History—1865–1898—
Pictorial works. 3. United States—Description
and travel—Views. I. Brady, Mathew B., 1823
(ca.)–1896. II. Title.
E415. .M47 1982 973 81-22432

ISBN 0-393-01395-2

W. W. Norton & Company, Inc. 500 Fifth Avenue, New York, N.Y. 10110
W. W. Norton & Company Ltd. 37 Great Russell Street, London WC1B 3NU

1 2 3 4 5 6 7 8 9 0

For Jo, the young in heart

Contents

Introduction

THE PURPOSE of this book is to provide the present generation with a glimpse into a vital, tumultuous period in American history through the medium of photography—the years between 1844 and 1895, a half-century of expansion, tragedy, bloodshed, and triumph.

It was an era of two wars, extraordinary advances in industry and commerce, transcontinental railway construction, electrical communication, exploration, discoveries in medicine, an overwhelming interest in the arts, the abolition of slavery, and the budding awareness of the question of basic human rights.

Photography made its bow on the American scene in 1839, and the man largely responsible for leaving us an important pictorial record of the men, women, actions, and places of America's past was Mathew B. Brady. There were, of course, other competent photographers, but Brady stands above them all, not only as a portrait photographer, but also as a pictorial journalist. He is best known as the Civil War photographer who followed the Union armies and made pictures of the soldiers, camps, and battlefields. Brady's war pictures are important, indeed; but there was much more to Mathew Brady than that. He was the prominent photographer of the American social scene. He recorded the people who made solid contributions to the nation's progress and advancement; and, for the record, he also recorded those who worked for the nation's dissolution.

Brady was a master photographer with a realization that history made claims on his camera. He conceived the idea of preserving "the lineaments of our great men for posterity." Brady was no worshipper at his own shrine, and his range of picture-making was great, for the most part, encompassing New York City, Washington, D.C. and its environs, and, of course, the war theaters of Virginia, Maryland, and Pennsylvania. There is no record of his being anywhere else, except for his travels through Europe, where he remained for several months, exhibiting his works and studying the technical advances made in European photography.

Therefore, the pictorial and historical range of this book is largely confined to the nation's commercial, political, and industrial nerve centers. The people whose lives and work played an important series of roles in this era numbered in the thousands; a good number of the most influential sat for Brady's camera. Their fields of influence included politics, art, medicine, literature, law, music, theater, the military, and the sciences. Lastly, but by no means least, were the journalists. The most important and reliable of them were Lawrence Gobright of the Associated Press, and George Alfred Townsend, correspondent for the *New York World*. Their professional integrity and skill precluded any need to distort or misrepresent. They were the only journalists permitted to attend cabinet meetings during the Lincoln adminis-

tration. I have quoted their impressions freely in the course of this narrative.

Moreover, I have made no attempt to arrange the personalities in rigid chronological order which in many instances, had I done so, would have interrupted the narrative. The personalities represented here lived, worked, and moved within the same time frame; that is sufficient.

What I have attempted is not a history of Mathew Brady, but a use of Brady's pictures to present his times. If he sometimes appears personally in these pages, so be it; he was there.

In the course of the narrative I have depended upon the most reliable sources obtainable and have drawn my own conclusions from what I consider to be the best evidence. The era in which Brady lived was active, boisterous, and perilous. It had more than its share of trials and tribulations, including political hacks and corrupt officials, especially in New York, the nation's largest city, where the business of political corruption was regarded as a fine art.

I have had more than a nodding acquaintance with Mathew Brady's work for the past thirty-five years and in the course of that time I think I have come to know him as well as one can know any historical figure. In past years there have been many attempts to belittle his contribution to photographic history, mainly on two counts. The first—that he never saw a battlefield—is easily dismissed since he can be seen plainly in numbers of battlefield photographs. The second charge is both irrelevant and untrue. Brady did not have an extensive formal education, but he was far from illiterate. The record speaks for him.

Mathew Brady earned his reputation as one of the finest photographic artists in the country, who outdistanced all competition, the hard way; he worked at it. He died in poverty, a broken-hearted man, ignored; his work, and what it would mean to future generations, unrecognized. Until the day he died, Brady never gave up hope that his work would be included in the *Official Records of the War of the Rebellion*, then being compiled. It was a forlorn hope.

Mathew Brady was an artist and a courageous man who unwittingly followed the advice of Justice Oliver Wendell Holmes, whose life span paralleled his own. Some years after Brady's death, in an address to a Harvard Law School graduating class, Justice Holmes, in concluding, said: "Have faith and pursue the unknown end." Mathew Brady, in his own way, did just that. To the end of his career, he fought a good fight against the odds. Time and age were against him.

Acknowledgements and Sources

I HAVE BEEN fortunate in the research assistance I have received for this work, and am greatly indebted to a number of accomplished people: Josephine Berti, whose kindly firmness and assistance in the selection and preparation of a mountain of material got this book off to an early start; my friend of many years, Leon Weidman, of the American History Room of the New York Public Library for his help in locating important reference works on New York of the nineteenth century; Edith Ostrowsky and Jerry Stoker, also of the New York Public Library, whose cheerful help, general laconic outlook on present-day life, and humorous repartee brightened otherwise laborious days.

Also in order is my thanks and appreciation to Eleanor Crapullo, executive assistant to Eric Swenson, vice chairman and executive editor of W.W. Norton & Company, whose assistance in many ways made things a lot easier; Lieutenant Colonel George J. Blahuta, D.C.U.S.A., a friend and consultant in medical matters, particularly New York's historic epidemics of the 1840s.

Finally, with or without his consent, I "make my manners" to Eric Swenson, my editor and friend of thirty years, for his editorial guidance in the final stages that put this book between covers.

I do not believe that a myriad of footnotes and reference numbers is a necessary sign of scholarship. Not wanting to clutter the narrative, I have refrained from using them. Generally, my material was derived from the following sources: the Museum of the City of New York and the New York Historical Society furnished important material on life in New York City in the nineteenth century; the American History Room of the New York Public Library (which room, sadly, has been discontinued) was, in this writer's opinion, the best historical source available. Among the writings consulted are Philip Hone's many-volumned reminiscences of New York during the colorful period when he was mayor of the city; the newspaper accounts of various important political, industrial, medical, and theatrical personalities of the period, contained in, among other publications, *The New York Times, New York Graphic, New York Tribune, New York World,* and *New York Sun.*

For the Washington, D.C. scenes, I have referred to Mary Clemmer Ames's *Ten Years in Washington* (Hartford, Connecticut, 1873), *Anthony's Photographic Bulletin,* and copies of Mathew Brady's correspondence with William Riley and William H. Slocum covering the year 1895–96. *Brady's National Gallery of Civil War Scenes and Representative Men,* circa 1866, provided material for many captions, both military and civilian.

For the military sequences I have referred to the 128-volume *Official Records of the War of the Rebellion* and *Battles and Leaders of the Civil War*

(The Century Company-Appleton, 1883), the most accurate; George Alfred Townsend's *Tales of a Non-Combatant,* the most accurate correspondent; William Swinton's *Campaigns of the Army of the Potomac,* and Major General A.A. Humphrey's *The Virginia Campaigns,* most reliable; General Palfrey's *The Antietam and Fredericksburg;* and General Horace Porter's *Campaigning with Grant,* 1897. I have consulted many other sources but space does not permit their listing. However, I would be happy to furnish specific sources to anyone sufficiently interested to write me.

All photographs, unless otherwise indicated, are from the author's collection.

Finally, I have tried to be accurate without being tiresome and technical. And I reiterate: what I have attempted here is not a history, nor is it a biography of Mathew B. Brady. The book is simply what its title implies—a portrait of an era, as the world's best photographer of his time saw it and lived it.

PART I NEW YORK THE FORMATIVE YEARS

The Youthful Mathew B. Brady in 1843–44.

Brady as he looked shortly after his arrival in New York City. The lithographic plate was made by François D'Avignon, France's leading lithographer, from a daguerreotype made by one of Brady's operators.

From a daguerreotype made in the Fulton Street Gallery.

Louis Jacques Mandé Daguerre, Inventor of the Daguerreotype.

"Their exquisite perfection almost transcends the bounds of sober belief," wrote Lewis Gaylord Clark," editor of *The Knickerbocker Magazine,* after seeing examples of Daguerre's pictures.

From a daguerreotype copy of an original made by Charles R. Meade, Courtesy United States National Museum.

CHAPTER 1

"Hobbledehoy Metropolis" and the Arrival of Mathew Brady

THAT NEW YORK CITY was destined by location to become important was clear from its founding as New Amsterdam in 1626. However, the frequency and nature of its calamities, political and social, after 1844 made of it, in the words of James Fenimore Cooper, "a hobbledehoy metropolis, a rag-tag sort of place." From that time onward New York gradually made its presence felt the world over with its nearly brutal vitality, growing material power, and social complexity. The city's cultural life followed in due course. Its libraries, theaters, art museums, music halls, schools and other educational institutions once maintained the highest standards and challenged the best Europe had to offer.

New York was the hub, the epicenter of a national commercial and industrial galaxy around which everything else revolved. In 1840 the hobbledehoy metropolis would welcome an enterprising, artistic young man named Mathew Brady who, in four years, would become New York's most celebrated society photographer, the man called "Brady of Broadway."

Mathew Brady, the son of Irish immigrant parents from County Cork, Ireland, was born in Lake George country new Saratoga Springs in Warren County, New York, in 1823. His father was probably a farmer; of his mother, he had apparently no recollection. In all Brady's utterances, contents of letters, and interviews he gave to journalists in later years, no reference is made to either parent. Brady had an older brother, John, and an older sister. The sister's name is unknown, and their exact ages are indeterminate. When his sister died, he adopted her two children. He seems to have been fond of them, but judging by still-existing correspondence, they "had little consideration for their adopted father." Apparently there was little communication between them. One letter, written to William Riley, Brady's lifelong friend, by a distant cousin, Mrs. Eliza Handy, mentions Brady's adopted children with much bitterness, "for the way they treated their adopted father before he died."

Brady's parents named him Mathew out of the Bible; he added the initial "B" to his name. It "meant nothing, simply added to lengthen the name." Eventually the signature "M. B. Brady," applied to a photograph, would mean a great deal to a great many people.

At the age of seventeen, Mathew Brady met the American portrait painter, William Page, then living in the Lake George region. Charles Edwards Lester, onetime United States Consul to Genoa and a New York writer of some consequence, wrote of this meeting. "Mathew Brady during his lifetime became extremely attached to William Page, the celebrated painter . . . [and] made frequent visits to the Page studio, where he received many ideas on art. . . . [Page gave his young student] a number of drawings as tokens of his esteem, which he still preserves as mementoes of his friend."

Page, thirty-four at the time, seventeen years Brady's senior, had studied oil painting with Professor Samuel F. B. Morse and law with Frederick de Peyster. Page had hoped to continue his painting studies with the famous Colonel John Trumbull, celebrated for his paintings of the Declaration of Independence and other large works depicting the historic events of the American Revolution. However, after seeing Page's work, Trumbull advised him to "stick to the law." This premature, ungenerous criticism had little effect on Page, who later went to Italy to study and become famous in his own right.

In 1838 or 1839, Page agreed to accept young Brady as a student and it would seem that Brady had every intention of becoming a painter. Brady said Page "had given him some crayons." The record of the next two years is a blank, but sometime late in 1839, Page and Brady arrived in New York.

While young Mathew Brady formulated plans to study portrait painting with William Page and Professor Morse, an event of great importance had been taking place meanwhile in France, three thousand miles away, and would profoundly influence the lives of both Mathew Brady and Professor Morse.

A French citizen, Joseph Nicéphore Niepce, later to become a partner of Louis Jacques Mandé Daguerre, a Parisian artist and painter of Dioramas, had been conducting extensive experiments with "heliography" at his home in Chalon-sur-Saone. Niepce, in 1816, began his first experiments with a crude camera he made from a jewel box, to which he had attached a lens taken from a solar

microscope. With his camera, and paper sensitized with silver chloride, Niepce successfully produced a "fixed" image.

Niepce had met Daguerre through Charles Chevalier, an optical instrument-maker, whose "Chevalier Lens" would be the first optical system used on a practical Daguerreotype camera. Niepce had intended writing a book about his early experiments with "heliography" entitled, *A Means of Automatically Fixing by the Action of Light the Image Formed by the Camera Obscura.*

Daguerre, learning of Niepce's discovery and his intention of writing a book about it, deterred the inventor from publishing until he could derive some money from it. "There should be some way," wrote Daguerre, "of getting a large profit out of it before publication." Niepce agreed, and they later formed a partnership which lasted until Niepce died four years later. On January 19, 1839, Daguerre revealed Niepce's discovery to Professor François Arago, a prominent scientist and Secretary of the French Academy of Sciences, to whom Daguerre had appealed for government financial aid.

Arago, realizing the importance of the discovery, wrote enthusiastically, "The most minute details of a scene are reproduced with an exactitude and sharpness well-nigh incredible!" The French scientist, who thought Daguerre was "a man who possessed too much modesty," invited the inventor to preview his process before a special closed meeting of the Academy's membership body.

Daguerre, hoping for scientific recognition and public acceptance, displayed his best samples before the astonished members of the institute, without revealing the essential details of the process until certain financial arrangements were agreed upon with the French Chamber of Deputies.

Professor Arago, seeing world recognition for French science with this revolutionary discovery, recommended that the French government accept Daguerre's invention as a gift. Daguerre and the heirs of his partner, Neipce, would receive an annual income of six thousand francs for life. Daguerre agreed with the terms of the contract, and the French government accepted the invention on June 15, 1839, at the same time asking Daguerre to deliver a public lecture at the Academy on Monday, August 23, 1839.

So great was public interest, one reporter noted that "the entire meeting was sold out, leaving upwards of two hundred persons unable to gain admittance, and who were obliged to remain in the courtyard of the Palace of the Institute." The French government completed its transactions with Daguerre and made his invention available to the entire world. With little or no further interest in subsequent developments of his process, Daguerre retired to Bryn-sur-Marne, where he died in 1851.

Concurrent with Daguerre's experiments in France, Professor Samuel F. B. Morse, a scientifically minded portrait painter, was teaching literature of the arts and design for starvation wages at New York University while experimenting with electro-magnetic telegraphy. An extraordinary man, Morse was for eighteen years president of the influential National Academy of Design, the first institution in the country under the exclusive control and management of professional artists.

In 1837 Morse announced the completion of his electromagnetic telegraph, which he demonstrated successfully in February at New York University and thereby revolutionized communication. A year later, in the summer of 1838, Morse sailed for Europe to acquire French and English patents. In March of 1839 Morse saw an announcement of Daguerre's discovery in the French newspapers, which immediately aroused his interest. At Yale several years earlier Morse had made some unsuccessful experiments along similar lines. He sent a note to Daguerre at his home in the Diorama, asking the artist-inventor if he would consent to show him the results of his latest experiments in photography. Daguerre readily consented, and Morse became the first American to meet the French inventor. Two days later Morse sent a letter to the *New York Observer:*

A few days ago I addressed a note to Mr. D., requesting as a stranger, the favor to see his results, and inviting him in turn to see my Telegraph. I was politely invited to see them under these circumstances, for he had determined not to show them again until the Chambers* had passed definitively on a proposition for

*French Chamber of Deputies.

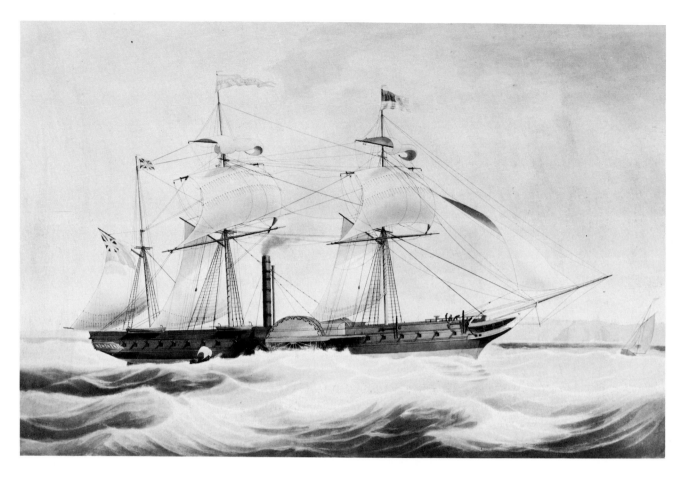

The Steam Packet, *British Queen,* **in 1839.**
The early transatlantic steamship brought the first news of Daguerre's discovery to the United States in 1839.

From an aquatint engraved by Edward Duncan, circa 1839, Courtesy New York Public Library.

the government to purchase the secret of the discovery, and make it public.

The day before yesterday, the 7th, I called on M. Daguerre, at his rooms in the Diorama, to see these remarkable results . . . No painting or engraving ever approached it. For example: In a view up the street, a distant sign would be perceived, and the eye could just discern that there were letters upon it, but so minute as not to be read with the naked eye.

The impressions of interior views are Rembrandt perfected. One of Mr. D's plates is an impression of a spider. The spider was not bigger than the head of a large pin, but the image magnified by the solar microscope to the size of the palm of the hand . . . this discovery is therefore about to open a new field of research in the depths of microscopic nature . . . The naturalist is to have a new kingdom to explore, and much beyond the microscope as the microscope is beyond the naked eye.

On the following day, Daguerre came to see Morse demonstrate his telegraph instruments. While they were thus engaged, a devastating fire of unknown origin broke out at the Diorama and burned the entire building to the ground, including Daguerre's living quarters. Obviously

touched by the extent of Daguerre's loss, which included all his paintings, scientific notes, and papers—the accumulation of a lifetime of work—Morse wrote: "His secret indeed is still safe with him, but the steps of his process in the discovery and his valuable researches in science are now lost to the scientific world."

In September, 1839, the British steam packet, *British Queen,* arrived in New York. Aboard was a François Gouraud, along with copies of the *London Globe,* which carried the announcements of Daguerre's important discovery later reprinted in the *New York Courier* and *New York Inquirer.*

Gouraud claimed to be ". . . a friend and pupil of Daguerre's, charged with introducing to the New World the perfect knowledge of the marvelous process of drawing . . . the Daguerreotype." Gouraud established himself at the Hotel Francois, at No. 57, Broadway, and immediately began preparations for his demonstration of Daguerre's invention. On December 4, 1839, Gouraud invited Philip Hone, former mayor of New York and one of the city's leading citizens, to see his exhibition of daguerreotypes.

"I went this morning, by invitation of Monsieur Gouraud, to see a collection of the views made by the wonderful process lately discovered in France by Mon-

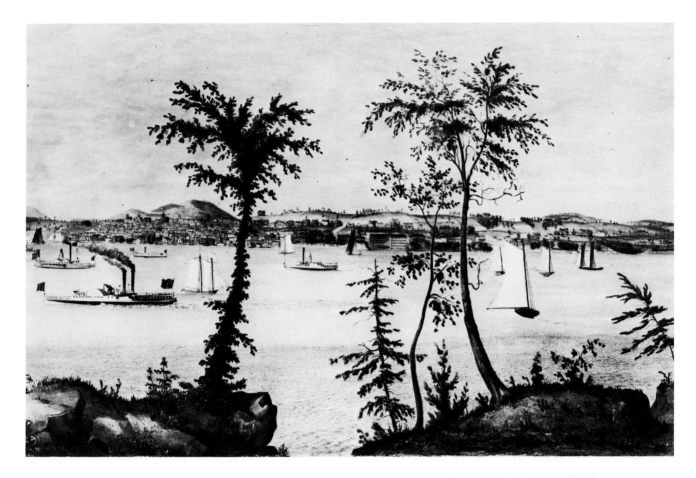

Hudson River Travel in the 1840s.
Traveling between Albany and the New York metropolis was a lot faster by Hudson River steam packet than by stage coach in 1840. The People's Night Line tied up at Pier 15, North River, between Cortlandt and Liberty Streets. Brady and Page traveled this line to New York.

From a stereograph, Courtesy New York Public Library.

sieur Daguerre," wrote Hone. "Mr. Gouraud is a pupil and friend of the inventor, and comes to this country to make known the process. The pictures he has are extremely beautiful. They consist of views in Paris, and exquisite collections of objects of still life."

Gouraud's exhibition created great interest in New York and, as Daguerre's disciple, he lectured and taught the process. Everything would have gone well for Gouraud if he hadn't allowed personal ambition to interfere with the main purpose of his visit. Conferring upon himself a "doctorate," Gouraud manifested all the mannerisms of a carnival snake-oil salesman, even selling drugs and toilet articles on the side, along with demonstrations of his daguerreotypes. This behavior angered the scientific community, especially Morse, who had just returned from Europe and took strong exception to Gouraud's behavior.

A row broke out between the two men. The controversy became public and when it reached the ears of Daguerre, he ordered his disciple home. Rightly or wrongly, the Frenchman popularized the daguerreotype. Morse came out of the controversy unscathed and with his new camera built to his own specifications by George D. Prosch, his instrument-maker, Morse made his first successful daguerreotype—a view of the Unitarian Church from the window of the third story staircase of the New York University.

By summer of 1840, making daguerreotype portraits became a thriving business in many cities and towns across the country, particularly New York City.

Meanwhile, in the late fall of 1839, Mathew Brady and William Page boarded the stage at Saratoga Springs and rode to Albany, where they made connections with the Hudson River steam packet of the People's Night Line, the most prominent of three steamship lines operating between New York City and Albany. There was no railroad service.

The water route, the main mode of travel, connected the small towns along the Hudson River with both major cities. The trip took six to ten hours, depending on the state of the tide and upon the number of stops made on the way downriver.

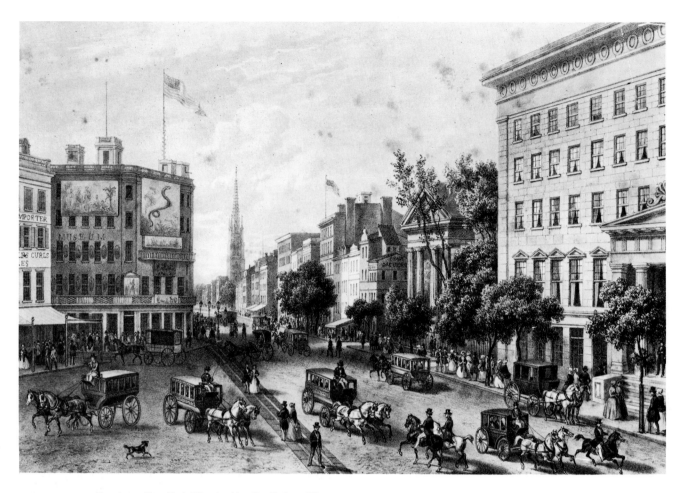

Broadway, New York City, Looking South from City Hall Park, 1850.

Brady's Miniature Daguerrean Gallery stands at the southwest corner of Fulton Street and Broadway. St. Paul's Church and Stetson's famed Astor House appear on the west side of the main thoroughfare. P. T. Barnum's American Museum stands on Broadway at Ann Street.

Lithographed by August Kollner in 1850, Courtesy New York Historical Society.

When young Mathew Brady arrived in the "nation's commercial emporium," the population of Manhattan was 312,710. Horace Greeley, editor of the *New York Tribune*, was the city's self-appointed moral conscience, and Dr. John H. Griscom, New York's medical inspector, was loudly calling the city's attention to its dilapidated housing conditions, particularly in the tenement areas, blaming the overcrowding "on the recent influx of a horde of ignorant, poverty-stricken immigrants, which were flooding the city, and placing a heavy strain on the sanitary facilities."

Yet even with all its problems, its new buildings, and its traffic congestion, some parts of lower New York still retained a country look. The Battery, long a favorite promenade of beautiful homes, overlooked the natural harbor and its myriad steamboats and sailing ships. Everything above Fourteenth Street was still open farm country dotted with small hamlets and tiny villages such as Greenwich, Chelsea, Yorkville, and, farther up the island, Harlem. Many streets below Fourteenth Street followed former cowpaths; Broadway, the widest street of all, was lined with poplars. William Street, the main shopping center, competed with Wall Street, the fashion center, and both had become somewhat citified. At night many of the streets, dimly lighted by flickering street lamps, were dangerous to the unwary. Wooden shanties, dirty hovels, and slums outnumbered the marble mansions and clean houses of red brick and white-painted windows and doorways.

At this juncture the two most influential men in Brady's life were William Page and Samuel F. B. Morse; he was about to meet a third. To eke out a living, Morse had labored long and hard to become a professional daguerreotypist. He had just begun to conduct classes in the subject at New York University, at the same time deploring his personal financial problems. Page, to young Brady, was a near-by inspiration, and it was undoubtedly Page who introduced Brady to Morse. Page was probably

A. T. Stewart

An Irish immigrant from County Cork, Stewart began his career selling lace. In five years he built New York's largest department store, which netted him two million dollars a year.

From a photograph by Mathew Brady.

instrumental in Brady's meeting with Alexander T. Stewart, the multimillionaire department store tycoon, who was to become young Brady's first employer. Brady was given a job as a clerk in A. T. Stewart's store.

A. T. Stewart, an interesting, wiry, little man with a genius for making money, had gone into trade in 1823, the year Brady was born. He opened a tiny little dry goods store on lower Broadway and laid the foundation of his personal fortune, gambling three thousand dollars on imported Irish lace and quickly turning a huge profit.

When the business depression hit the city, Stewart—a born winner—bought up his bankrupt competitors' stock at auction and made another huge profit. Not being afraid to take chances, he built a marble-faced emporium, installed a wholesale and retail dry goods department, and prospered. When the Civil War was at its worst in 1862, with the outcome of the conflict in serious doubt for the United States, Stewart took another gamble and constructed his largest department store on Broadway between Ninth and Tenth Streets, constructed entirely of steel and concrete with ornate facings of marble. One year from the day of its opening, the store earned more than $23,000 in sales. As a side issue, Stewart accepted contracts for army and navy uniforms and gathered in another two million while the war lasted.

The business and economic depression of 1837 lingered on into the 1840s and it was a difficult time for most business people, especially for Samuel Morse. Frustrated by the delays in the federal grant to finance his telegraph, Morse turned to daguerreotypy to support himself. With some help from his brothers, Sidney and Richard, Morse built a glass-roofed studio on the roof of a building at the corner of Nassau and Beekman Streets, where he practiced and taught the daguerreotype process at tuition rates ranging from twenty-five to fifty dollars.

Despite his high fees, Morse apparently attracted large classes. Uniquely qualified to teach the subject, Morse's scientific skills as a highly respected inventor and his stature as a portrait painter and professor of art, literature, and design, gave him the credentials he needed to attract students. Among them were Edward Anthony, soon to be a power in the photographic supply business, and young

Mathew Brady, soon to be the leading daguerreotypist of them all.

Whatever the merits of instruction Brady received in Morse's classes, it can be certain that Brady's natural artistic talents in portraiture quickly became apparent. "Availing himself of everything that was published on the subject at the time, and seizing hold of every new discovery and improvement," wrote Charles Edwards Lester, "Brady was soon able to produce pictures that were regarded as quite equal, if not superior to all that had been made before." His aptitude for taking and processing pictures, and the generally poor quality of most daguerreotypes being made at the time, prompted Brady to open his own gallery.

Somewhere along the line in his early youth Brady had learned the trade of making miniature jewel and surgical cases, a skill which he later turned to daguerreotype frames and cases. The New York Directory for 1843 and 1844 lists him as a manufacturer of such items in a building at 164 Fulton Street. In fact, his name is listed twice; the

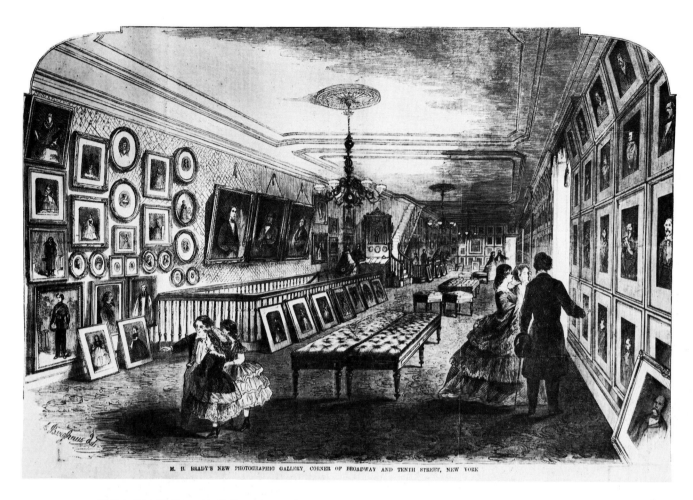

M. B. BRADY'S NEW PHOTOGRAPHIC GALLERY, CORNER OF BROADWAY AND TENTH STREET, NEW YORK

Brady's New Photographic Gallery.
This representation appeared in *Frank Leslie's Weekly* and shows the waiting room of the Broadway and Tenth Street Gallery shortly after it opened.

second location being 187 Broadway, opposite John Street. In a letter addressed to Albert S. Southworth, Boston's leading daguerreotypist, Brady solicited Southworth's frame business for his own company, giving his address as 162½ Fulton, near Broadway, opposite St. Paul's Church.

Actually, this is the same address Brady later listed for his first "Miniature Daguerrean Gallery," so both enterprises must have been in the same building. Brady's letter to Southworth is both interesting and revealing. Dated June 17, 1843, the letter indicated that Brady had been in the miniature jewel and surgical case business for some time and was well established by 1843. Prior to that he was undoubtedly studying the daguerreotype portrait process with Morse, while working at Stewart's store until 1842. It is possible that Stewart was Brady's original backer in the miniature and jewel case business. In any case, they remained friends for as long as Stewart lived.

1840 was an election year, and the political circus it

spawned has since become a national institution. The campaign got off to a running start with an avalanche of slogans, ribald songs, "log cabin raisin's," inflammatory speeches, and torchlight parades throughout every town, city, and hamlet in the country.

The Democratic presidential candidate, trying for a second term, was the incumbent, Martin Van Buren. His opponent was the Whig candidate, General William Henry Harrison, hero of the Battle of Tippecanoe. Organized on a grand scale, this was the first presidential campaign to introduce every vote-getting device under the sun to attract the vote of the "common man," a term also used for the first time to spell out the difference between the grass-roots, uneducated working man and the educated aristocrat. The fervor of the Harrison–Van Buren campaign was national in scope, and as entertaining as only a lurid carnival sideshow can be.

The outcome of the campaign of 1840 had little or no effect on Morse. By midwinter of 1841 he had established himself in his studio at Nassau and Beekman Streets. In a letter to his cousin on February 14, 1841, Morse wrote that he was "at present engaged in taking portraits by Daguerreotype" and that he had been "at considerable expense perfecting apparatus and the necessary fixtures,

Mathew B. Brady as He Looked in 1845.

Photographed on an 8 × 10 daguerreotype plate in
the new Fulton Street gallery, this portrait shows
Brady when he first arrived in New York City.

From a photographic copy of a daguerreotype.

25

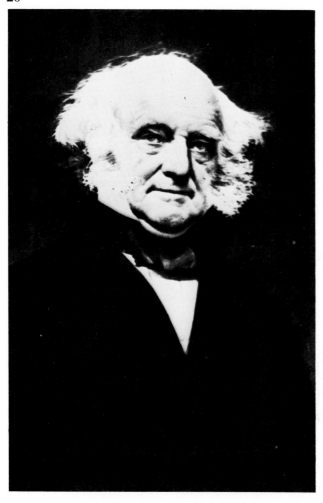

President Martin Van Buren, circa 1840.
Democratic candidate for a second term in the White House, Van Buren, a nondescript politician, was roundly defeated by General William Henry Harrison in the wildest campaign in the history of politics. Harrison died in office less than three months later.

From a photograph by Mathew Brady.

and [was] just reaping a little profit." Morse had not altogether abandoned portrait painting for daguerreotypy. "My ultimate aim," he later wrote, "is the application of the Daguerreotype to accumulate for my studio models for my canvas."

Finally on October 18, 1842, after many years of experimentation and patient waiting, matters began to favor Morse. With the success of his telegraph, he ceased both to paint and to invent. His future secure, he devoted his time to the management of his new corporation.

New York had become a cosmopolitan crossroads and distinguished visitors from abroad added stimulus to the city's daily life. When Charles Dickens arrived on his first visit to the United States on February 14, 1842, New York's social elite entertained him that night as guest of honor at a "Box Ball" in the Park Theater. Four days later Dickens was honored at a public dinner at City Hall, where the city fathers and some of their constituents had the opportunity of meeting the man who wrote such lively and imaginative stories of life in nineteenth century London.

In April, months later, some reliable city officials felt it was about time the children of New York receive free education. To implement the project, the Ward Schools system was introduced. Commendable though it was, the system carried heavy political overtones. To make certain City Hall controlled the new public school system, two commissioners, two inspectors, and five trustees of "common schools" were elected in each of the city's wards. All political appointees, they constituted the new Board of Education. For good or ill, the public school system of New York has been under political control ever since.

That same year saw the opening of the Croton Reservoir at Fifth Avenue between Fortieth and Forty-second Streets, present site of the New York Public Library. Begun in 1837 and taking seven years and $12,500,000 to complete, the reservoir was opened in celebration with military and civic parades, ending with a ceremony at the City Hall Fountain. The Reservoir produced a daily flow of 35,000,000 gallons of water, which immediately improved the deplorable, antiquated sanitary conditions Dr. Griscom had warned city officials about. Equally important, this available water from street hydrants greatly reduced the dangers from fire.

The nineteenth century was, of course, a great era for the beginnings of everything; it was also the great age of photographic portraiture.

PART II THE DAGUERREOTYPE ERA

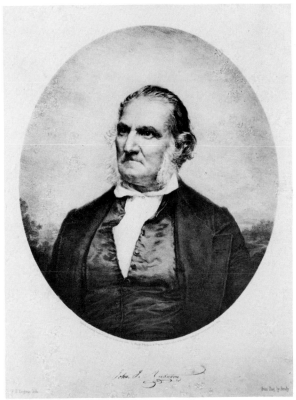

1839–1850

John James Audubon, circa 1845.
Most popular naturalist in America, Audubon led an adventurous life. His father was a sea captain; his mother was a Creole beauty of Santo Domingo. "Patron saint of birds," a sentimental observer of nature, Audubon did most of his bird paintings in the Kentucky wilderness.

From a daguerreotype by Mathew Brady.

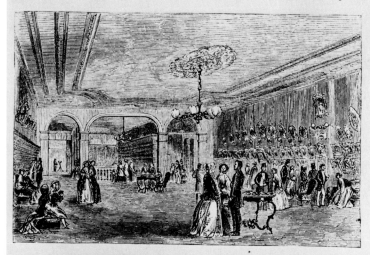

BRADY'S DAGUERREAN GALLERY,

359 BROADWAY, over Thompson's Saloon, New York.

This New and Extensive Establishment

Has been recently completed, and the public are invited to view the many improvements combined in this MAGNIFICENT GALLERY. *The proprietor has no hesitation in claiming advantages possessed by no similar establishment, either in this country or in Europe. The facilities for the production of First-class Pictures are unrivaled.*

Attention is specially directed to the admirable arrangement of light for Children; also for copying DAGUERREOTYPES, PAINTINGS, STATUARY, &c. *An additional building has been erected, by which the* RECEPTION SALOON, LADIES' DRESSING ROOM, *and the* OPERATING ROOMS, *are on the same floor, forming a new and most desirable arrangement.*

This Gallery contains a matchless collection of EUROPEAN AND AMERICAN CELEBRITIES, *unrivaled on this continent. In addition to various Medals received in New York, the* PRIZE MEDAL *was awarded in London, at the World's Fair,* 1851.

359 BROADWAY.

Baker, Godwin & Co., Printers, 1 Spruce St., N. Y.

A Brady Daguerrean Gallery Advertisement.
One of many such advertisements released by Brady, this one announces the opening of the "new and extensive" gallery at 359 Broadway, New York—"over Thompson's Saloon." The ad also calls the attention to the various daguerreotype applications, such as copying paintings and statuary.

Visits to a Small Gallery

MATHEW BRADY opened his first gallery on the southwest corner of Broadway and Fulton Street sometime in the fall of 1844 and almost overnight became New York's leading society daguerreotypist. He was twenty-two.

Situated on the top floor of a three-story building of gray stone and red brick at 205 Broadway, in the most desirable neighborhood in the city, the gallery fronted New York's widest, most popular thoroughfare. A side entrance at 162½ Fulton Street, opposite St. Paul's Chapel, led to his miniature and jewel-case business and also served as a private entrance for visiting celebrities. A small marquee over the sidewalk and a large sign lettered in gold, reading *Brady's Miniature Daguerrean Gallery*, marked the Broadway entrance.

From the outset Brady did everything on a grand scale, constantly improving his facilities until he was able to produce daguerreotypes superior to any made by his competitors. No expense was spared to make the gallery the most sttractive, most efficient studio operation in the city. He employed the best operators, chemists, and artists available, among them James Brown. A young and very promising artist, Brown headed Brady's small group of skilled studio technicians. Sometime after Brown joined Brady's gallery, he successfully produced a transfer of daguerreotypes to the printing block.

The Reception Room was sumptuous. Its walls were covered with expensively framed, daguerreotype portraits, samples of his earlier works, many executed in oils and pastels. The French photographic art journal, *La Lumière*, observed that, "American daguerreotypists go to enormous expense for their rooms, which are elegantly furnished . . . worthy of comparison with the enchanted habitations which the orientals erect for their fabulous heroes."

The Operating Room, as he called it, was equally well equipped with the necessary studio furniture, backgrounds, and several cameras of various plate sizes. Overhead were several skylights, an innovation borrowed from John Draper and Samuel Morse. Mounted together on the sloping rooftop, the skylights, each about twenty feet long and three feet wide, held heavy rectangles of bluish plate glass. Inside the studio movable shades under the skylights controlled the brightness. Charles Edwards Lester wrote, "Brady has now reached such a stage in the art that it seems to make little difference to him what the state of the atmosphere or light may be, since his lenses and his camera obscura are so numerous and varied . . . that the light shed upon the picture seems to be entirely under his control. Some of the finest pictures have been taken on the darkest and stormiest days." Special equipment for copying oil paintings, statuary, and other daguerreotypes, with lighting arrangements and instruments designed for the purpose, completed the operating facility.

Not all daguerreotype galleries in New York were so well equipped, nor so well planned and operated. The average gallery that had sprung up in New York since 1839, or for that matter anywhere else, "was a chamber of horrors overhung with dreary draperies and arrays of portraits of distorted ladies and ferocious heroes in various attitudes." By 1844, the year Brady opened his gallery, 3,000,000 daguerreotypes were being taken annually, priced from fifty cents to a dollar, but most of these "counterfeit presentiments" were the dubious output of people in other trades, who practiced daguerreotypy on the side.

James F. Ryder, a successful professional of Cleveland, wrote: "It was no uncommon thing to find watch repairers, dentists, and other styles of business folk to carry on daguerreotypy 'on the side'! I have known blacksmiths and cobblers to double up with it, so it was possible to have a horse shod, your boots tapped, a tooth pulled, or a likeness taken by the same man; verily . . . a daguerreotype man in his time played many parts."

Ninety-six professional operators competed in New York City in 1844. The six most important of these were not only competent, but were all located on Broadway, within shouting distance of Brady's gallery. Yet even at this early stage the press acknowledged the newcomer, Brady, "as the leader . . . his establishment a pattern of the whole."

The prominent people who came to Brady's gallery to be "painted with sunbeams," as one reporter put it, came from every walk of life. Many were rich, others were

29

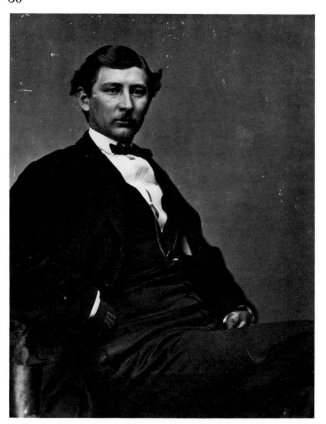

George Alfred Townsend in 1866.
War correspondent for the *New York World*, Townsend wrote under the sobriquet of "Gath"—his three initials with an added *h*—a conceit based on a biblical quote, "write it not in Gath." Author of several novels and a newspaper column, he also wrote the famous "Townsend Interview," with Mathew B. Brady.
From a photograph by Mathew Brady.

Mathew B. Brady, circa 1845.
A wet plate copy of an original Ambrotype (a negative photograph made positive when placed over black velvet) shows Brady at about twenty-two. Brady introduced the Ambrotype process in his gallery.
From an Ambrotype made in the Brady gallery.

famous, and some were titled. Together they formed a composite portrait of the era.

Many of Brady's patrons were among those responsible for the direction the nation was taking in 1844, and not the least of these were the New York politicians. Among his early sitters were influence peddlers and dealers in political mischief and corruption, among them Fernando Wood, sometime mayor of New York, and Clement Vallandigham, later known as Copperhead.

Brady knew all too well that his success depended upon being politically impartial. Although he himself was a member of Tammany Hall, there is no record of his ever having taken a stance on the issues or candidates of his time. His distinguished patrons spent their money not necessarily for *truth*. They accepted their portraits because his pictures in most cases flattered them. If there were remarkably few complaints, probably it was because he never allowed a bad portrait to leave his studio. Those

he considered not up to his standard were redone.

It has been said that Brady's nearsightedness and a lack of a knowledge of chemistry made it impossible for him to take daguerreotypes on his own. Nothing could be farther from the truth. In the first place, why was it necessary to be a chemist? Few, if any, of his competitors were chemists. Once the process was learned, by trial and error, the process became routine. Charles Edwards Lester, said that Brady "had a good deal of practical experience in mechanical and artistic experiments, . . . undertook a series of experiments for himself which resulted so satisfactorily, that he resolved to bring the daguerreotype to perfection." As for nearsightedness, any photographer afflicted with this minor eye problem knows that his eyes look no farther than the magnified image on the camera's ground-glass viewplate and presents no problem at all.

Although Brady's success was swift, he must have been financed at the start. No record exists, but there is a strong possibility that his friend and former employer may have been the original backer. Always willing to take chances on a money-making venture, Stewart could have easily afforded to risk a small investment. Another possible backer may have been P. T. Barnum, who made it a point to send Brady patrons at every opportunity.

At about this time George Alfred Townsend, correspondent for the *New York World* described Brady as "a medium-sized, fine-looking young man, about five-feet seven or eight inches tall, with a sensitive face and curly black hair any woman would have envied; a gray, broadbrimmed felt hat gave him the look of a Paris art student."

Townsend could have also added: a kindly, well-mannered, quiet man of purposeful demeanor, who knew what he wanted from life and was willing to work for it. Always neatly dressed, his dove-gray, well-tailored trousers, elegantly fitted jacket, and polished black boots set him apart. Hard work, Brady believed, was the secret of success, and he kept to that rule all his life.

Brady's gallery was a part of the charming community of South Broadway, an area from City Hall Park to the vicinity of Barclay and Vesey, Wall and William Streets—a microcosm which encompassed Barnum's

31

South Broadway, New York City, circa 1850.
Broadway, photographed from a high angle looking
south from City Hall Park, was a busy thoroughfare
and New York's fashionable street.

Photographer unknown.

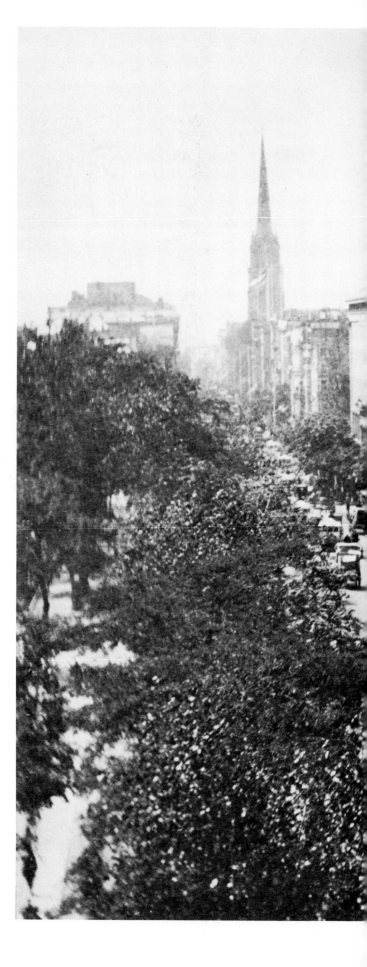

Museum, St. Paul's Chapel, Trinity Church, and Charles
Stetson's fashionable Astor House. Farther south, Battery
Park and its tree-lined, promenade completed the pic-
turesque, miniature community of which Philip Hone
wrote, "a more delightful scene can nowhere be found."

In sharp clarity also were the fancy gas-lighted saloons,
elite restaurants like Niblo's Garden, the Park Theater,
and A. T. Stewart's Store. It was the city of the mil-
lionaire, a word coined in New York and applied to the
Aspinwalls, Vanderbilts, and Cookes, those celebrated
merchants and businessmen who made undreamed-of
fortunes in steamships, finance, railroads, street cars, and
a foreign adventure or two.

If New York's smart hotels, theaters, business es-
tablishments, palatial Fifth Avenue mansions, and the
distinctive homes along the Battery were its proof of
affluence, then its forgotten conscience rested only a
stone's throw away in the most despicable slum district in
the city. Here the streets, dirty beyond belief, carried the
filth of weeks. Here life was a cheap commodity. A lone
watch officer, walking his beat through "Murderer's Al-
ley," "Cow Bay," or "Paradise Square," took his chances
on coming out alive. Gangs of the toughest hoodlums,
thieves, murderers, prostitutes, and fences for stolen
property infested the area. The Dead Rabbits Gang, the
worst of several such murderous organizations, controlled
the district unchallenged. The city's Old Watch Depart-
ment, a pseudopolicing organization, had neither the
manpower nor the muscle to deal with the appalling
situation.

The Republican mayor James Harper, elected in 1844,
tried to solve the city's crime problem, but with little or
no help from his Democratic colleagues he was unable to
carry out his reforms. However, the New York Legisla-
ture empowered him to abolish the Old Watch Depart-
ment and replace it with an organized, day-and-night
police force "to number not more than eight hundred
patrolmen," which amounted to approximately one
patrolman for every four thousand two hundred and fifty
citizens.

From his gallery windows, Brady could see a continu-
ous flow of omnibuses, brewery wagons, water carts,

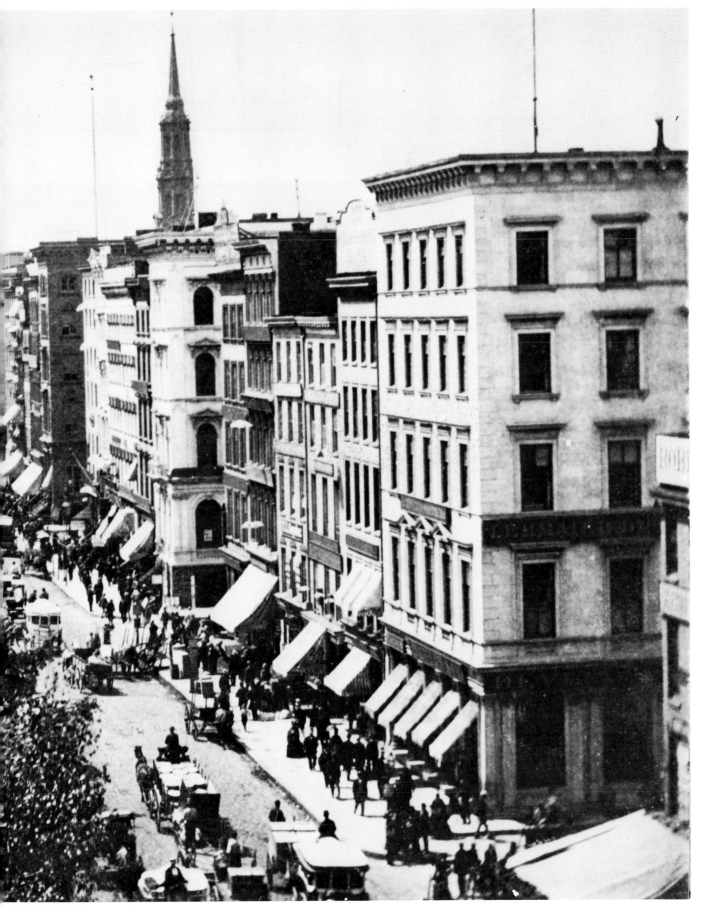

heavy trucks, and liveried carriages, competing for right-of-way without benefit of traffic regulations of any kind.

"The traffic was a never-ending rumble," wrote Philip Hone "and it was worth one's life to cross New York's main thoroughfare from the 'shilling side' to the 'dollar side' at any time of day or night. There was scarcely a block in the entire length of this fine street of which some point is not in a state of transmutation."

P. T. Barnum's American Museum of Oddities occupied a five-story building on the northeast corner of Ann Street, directly across from Brady's gallery. Opened in 1842, the museum—with its enormous, colored posters of sea monsters, Fee Jee mermaids, exotic oriental figures, and Niagara Falls—overpowered everything in sight. "I don't much care what the papers say about me," Barnum once told a reporter, "providing they say something!"

Brady made his residence the Astor House, the city's most elegant and popular hotel. Built in 1836, fronting the west side of Broadway from Barclay to Vesey Streets, the Astor House was an imposing building of white granite with a facade of Corinthian columns forming the portico over the main entrance. Room Eleven had long been the home of Thurlow Weed, political prime mover and wizard of the Albany lobby. Weed had once said laughingly, that "he knew his political enemies thought him a scoundrel," but not until 1839, did he "discover that his friends thought the same!" Daniel Webster, secretary of state in President Tyler's cabinet, had a standing order for a "suite of rooms held ready at a moment's notice."

Charles Augustus Stetson, the Astor's owner, led a glamorous life in the company of his famous guests. His sumptuous dinners made him New York's unofficial host

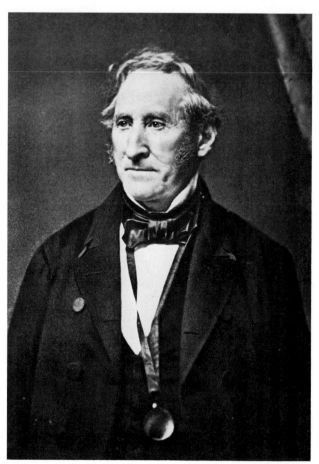

and the Astor the city's center of social life. Brady became a familiar figure at the Astor, and something of a social personality himself.

All this activity required money, which the rapidly growing commercial system provided. Anthony Trollope, the English novelist, noted after his visit to New York, "The ascendency of dollars are the words written on every paving stone along Fifth Avenue, down Broadway and up Wall Street. Every man can vote, and values the privilege. Every man can read, and uses the privilege. Every man worships the dollar, and is down before his shrine from morning till night."

An industrious search for improvement was one of Brady's strong points and much of the profit went back into his business, a practice that would one day prove his undoing. "So far as the daguerreotype is concerned," wrote Charles Edwards Lester, "we are not aware that any man has devoted himself to it with so much earnestness or expended upon its development so much time and expense, as Mr. Brady."

With the opening of his first gallery, Brady had, on the practical level, almost reached the fulfillment of his early professional ambitions. An enormously influential and popular photographer with a rare visual understanding, he never suppressed his own outgoing personality, no matter who sat before his camera.

Among the first of the national political figures to visit the Fulton Street gallery during the election of 1844 were Governors William Bouck and Silas Wright of New York, General Lewis Cass, Millard Fillmore, Henry Clay, John C. Calhoun, and Daniel Webster. The precise dates of their sittings are unknown, as Brady's gallery appointment book for that year has been lost, but they all faced Brady's camera sometime in the early fall of 1844. In the case of Governor Bouck's sitting, it is possible that Brady traveled to the State Capitol at Albany to make the plate. In any case, it was during the period of the antirent riots against the patroons in upper New York State.

Silas Wright, Bouck's successor as Governor, had been a farmer, lawyer, county surrogate, and a brigadier-general in the state militia, and had won a seat in the United States House of Representatives in 1827. Admit-tedly in sympathy with the tenant farmers, Governor Wright advocated "redress by law," but a fresh outbreak of anti-rent violence became a matter of homicide when an armed rider shot and killed a sheriff's deputy at an eviction sale. Wright acted at once, declared Columbia County in a state of insurrection, quelled the riots, and arrested the ringleaders. Wright's prosecution of them cost him re-election in 1846.

On the national scene matters were no less chaotic. The election of 1844 assumed all the peculiarities of the Harrison–Van Buren election only four years before. The open personal hostility among prominent Democrats almost brought about a complete breakdown of the convention. At the root of the problem lay the questions of states' rights, slavery, and the Oregon boundary dispute with Canada and Great Britain. The uncontrolled convention in Baltimore produced a dark horse, James Knox Polk.

The Whig National Convention nominated Henry Clay of Kentucky by acclamation, a very controversial figure, indeed. No politician in American life could lay claim to more bitter enemies, nor more ardent supporters, than Clay. Once a brilliant criminal defense lawyer and long a politician, Clay was a skillful orator with a golden voice. Envisioning himself as a representative of all the people rather than the privileged few, Clay had exchanged his seat in the Senate for a seat in the House of Representatives. In an address to House members, he said: "In presenting myself to your notice, I conform to the sentiments I have invariably felt, in favor of the station of an immediate representative of the people."

In 1844 Clay's declaration that slavery was not involved with the Texas annexation question—"if it could be done without dishonor, without war, with the consent of the Union, and upon fair and just terms"—cost him the New York State abolitionist vote and gave the election to Polk.

Clay's defeat at the polls was a national tragedy to an enormous number of people across the country. "Never before or since," wrote James Ford Rhodes, "has the defeat of any man in this country brought forth such an exhibition of heartfelt grief from the educated and respectable classes of society as did the defeat of Clay."

Brady needed the illustrious Clay's picture, and early

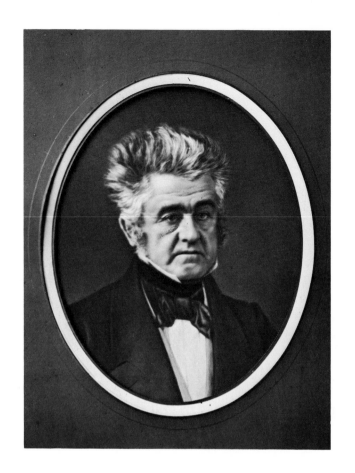

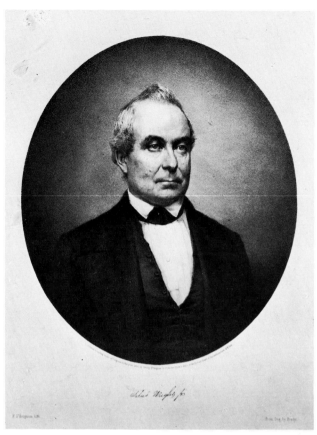

Silas Wright, Jr.

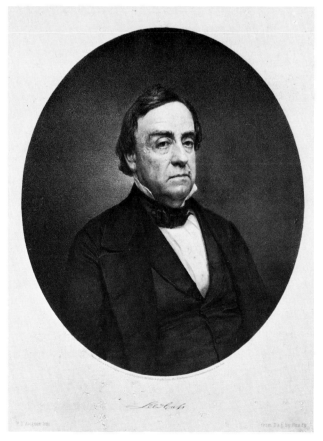

Lewis Cass

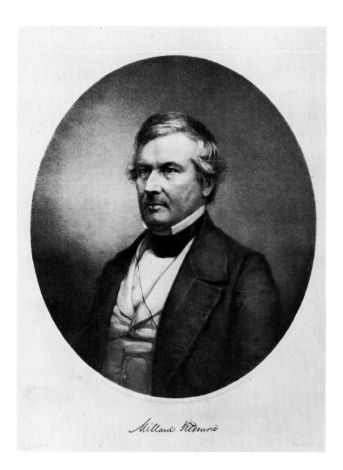

Millard Fillmore

Governor William Bouck of New York, 1845.
(facing page upper left)
Ardent disciple of Thomas Jefferson's brand of
politics, and an upstate New York farmer, Governor
Bouck put down the farmer's land revolt against the
patroons, descendants of the Dutch landowners.

 From a daguerreotype by Mathew Brady.

Governor Silas Wright of New York, circa 1845.
(facing page upper right)
Farmer, lawyer, and brigadier general in the New York
State Militia, Wright, in sympathy with the tenant
farmers, inherited Bouck's problem, declared martial
law, and arrested the ringleaders.

 From a daguerreotype by Mathew Brady.

Lewis Cass, circa 1845. *(facing page lower left)*
Incapable of inspiring political enthusiasm, Cass
was, nevertheless, honest and precise in his dealings.
A fine soldier in the War of 1812, Cass lost the
election to Zachary Taylor in 1848. Secretary of State
to James Buchanan in 1861, he became a cypher in a
conspiracy-ridden cabinet.

 From a photographic copy of a
 daguerreotype by Mathew Brady.

President Millard Fillmore, circa 1846.
(facing page lower right)
President Zachary Taylor's sudden death on July 9,
1850, moved Vice President Fillmore into the White
House as thirteenth president. "Strickly temperate,
industrious and orderly," his integrity was above
reproach.

 From a photographic copy of a daguerreotype by
 Mathew Brady.

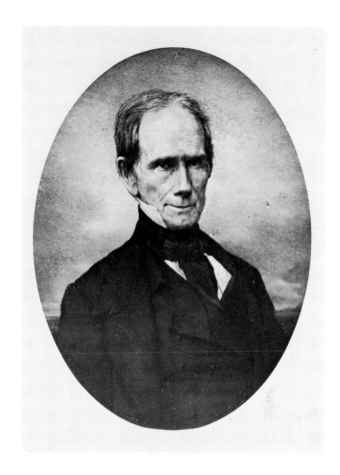

Henry Clay of Kentucky, circa 1845. *(upper right)*
Strongly nationalistic, Clay envisioned himself a
champion of the poor and underprivileged. He was a
brilliant criminal defense lawyer, and "no client of his
was ever hanged." His sitting for Brady at City Hall
was a fiasco.

 From a daguerreotype by Mathew Brady.

Senator Daniel Webster, circa 1849. *(lower right)*
Senator from New Hampshire and former Secretary of
State in President Harrison's cabinet, Webster, was
the greatest Constitutional lawyer of his time, "a
product of America, and made of granite."

 From a photographic copy of a daguerreotype by
 Mathew Brady.

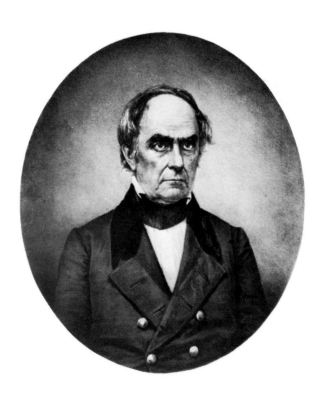

in the 1844 campaign Henry Clay arrived in New York City to attend a political reception given in his honor at City Hall. Nothing subtle in his approach, Mathew Brady asked Clay to sit for his portrait, but the request was declined on the grounds that a heavy schedule precluded a visit to the gallery. Unperturbed by Clay's refusal and unwilling to let the matter rest, Brady sought the help of his friends Moses Grinnell and Simeon Draper, millionaire merchants, and Joe Hoxey and Clay's friend William V. Brady, both well known at Tammany Hall. Brady discovered that they, too, wanted pictures of Clay for themselves. Together, they managed to arrange an appointment for Clay to sit at the gallery before noon of the following day, coincident with the reception at City Hall.

Somehow rumor spread and crowds gathered outside the Broadway and Fulton Street entrances to the gallery, hoping to catch a glimpse of the celebrated visitor. Noontime passed without a sign of Clay, who had been detained at City Hall by the aldermen and hundreds of admirers. Just when Brady was about to give up, a policeman arrived at the gallery requesting that Brady bring his equipment to City Hall at once. Gathering their cameras and apparatus, Brady and James Brown, his artist-assistant, rushed into a cab and drove the few blocks up Broadway to City Hall, where the Chief of Police, George Mattsell, personally escorted them to the Governor's Room.

Brady hastily set his cameras on their tripods, while young Brown pulled aside the heavy window curtains to allow as much light into the room as possible. Moments later, Henry Clay entered the room, followed by a group of admirers. He walked over to Brady, held out his hand in a cordial greeting and announced, "Well, here I am, Mr. Brady."

Outside the room someone was hammering. Brady acknowledged the greeting, trying to speak above the noise, at the same time showing Clay to his seat. While the camera was being adjusted, the hammering stopped suddenly and Clay commented on the welcome quiet that had settled over the room. But the quiet didn't last very long, for the crowds outside became boisterous, and the halls and corridors resounded with their shouts and demonstrations.

Brady studied his subject and later reported him to be a man with "personal magnetism—tall, with a high forehead, gray eyes, and a large mouth. His voice was engaging, and every movement of his body made with grace and skill." Father of eleven children, Clay played cards, liked horse racing, good cigars, and good liquors, but did not drink to excess. He had fought duels; defended criminals in court and seldom lost his cases; believed firmly in the United States; was "the defender of the people." Just when Brady was about to make the plate, a rowdy group of political hangers-on burst open the door to the reception room, and proceeded to devour the buffet lunch. Some pushed themselves into the Governor's Room and almost brought Clay's sitting to an abrupt end.

Irritated by the outrageous behavior of this motley group and by the cigar smoke that filled the room, Brady nevertheless decided to try again. Clay had dressed with particular care that morning, as he was to address the Ladies Reception Committee later in the day, but his clothes had become rumpled in the crush. He tried to adjust his coat and stock, then resumed his seat before the camera and said: "Well, I am ready, Mr. Brady." But before Brady could make the plate, another group of Clay's overly enthusiastic admirers poured into the already crowded room. Jostling around Clay, they blocked the camera, and created a general disturbance.

Noting Brady's discomfiture, Clay—somewhat annoyed himself—stood up, raised his hand for silence, and motioned the crowd to step aside. When the silent crowd moved away, Clay assumed his pose once again, and Brady made the plate. Knowing beforehand that the plate would be unsatisfactory, Brady asked Clay if he would come to the gallery, where he could make another under more conducive conditions. Clay agreed, and other plates were made.

Brady related to the people he came in contact with in a professional way with a personal touch; when that personal touch wasn't there, things happened.

James Fenimore Cooper, the author of the famous Leatherstocking Tales including *The Last of the Mohi-*

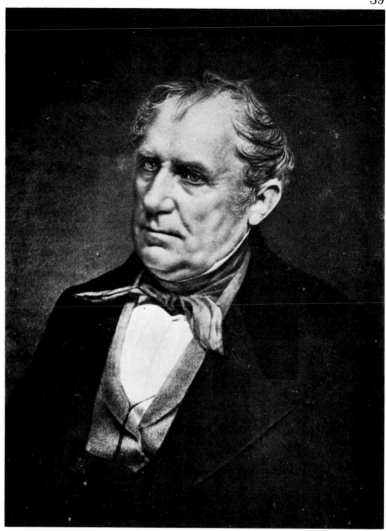

James Fenimore Cooper, circa 1845.
Cooper resented an indiscreet remark of Brady's assistant, concerning Cooper's problems with his publisher, got a temper tantrum, and ran from the studio.

From a daguerreotype by Mathew Brady.

cans, consented to sit for Brady in the early months of that year. When the author arrived at the gallery, Brady wasn't there to receive him. The task of making Cooper's portrait fell to James Brown, Brady's young assistant. Brown was an exceptional artist, but he evidently lacked Brady's discretion when dealing with inflated egos.

At the time, Cooper was having some disagreeable differences of opinion with his publishers, which had been reported in the newspapers. Cooper took his seat before the camera. Making conversation while he prepared the apparatus, Brown remarked in favor of Cooper's position against his publishers. Apparently Cooper didn't appreciate this invasion of his privacy; he leaped from his chair, without a word, and rushed from the gallery.

When Brady returned and was told about the incident, he immediately went to see Cooper at Bixby's Hotel, at Park Row and Broadway, to apologize. Cooper refused to see him, and Brady left determined not to let the matter rest there.

Realizing he needed an influential third party to intervene in the matter, Brady went to see his friend William Cullen Bryant to solicit his help in correcting the delicate situation. After Brady explained the misunderstanding, Bryant wrote a personal note to his friend, Cooper, which he gave to Brady to deliver by hand. Armed with Bryant's note, Brady returned to Bixby's Hotel, determined to use all his powers of persuasion to induce Cooper to come to the gallery. Fully expecting a curt refusal, Brady knocked on Cooper's door. The cordial greeting he received surprised him momentarily, and he handed Cooper the note not knowing what to expect. Cooper read it, and surprised Brady again by saying that he would dress immediately. Moments later they hailed a cab and drove to the gallery, where the portrait was made without further incident.

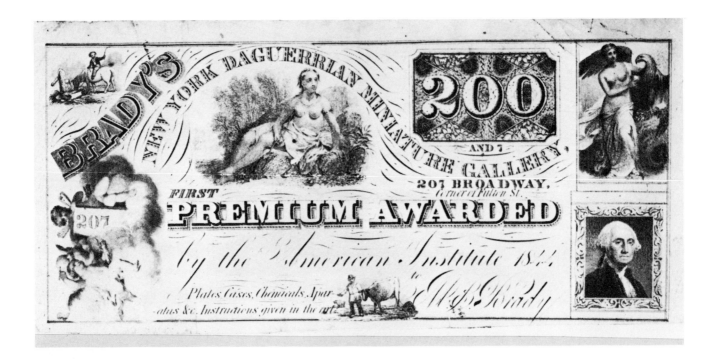

Posterity has given Mathew Brady very high marks for these early daguerreotypes, particularly those he made in the months before the Fair of the American Institute in 1844. There were two competitions that year, and in the first Brady received honorable mention. In the second competition he won the First Premium Award; a remarkable accomplishment inasmuch as he had been in business only a few months. "Even at this period," said the press, "Mr. Brady has already acquired the reputation of being one of the first artists in the country to receive a premium."

Although no record exists as to which of these early daguerreotypes Brady entered in the Fair of the American Institute, one likely candidate would have been his portrait of "the patron saint of birds," John James Audubon, the most popular naturalist in America. Audubon's father, a sea captain during the American Revolution, had been captured by the British in 1779, and held prisoner in New York. Little is known of his mother, except that her name was "Mlle Robin" and that "she was a Creole of Santo Domingo," who died on the Audubon plantation at Les Cayes, Bay of Biscay, a year after the boy, John James, was born. Brought up by his stepmother, and educated as a young bourgeois, he received instruction in mathematics, geography, English, music, and fencing; his one regret was that he "had no drill in writing in his own tongue."

Audubon's interest in natural history began with his collecting of original French birds, an enterprise not ap-

preciated by his father, who packed him off to a military school for discipline. Before young Audubon came to the United States, he had studied drawing with the famous French artist, David, for about a year, after which he sailed for America in 1803. He lived on his father's estate at Mill Grove, near Philadelphia, where he "enjoyed the life of a country gentleman, free from money cares, and a sentimental and enthusiastic observer of Nature."

Two years later he married Lucy Bakewell and settled in Henderson, Kentucky, where he became acquainted with Daniel Boone. The wilderness gave him the scope he needed, and he began his major work, an elephant-sized folio, *Birds of America,* executed in hand-colored engravings by Currier and Ives from his original watercolors.

Brady's daguerreotype of Audubon, made in the Fulton Street gallery, shows the naturalist as he looked in his thirties and forties, a rather portly figure.

Two eminent American writers sat for Brady that same year; both were products of New England, and both attended Harvard College. When William Hickling Prescott sat for his portrait, he was forty-six, a famous historian, and almost totally blind. William Ellery Channing was at twenty-six a promising poet.

Both men, in their writings and personalities, were diametric opposites. Tall and handsome, William Prescott was a man not easily swayed from his mission in life, nor thwarted by a devastating physical handicap. He was struck accidently in the right eye by a hard crust of bread thrown during a student frolic at Harvard. It permanently

40

American Institute Award, 1844.
Brady won this award for the best in daguerreotypes, a remarkable achievement since he had been in business but a few months. He used it in advertisements like this.

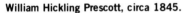

William Hickling Prescott, circa 1845.
Almost totally blinded accidentally by a student prankster Prescott, one of America's foremost historians, overcame his eyesight handicap by the use of a Noctograph, a writing instrument "to obviate the difficulties of a blind man's writing."

From a daguerreotype by Mathew Brady.

destroyed the sight of this eye, and caused a sympathetic reaction of painfully acute inflammation of the left eye, which he could use for only short periods of time, making him almost totally blind at the age of eighteen.

Near total blindness, however, didn't prevent Prescott from later writing two major historical works on the Spanish Conquistadores in North America—*The Conquest of Mexico* and *The Conquest of Peru*. The advancing years were kind to Prescott. He retained his youthful looks until he reached fifty, and despite the loss of his eyesight remained a charming man with a winning personality, a favorite of Boston's drawing rooms.

William Ellery Channing was writing for Horace Greeley's *New York Tribune* when he sat for Brady the year before he traveled to France and Italy. A product of the Boston Latin School and other private schools, young Channing entered Harvard College in 1834 at sixteen, but he remained only a few months. Although a brilliant student, Channing found college a bore, and he ran away. After some searching, his family found him at Curzon's Mills on the Merrimac River, writing poetry. Channing never returned to Harvard. His first verses, entitled "The Spider," appeared in *New England Magazine;* for the most part he wrote for newspapers and periodicals to earn a living.

In later years his friend Henry David Thoreau said that Channing's personality was "as elfish and so naturally whimsical as a cow is brindled." Apparently his friends Nathaniel Hawthorne, Ralph Waldo Emerson, and Franklin B. Sanborn thought the same; but of these writers, Emerson was Channing's favorite, and they remained close friends.

Channing's poetry written while he was at the *Tribune* was later described by Thoreau as "sublimo—slipshod," not exactly laudatory criticism, though far kinder than Edgar Allan Poe's scathing review in *Graham's Magazine*, in which Poe pointed out faults in diction, meter, and syntax. Emerson believed Channing to be a genuine poet, and wrote a favorable critique of Channing's poems for *The Dial*, and agreed with many that Channing was "as indigenous to New England as a russet apple."

After his stint on the *New York Tribune*, Channing settled in Concord with his wife, Ellen Fuller, to be near Emerson, and resumed his position as editor of *The New Bedford Mercury*. Soon afterward, Channing wrote the biography of his friend Thoreau and edited several volumes of his writing.

After the death of his wife, wishing not to be alone in his old age, Channing lived with Franklin B. Sanborn until he died in 1901 at the age of eighty-three.

George Opdyke, Mayor of New York, 1861.
Elected in December of 1861, Mayor Opdyke
presided over the more than one hundred thousand
people gathered in Union Square to pledge their
loyalty to the Union at the outbreak of the Civil War.
From a daguerreotype by Mathew Brady.

flourished and, absurd though they were, had numerous followers and devout believers. One shadowy character, Andrew Jackson Davis, "The Harmonial," whose sexual advice and predilections were, to say the least, strange, gave New Yorkers a view of uninhibited eroticism.

Charles Fourier, a business clerk, ran a close second in this weird nonsense. Opening a school for "Passional Hygeine," he taught "attractional harmony" to the bored, the gullible, and the ignorant who looked for novelty diversions in his (or her) sexual and living habits. Fourier's operation could be described as the mental massage parlor of the day.

Sometime in early winter of 1845, Mathew B. Brady conceived the idea of collecting all the portraits of distinguished individuals he could induce to sit for his camera, with the intention, "if his life was spared," of producing an elaborate book, entitled the *Gallery of Illustrious Americans.* The book was to be a deluxe edition, containing "twenty-four of the most eminent citizens of the American republic since the death of Washington," lithographed from original daguerreotypes made by Brady personally, each accompanied by a biographical sketch written by a prominent writer.

Brady had first approached John Howard Payne, the American actor, dramatist, and author of "Home Sweet Home," to write the biographical sketches, during a sitting at the Gallery, and Payne had accepted, but after being reappointed to his diplomatic post as Consul to Tunis, Africa, he was unable to begin the project. Brady turned to another retired diplomat, Charles Edwards Lester, former Consul to Genoa, who accepted the assignment as writer and editor.

For the lithography, Brady hired Francis D'Avignon, a master lithographer, to make the lithographic stones at $100 each. Brady financed the entire venture. Five years in the making, the book eventually contained only twelve of the originally planned twenty-four portraits. Of these he already had Governors Silas Wright and William Bouck of New York, James Fenimore Cooper, William Prescott, and William Channing.

Sometime in March, 1845, Brady learned that the aged General Andrew Jackson, "Hero of New Orleans" and

Sharp contrasts and extremes in almost everything characterized New York in the closing months of 1844. "Washington Irving's town is in its Golden Age . . . not yesterday or tomorrow, but today," bellowed George William Curtis, editor of *Harper's Weekly.* Colonel Davy Crockett commented laconically to ex-Mayor Philip Hone that "there were too many people in New York, and too close together."

Uncontrolled immigration put great pressure on the city's resources. Hordes of poverty-stricken immigrants brought down living standards. Language barriers and overcrowding fomented occasional riots between old residents and the newcomers. Native Americans charged city officials, with justification, that they had come into office on the votes of German and Irish aliens, and were using new aliens, not to mention tombstones, to keep themselves in office.

The city was rapidly becoming a metropolis. Burgeoning cultural activity was accompanied by massive overcrowding and runaway crime. The lunacy fringes

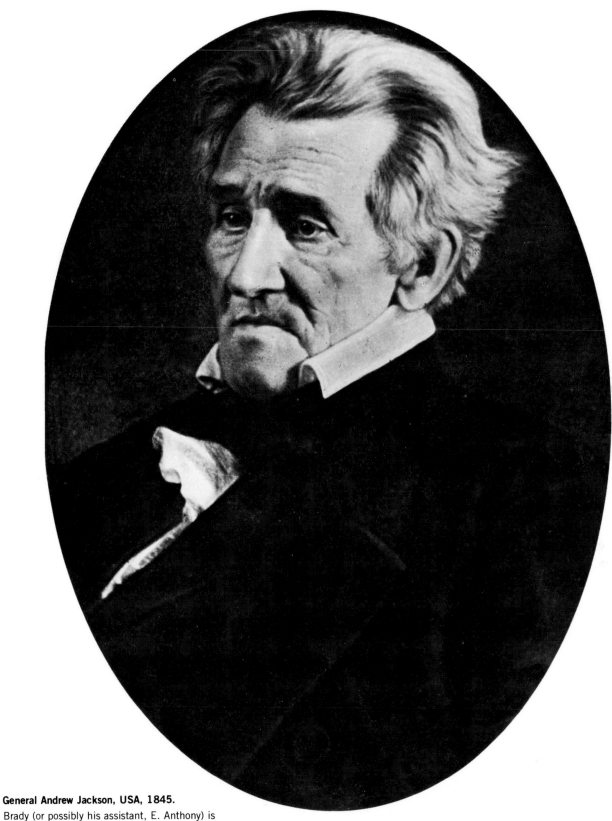

General Andrew Jackson, USA, 1845.
Brady (or possibly his assistant, E. Anthony) is
believed to have made this daguerreotype of the Hero
of New Orleans at the Hermitage, Jackson's home in
Kentucky, when George Healy painted his portrait for
Napoleon III. An aging invalid, Andy Jackson died
shortly thereafter.

From a photograph attributed to Mathew Brady.

Thomas Bangs Thorpe.
Starting life as a painter and draftsman, Thorpe
became a humorous writer. His jounalism in the
1850s covered every comic aspect of American life.
As a reporter, Thorpe was present at the Hermitage
when Brady made his picture of General Andrew
Jackson.

From a photograph by Mathew Brady.

George P. A. Healy, Artist, circa, 1858.
Healy, an American artist living in Paris, was
commissioned by Napoleon III to make a portrait of
General Jackson, when the French Emperor learned
of Jackson's illness.

From a photograph by Mathew Brady.

seventh President of the United States, was seriously ill at
the Hermitage, his home outside Nashville, Tennessee.
His full recovery was doubtful. Realizing that he had
no portrait of one of the nation's most controversial
and beloved heroes and never one to abandon history,
Brady gathered up his bulky equipment and went to
Nashville.

The rapidly aging, seventy-eight-year-old soldier, was
by now a caricature of the tall, lean, strong backwoods-
man, who had led such a rich and colorful life. Born March
15, 1767, at Waxhaw, South Carolina, he came to Charles-
ton as a young man and there learned what it meant to be a
gentleman. He indulged himself in horse racing, cock-
fighting, and carousing. After studying law for two years,
Jackson packed his two fine horses and headed West. At
Jonesboro, Tennessee, he augmented his possessions—

horses, gun, a brace of pistols, and saddlebags—by pur-
chasing a slave-girl. Although he later practiced law and
entered politics, he ended up in the army, and through
sheer military ability rose to become a major general in
the United States Army.

On January 8, 1815, a small army of sharpshooting
backwoodsmen, pirates, and Kentucky riflemen led
by General Jackson defeated Major General Edward
Packenham's superior British Army of regulars with a loss
to the British of two thousand men including General
Packenham. The outcome of this battle, the Battle of New
Orleans, created a president, a political party, and a
tradition—Andy Jackson. His presidency was a stormy
one, and his social life more so, particularly because his
wife, Rachel, was not accepted by the elite of
Washington, which cut him deeply.

On the other side of the Atlantic, King Louis Philippe of France, having also received news of General Jackson's illness, contacted George Peter Alexander Healy, an American portrait painter then living in Paris, and commissioned him to paint Jackson's portrait. Healy left at once for the United States. The son of a sea captain, Healy had been sent to Paris to study painting by a wealthy patron and became one of France's foremost portrait painters with a large French patronage, including the King.

Brady and Healy both arrived at the Hermitage in late March, 1845. Brady's plate was made on April 15. In an interview with George Alfred Townsend, correspondent for the *New York World*, Brady recalled in 1888: "I sent to the Hermitage and had Andrew Jackson pose barely in time to save his aged lineaments for posterity."

Brady's statement to Townsend does raise the possibility that Brady did not make the picture himself, but it is hardly likely that the meticulous portraitist would have left such an important picture to one of his operators. Time was the vital element here, and Brady could easily have taken the assignment himself.

On that particular morning in April General Jackson, against the specific instructions of his physician and the concern of his family, had dressed with particular care, and would not listen to any denial. Assisted to his seat before the camera, bolstered with cushions and pillows for support, the aging general waited for Brady to make his plate. T. B. Thorpe of *Harper's Weekly* and Healy were both present at the sitting. Thorpe wrote, "His hair, once such a remarkable steel gray, which had stood like a mass of bayonets around his head, was now soft and creamy white and, combed away from his temples, fell upon his shoulders. When the moment came that he should sit still, he nerved himself up with the same energy that characterized his whole life, and his eye was stern and full of fire. The task completed, he relaxed into his comparative helpless condition.

Brady and Thorpe probably left the Hermitage shortly after the sitting, but George Healy remained there for seven weeks to paint the old general's portrait and didn't leave until after Jackson's death on June 8. Jackson had

first refused to sit for Healy, and it was only through the kindness of young Mrs. Jackson, wife of Andrew Jackson Jr., and weight of the letter from King Louis Philippe that Healy was able to carry out his assignment.

Early in May, 1846, Ross Wallace, the writer and poet, strolled into the gallery unannounced, accompanied by a friend. Wallace approached Brady, said he would like to have a daguerreotype made of himself, and insisted upon paying for it. After arrangements were made, Wallace introduced his friend, Edgar Allan Poe, then one of the most controversial figures in American literary circles. Brady expressed his delight at having two such distinguished literary celebrities in his gallery at the same time.

Poe was not a well man and, as Brady wrote to a friend, his eyes reflected all the misery one person alone could sustain and remain sane. It was quite evident to Brady that Poe was in abject poverty. Indeed Poe had since childhood often suffered tragedy and poverty. Poe was never legally adopted by his foster father, John Allan, a Scottish merchant from Richmond, Virginia, and it was largely due to Francis Keeling, Allan's childless wife, that young Edgar was accepted into the Allan household.

Poe's real mother was Elizabeth Arnold Poe, a successful English actress who supported herself and her family playing opposite Charles Tubbs, a well-known British leading man. In Charleston, South Carolina, Mrs. Poe became desperately ill with pneumonia. While fighting the disease, she returned to Richmond poverty stricken and there she died. Edgar, the eldest of three children, was fostered with the Allan family in Richmond; his sister, Rosalie, and his brother, William, remained with their grandparents in Baltimore.

In 1815 John Allan sailed with his family for London, where he established a branch office for his mercantile firm. During that time Edgar was packed off to the Irvine School in Scotland, then later to a boarding school in Chelsea. John Allan's business failure compelled the family to return to Richmond where Edgar, at age fifteen, was farmed out to Judge Robert Stanard until John Allan could recoup his losses. Young Edgar was unprepared for what

Edgar Allan Poe, circa 1848.
Carefully disciplined and somewhat spoiled by foster
parents, Poe suffered as an innocent victim of a
misunderstanding world. Poverty-stricken
throughout his adult life, Poe became an alcoholic,
following the death of his wife, and died in a
Baltimore hospital at fifty-four.

From a photographic copy by Brady of
a daguerreotype taken by Manchester.

46

he found in Jane Stanard, the Judge's wife and mother of a classmate. A beautiful, sympathetic, understanding woman, she "aroused in young Poe a youthful and romantic worship," something he had never known before. In 1824 she died unexpectedly "in circumstances of great tragedy," inflicting on young Poe a second loss akin to the death of his mother. It was said, perhaps apocryphally, that Poe visited her grave at night. In the poem "To Helen," his lines probably are addressed to Jane Stanard—"Helen, thy beauty is to me. . . ."

That same year, young Poe entered the Virginia Military Academy where his celebrated debaucheries began. In due course, he came to New York and took a cottage in Fordham, where he tried to survive by writing and doing editorial work.

Brady's observation of Poe was acute and overlooked nothing. "Poe," Brady wrote, "was dressed in a seedy black coat, tightly buttoned across his emaciated frame, with little linen showing. A swath of black silk tie encircled his throat in a mass of wrinkles, carelessly twisted around and around many times, like a bandage on a fracture. His long hair hung down to his collar, covering his ears, and in his dark eyes was reflected the desperate grief brought on by the death of his devoted wife, Virginia, who had died two years before in their cottage in Fordham, wrapped in an old black military cloak, on a straw mattress to keep from freezing."

Poe's strong face was pale, tending to puffiness around the eyes, and the dark circles under them told of his heavy excesses in drink. He stood near the camera and watched with interest while his friend Wallace sat for several plates. Brady then asked Poe if he would also care to sit for the camera, but Poe declined "with a slight trace of a smile and a shake of his wild loose locks."

There was little about this strange man that escaped Brady. Quickly sensing the reason behind his refusal to pose, Brady gave the penniless Poe to understand that, as an admirer of his writings and stories, he wanted the picture for himself, to hang in the gallery, but Poe was adamant. Finally, after much persuasion by his friend, Wallace, Poe finally consented and took his seat before the camera "without even so much as a tug at his tie." And

although he responded to Brady's posing instructions, "the expression of gloom never left his face."

Toward the end, because of his excessive drinking, Poe earned more enemies than friends. Barely two weeks after leaving Brady's gallery Poe returned to Richmond to recover his health. In the fall when he was well enough to travel, Poe returned to New York, then suddenly dropped from sight. After a week of frantic search, his friends found him in a notorious Baltimore barroom, hopelessly intoxicated. They managed to get him to a hospital, but they had found him too late. Poe died four days later, at fifty-four, a victim of despair and indulgences.

Brady once again exhibited his work before the Fair of the American Institute, and this time "received first prize for plain and colored daguerreotypes." Like his friend, P. T. Barnum, Brady had a flair for showmanship and publicity and he made the most of every opportunity. The unquestioned quality of his work and his credit line— Photograph by Brady—were becoming world famous. The roster of his clientele was beginning to read like a *Who's Who* of the daguerreotype era. The bespangled upper crust of New York and New England Society, the "Codfish Aristocracy" of Boston, all posed for the glistening red mahogany cameras of New York's foremost society photographer, the scholarly looking man with the curly dark hair and beard, who looked like a Paris art student. The press, always friendly to Brady, was also very instrumental in bringing his expressive portraiture to public attention. And Brady's zest for his work never deserted him. He was a doer—and an astute observer of the tremendous changes taking place around him.

When Lieutenant Colonel Robert E. Lee and his eight-year-old son, William Henry Fitzhugh came to the gallery to pose for his first daguerreotype (and only one with his son) in the autumn of 1845, Brady little realized twenty years later in the back garden of Lee's home in Richmond, Virginia, he would make the last pictures of the Commander of the Army of Northern Virginia, in his Confederate uniform, a few days after the General sur-

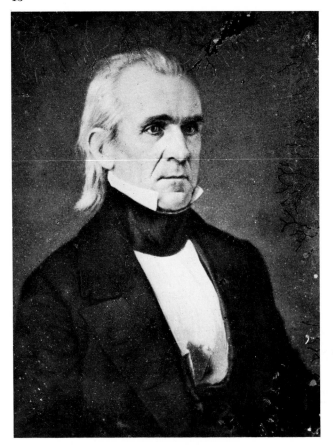

President James Knox Polk, 1849.
On February 14, 1849, Polk wrote in his diary: "I yielded to the request of an artist named Brady of New York by sitting for my daguerreotype likeness today. I sat in the large dining room." To collect damage claims owed by Mexico, Polk precipitated the Mexican War, won it, and collected California and New Mexico in lieu of cash, along with Texas.

From a photographic copy of a daguerreotype by Mathew Brady.

rendered his army to General Grant at Appomattox Court House.

At the time Lieutenant Colonel Lee, United States Army Corps of Engineers, was stationed at Fort Hamilton, New York, assigned as military engineer to renovate the magazines and guns of Fort Hamilton and Fort Lafayette. There was the possibility of a war with England over Oregon, or with Mexico over Texas, and work was going on to strengthen the coastal defenses. This was the first time Brady had ever met Lee; it was a known fact among the members of Lee's family that the Colonel "could never bear to have his picture taken." Be that as it may, Brady made the plate, probably never dreaming he would meet the celebrated soldier again at the most despairing moment of his life.

The growing signs of impending war with Mexico over the Texas question, however, did not concern Brady much, if at all, even though he did keep abreast of the political events that eventually led up to the conflict. He took a portrait of James Knox Polk, the Democratic dark horse candidate in 1844, who asserted that the acquisition of California would be one of the first measures of his administration and was resolved to collect a long overdue debt Mexico owed the United States for damage claims. Willing to cancel the debt and pay Mexico fifteen or twenty million dollars if Mexico would cede New Mexico and California to the United States, Polk sent John Slidell to Mexico to negotiate a settlement, but the Mexican authorities refused to treat with him, and Slidell came home emptyhanded.

Texan colonists, American citizens with land grants to settle Mexican territory, flouted Mexican laws and openly engaged in slavery. In response to constant border attacks, the Texans organized a military force, routed the Mexican army at San Jacinto, and captured the Mexican general (twice president of Mexico). Realizing she could not hold the territory for long, Texas declared her independence and offered herself to the United States. On July 4, 1845, the United States announced the annexation of Texas. Mexico denounced the partition of her territory and ordered her army to the Rio Grande.

For the next year sporadic battles were fought along the Rio Grande. When word reached Washington that some American troops had been killed in a skirmish on American territory, Polk acted quickly. Following an address to Congress on May 9, 1846, war was declared against Mexico, on the grounds that Mexico had "invaded our territory, and shed American blood on American soil."

Polk ordered General Zachary Taylor to prepare an army of occupation for the march into Texas. Strangely enough, many soldiers in Taylor's army had little sympany with this action by their government. Lieutenant Ulysses S. Grant of the United States Fourth Infantry, recently graduated from West Point, was the most outspoken. Young Grant understood the politics of the situation as well as he did the military aspects. "We were sent to provoke a fight," he wrote, "but it was essential that

General Zachary Taylor in 1848–49.
In the War with Mexico, Old Rough and Ready scored four major victories in spite of heavy odds. Taylor, twelfth president, died of an attack of gastroenteritis in Washington.

From a photographic copy of a daguerreotype by Mathew Brady.

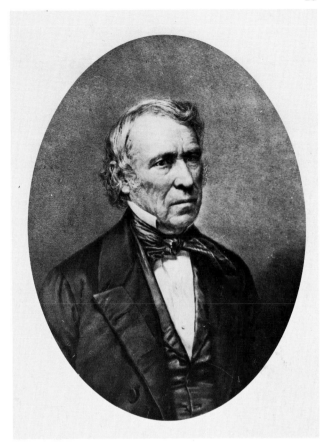

Mexico commence it." Grant also observed that since "Mexico showing no willingness to come to the Neuces to drive the invaders from her soil, it became necessary . . . to approach within convenient distance to be struck. Accordingly, preparations were begun for moving the army to the Rio Grande, to a point near Matamoras." But Lieutenant Grant's unsympathetic views on the war didn't preclude his winning a medal for bravery and gallantry in one of the actions.

With the march of the American army into the Mexican interior, the war grew in intensity, and the battles with romantic names such as Buena Vista, Contreras, Monterey, Churubusco, Saltillo, San Juan de Ulloa, and finally Chapultepec, found their way into the newspapers. In 1847 an enterprising unknown daguerreotypist made twelve "views" of the Mexican War, all with hand-written titles, in and about Saltillo. The plates he made, although not to be classed as "war views" such as Brady would make twenty years later, are descriptive and the essence of the period. The chances are that the daguerreotypist was an army officer in General Wool's division then stationed in Saltillo.

Evidently Brady gave no thought to photographing the Mexican War; probably since his business needed his full attention. At this time it would have been foolhardy for him to absent himself for long.

Chapultepec, the last great battle of the Mexican conflict, captured the imagination of the country. Outside Mexico City on Hill of Grasshoppers, site of the citadel of Mexico's Military Academy, Chapultepec was a strongly fortified, formidable position for defense. A navigable canal of great depth and breadth protected the entire area, making it a very difficult position to breech against determined defense. Here, the Mexican army prepared for a last stand.

The American forces under General Winfield Scott assaulted the fortress on the morning of September 13, 1847. The Mexican batteries opened fire with everything they had and inflicted heavy losses, but armed with scaling ladders, the American regulars fought their way to the walls and reached the top where the fighting became a desperate hand-to-hand struggle. The Mexican resistance

finally collapsed and though Mexico City itself remained to be captured, the war was essentially over.

Early in January, 1849, Brady wrote President Polk requesting a sitting at the White House. Polk would be finishing his term in March and Brady wanted a portrait of the controversial chief executive while he was still in office. Brady's second reason for coming to Washington was to try and establish a branch gallery in the capital city. At any rate, the appointment for the sitting at the White House was set for February 14, 1849.

Brady arrived at the White House at the appointed time and was shown into the large dining room where the plate was to be made. When President Polk came into the room and took his place before the camera, Brady noted "Polk's gray hair, sparse above the temples, combed straight back in long strands, reaching the collar of his black suit, flowing over the high wing collar and black stock. His face was line on both sides of his nose, and his mouth drawn in a tight line."

By June, Polk was dead.

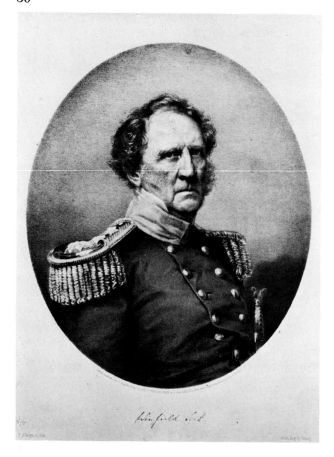

General Winfield Scott, USA, Commander of American Forces in Mexico, 1846–48.

One of America's most distinguished soldiers, Scott had the authority of size. Towering six feet four, weighing three hundred pounds, Scott was likened to a parade when walking in full uniform with his medals and epaulettes.

From a daguerreotype by Mathew Brady.

In September, 1847, Washington Irving returned to his beloved Sunnyside near Tarrytown on the Hudson River, having completed his diplomatic mission to Spain. Back in his "quiet little home" with his family about him, Irving at sixty-five was aware of the limited store of years remaining to him. His health had been poor for some time, undermined by asthma and an enlarged heart.

"If I had only ten years more of life! I must get through with the work I have cut out for myself," he said. "I must weave my web and then die. . . . If I can only live to finish it, I would be willing to die the next moment!" He was referring to his five-volume *Life of George Washington* to which he devoted the final years of his life. The last volume was published in 1859, the year he died. Praised by the historians Motley, Prescott, and Bancroft,

Irving died knowing his brother Americans appreciated his work, though later critics have not been so kind.

Managing to spare some time from his busy schedule, Irving embarked on one of the Hudson River packet boats and sailed down to Lower New York to pay a visit to Brady's Gallery. When Irving arrived, Felix Octavius Darley, the artist who had illustrated *Rip Van Winkle* and *Legend of Sleepy Hollow*, was in the studio, where he had occasionally done some work for Brady. In a letter to his nephew, Irving gave his opinion of Darley's work. "Jarvis tried," wrote Irving of this artist's work on the *Illustrated History of New York*, "but failed to embody my conception of Deidrich Knickerbocker, Leslie also. Darley hit it in the "Illustrated History of New York." Prolific and versatile, Darley "had a keen perception of the picturesque and dramatic."

As the American author walked into the gallery, Darley said, "But I haven't introduced you to Mr. Brady! Please forgive me!" After belated greetings were exchanged, Brady noted that Irving's manner was warm, his manners impeccable, and his smile disarming.

Brady made three portraits of Irving that afternoon.

When Brady opened his small "daguerrean rooms" in 1848 at Four-and-a-Half Street and Pennsylvania Avenue, the Washington Monument was already under construction. The Treaty of Peace and Friendship and Limits, between the United States and the Republic of Mexico, had been concluded at Guadalupe Hildago. But both events were overshadowed by the discovery of gold in California at Sutter's Mill. His first gallery in Washington Brady operated only during congressional sessions, providing plenty of competition for the Plumbe Gallery and other established operators.

"Brady in Washington", wrote Lester, "was treated with courtesy and attention by the most distinguished men," which his competitors hadn't counted on or acknowledged. And, continues Lester, "Brady was the only daguerreotypist in America favored by a *visit at his studio* from the President and his cabinet." Zachary Taylor not only gave him sittings at the gallery, but at the White House as well. Brady's picture of President Zachary

Washington Irving, Esq., 1849.
Lawyer and diplomat, pride of American literature as author of *Rip Van Winkle* and the monumental *Life of Washington*, Irving was daguerreotyped by Brady in the New York gallery. The plate later served as a model for a painting by Darley.

From a photographic copy of a daguerreotype by Mathew Brady.

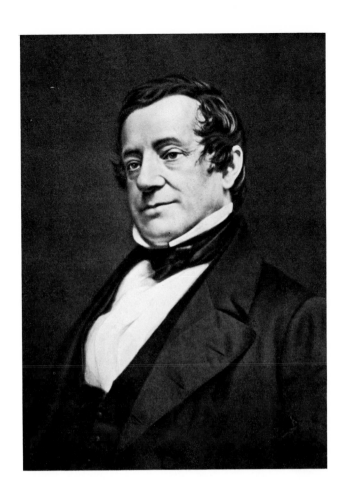

Taylor and his cabinet, "the first of its kind every published," according to the *Photographic Art Journal*, "won for Brady no little honor."

During his short stay in Washington, Brady had the good fortune to make daguerreotype portraits of three prominent Washingtonians. The first was Dolly Madison, widow of the former president and one of the most celebrated residents of the District of Columia. Born Dorothy Payne and named after Dorothea Dandridge, second wife of Patrick Henry, Dolly was the eldest daughter of John and Mary Coles Payne of Guilford County, North Carolina. As a young girl she lived a "restrained country life" in Virginia. She "had a fair skin protected from the rays of the southern sun; her eyes were blue, and her hair black . . . [and she] was tall and esteemed beautiful." Introduced to James Madison, fourth president of the United States, "a score of years her elder," by Aaron Burr, she married Madison and became one of Washington's most beloved social figures. She acted as First Lady to President Thomas Jefferson, which placed her in the center of events.

Washington Irving reported Dolly Madison "was a fine, portly, buxom dame, whose elegance was much remarked," and Charles Goodwin noted "she was brilliant in the things she did not say and do." During the War of 1812, when the British attacked Washington and burned the White House, Dolly stayed behind to save her husband's state papers and an oil portrait of Washington. Her last public appearance was in February, 1849, when at the age of eighty, she passed through the rooms of the White House on the arm of President Polk. In her last years she was heavily in debt because of her son's "waywardness," and Congress moved to buy from her the Madison papers. She remained the queen of official society in Washington,

Felix Octavius Carr Darley, circa 1846.
One of the fine artists who worked for Brady's New York and Washington galleries in the antebellum years, Darley made oil portraits from Brady's daguerreotypes of Daniel Webster, Henry Clay, and John C. Calhoun, which Brady later sold to the federal government for upwards of $2,500.

From a photograph by Mathew Brady.

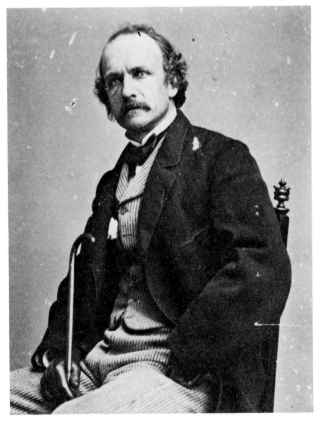

taking part in the city's social affairs until her death in the summer of 1849.

Another distinguished matron of old time Washington was Mrs. Alexander Hamilton, widow of the first secretary of the treasury. Perhaps at Brady's solicitation, Mrs. Hamilton, then ninety-three, came to Brady's studio for a portrait sitting "dressed in the apparel of Washington's time, wearing a plain, snug-fitting cap on her head." Brady had been experimenting with the restoration of daguerreotypes, and during the sitting their conversation turned to this subject. Brady assured her that it was possible to make copies of daguerreotypes by rephotographing them, and apparently Mrs. Hamilton asked Brady if it were possible to copy an ivory miniature of her late husband. Brady recalled: "She loaned me the framed miniature in profile of her illustrious husband—the same from which I made a copy."

Another sitting, important historically, was that of George Washington Parke Custis, the playwright, "who grew up under the charge of George Washington." His mother, Eleanor Calvert, was a direct descendant of Lord Baltimore; his father, a stepson of George Washington. In the course of things, Custis married Nancy Lee Fitzhugh and they had one daughter, who married Robert E. Lee.

Custis's first play, *The Indian Prophecy,* featured Washington as its central character; his second play, *Pocahontas,* dramatized the Indian girl's love affair with Captain John Smith. Both plays were performed at the Walnut Street Theater in Philadelphia, as was his play, *The Railroad,* which featured a real locomotive steam-carriage on stage. Brady reported him a man "of great personal charm, of medium height and fair complexion." Custis lived to be eighty-six, to the last an aristocrat.

Roger Brooke Taney, Chief Justice of the United States Supreme Court, known for his brilliant defense of the rights of civilians in wartime, was probably among the last patrons to pose for Brady during his short stay in Washington. Chief Justice Taney delivered the Dred Scott Decision, which was attacked by Abolitionists who disagreed that "the Negro could not possess rights of citizenship, and did not become free because of his resi-

dence in territory made free by acts of Congress, since Congress did not have the power to exclude slavery from the territories." The Supreme Court's dispassionate decision did nothing to alleviate the growing tensions of the slavery question in Congress, and became one of the causes of approaching Civil War.

Brady returned to New York sometime in the spring of 1849, and resumed his work at the Fulton Street Gallery. If the landlord difficulties which caused his failure to establish a branch gallery in Washington had been a disappointment, Brady never mentioned it. With his usual diligence and determination, he applied himself to the completion of his forthcoming book, the *Gallery of Illustrious Americans,* and the daily business of the gallery. The plates Brady made in Washington were important enough to include in his book, but for some reason they never were. It was nine years before he again attempted to establish a branch gallery in the capital city.

Upon his return to New York, Brady again exhibited his work before the Fair of the American Institute, and this time he won the first and only Gold Medal ever given to plain and colored daguerreotypes in this country. The award was a triumph for Brady, for it was won over the top daguerreotypists from Boston, Philadelphia, Albany, and New York. The fad for colored daguerreotypes poured gold into the Brady's gallery coffers.

On a rainy day in March, John Caldwell Calhoun, senator from South Carolina, arrived at the gallery with his daughter, Anna Maria. His granddaughter's request for his picture for her locket had brought the aging stormy petrel of the Senate, arch opposer of Henry Clay and Daniel Webster, to the gallery. Brady received his distinguished visitors and led them both into the gallery, prearranged for the sitting. By force of habit Brady studied his subject, aware that the aging man "had worn all the public honors for fifty years."

Apart from being an enigma to himself, John C. Calhoun was an enigma to almost everyone who knew him. Physically, age had taken its toll. Mentally withdrawn and introspective by nature, Calhoun's apparent reticence did not preclude a violent temper when the need called,

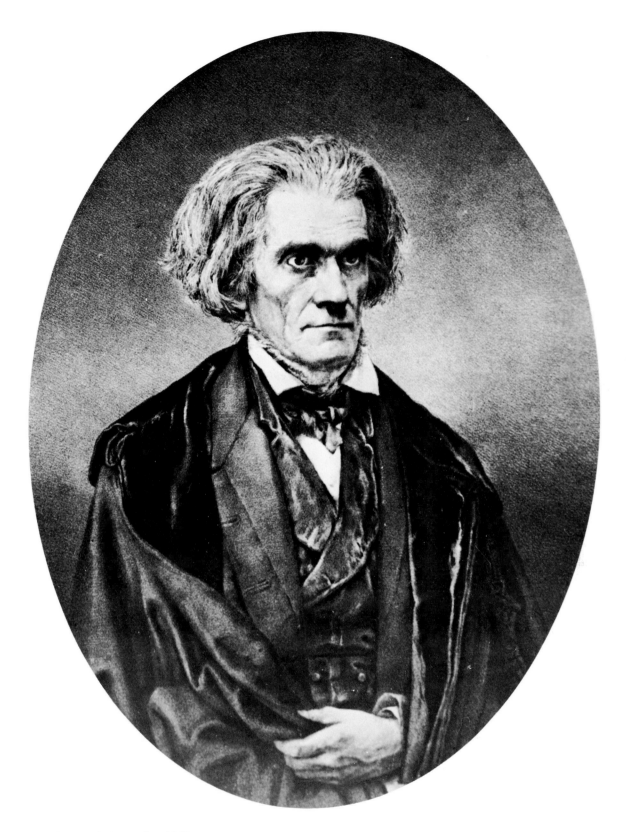

Senator John Caldwell Calhoun, circa 1848.
Calhoun, a pronounced individualist and an eloquent
speaker, was a fervent believer in states rights and an
advocate of slavery.

From a daguerreotype by Mathew Brady.

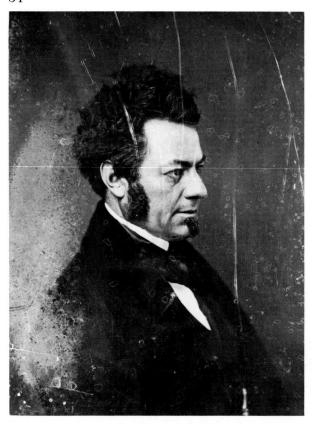

Edwin Forrest, circa 1849.
Powerfully built with a short temper and a very large ego, Forrest, a fine Shakespearean actor, became involved in a ridiculous feud with George Macready, an English actor with a larger ego. The Astor Place Riot resulted.

From a photographic copy of a daguerreotype by Mathew Brady.

mystery to Varina Howell Davis, beautiful wife of Jefferson Davis, the senator from Mississippi. Noted for her wit, Varina Davis catalogued Calhoun as "a moral and mental abstraction," who spoke "in the voice of a professor of mathematics."

When Calhoun took his place before the camera, the weather was bleak and wintry and he remarked on the poor quality of light, speculating on the negative effect it might have on the picture. Brady put him at ease, explaining that the poor lighting conditions could be overcome by longer exposure in the camera.

Although two inches over six feet, the elderly statesman now carried himself with a decided stoop, his face gaunt and gray under a head of wild, stringy hair, which hung over his ears. His broad, deep-socketed eyes, although simple, were direct and forceful. To Brady, these were his outstanding feature. "Calhoun's eyes were startling," he said. "They almost hypnotized me!"

Above all others, Calhoun was the great advocate of slavery in Congress. No temporizing or pettifogging the question would ever change his mind. Henry Clay's classic description of his arch enemy, had the feel of the sardonic about it. "Calhoun," he said, "is tall, careworn, with fevered brow, haggard eye and cheek, intensely gazing, looking as if he were dissecting the last and newest abstraction, which sprung from some metaphysician's brain, and muttering to himself, in half-uttered words, 'This is indeed a crisis!' "

Because of the murky atmosphere in the studio, Brady had taken a full two minutes for the first exposure. This appeared overly long to Calhoun, who with "some weariness" remarked upon it. Brady, himself dissatisfied, asked Calhoun to pose again, and the next plate was successful. During the sitting Calhoun's daughter, delicately arranging her father's hair and the folds of his coat, expressed her surprise at the length of time the first exposure had taken. "How is it," she asked her father, "that your first picture consumed so much more time than your second?" Calhoun, resuming his seat, while the third plate was being prepared, replied, "that he did not feel qualified to explain the exact method," but he then proceeded to give an educated explanation of the entire process, which as-

especially in the halls of Congress when that body was in session. President Andrew Jackson once threatened to hang him for treason and was ready to send troops to Charleston to nip in the bud any uprisings brought on by Calhoun's irresponsible speeches. To Harriet Martineau, the distinguished antislavery commentator and journalist from England, Calhoun was "the cast iron man who looks as if he had never been born and could never be extinguished!"

Women had always dominated Calhoun's life, and their number was legion. While in Washington, away from home, when Congress was in session, Calhoun managed to live the life of a bachelor without incurring a breath of scandal; at that time and in that city this was no mean feat. His romantic adventures with Peggy O'Neill, a Washington barmaid, later the wife of John Henry Eaton, had already become legend, and was the main topic of conversation at Washington's society affairs and gatherings.

Though for a man who professed a puritanical hatred of sin, who was not supposed to be a sensualist, Calhoun managed not only to keep his wife pregnant with nine children over a period of eighteen years, but also to keep numerous lady friends in style. He was, however, no

tonished the workers in the gallery.

Unshakable in his beliefs, baffled and bewildered at his inability to sway Congress, Calhoun died a disappointed man a year after Brady's portrait of him was made.

Edwin Forrest, the eminent Shakespearean actor, was a powerfully built, handsome man with a short temper easily aroused by supposed slights. An uneducated man in the formal sense, Forrest had received his indoctrination in the theater playing the Pittsburgh and Ohio river-towns. In 1823 in a play called *The Tailor in Distress* he became the first American actor to do a black face impersonation.

Despite his "wild and uncontrollable ways" Forrest became a very successful actor. In 1845, soon after his marriage, he went to London to appear as Macbeth. London's unemployed actors resented his presence, calling it a foreign invasion. While he was on stage, three separate claques hissed him loudly, compelling Forrest to abandon the stage.

Forrest believed that an English Shakespearean actor named George Macready was the instigator of this affront to his vanity. He retaliated in kind during a Macready performance in Edinburgh, and the feud was on in earnest, reaching a violent climax in New York, where Macready was also to play Macbeth at the Astor Place Opera House. Howled down by a riotous mob of Forrest's adherents, Macready walked off the stage and refused to continue the performance. His followers, "the better element of the city," were determined he would be heard and managed to persuade him to schedule another performance, promising they "would see to it that the audience was friendly."

On May 10, 1849, with Forrest appearing nearby in the Broadway Theater, the curtain went up for the second time, and Macready began his performance of *Macbeth.* This time Macready's friends were able to control the audience, but the angry mob of Forrest's followers outside went crazy, smashing all the windows and doors of the theater, attempting to destroy the playhouse altogether. The police arrived but were incapable of putting down the riot; the Seventh Regiment was called in. In the

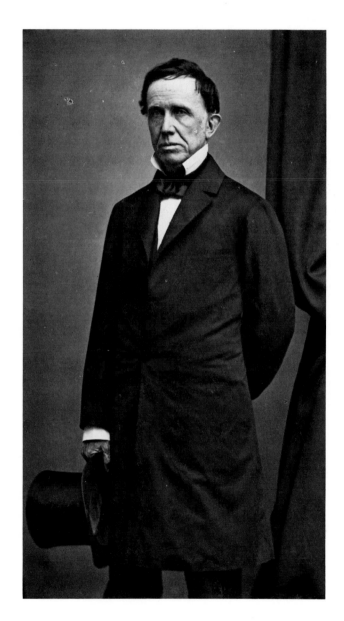

Robert Barnhill Roosevelt.
A lawyer who dabbled in politics and editor of *The New York Citizen,* Roosevelt organized the Committee of Seventy, overthrew the Tweed Ring, created a paid Fire Department in New York, and was Commissioner of the Brooklyn Bridge. As Congressman, Roosevelt exposed a corrupt ring of political thieves in the District of Columbia.

From a photograph by Mathew Brady.

color daguerreotypes on ivory, porcelain, and prepared plates, for oil and pastels. Never seeming to tire of what Lester called "the ceaseless repetition of the daguerreotype process," even after several thousand experiments, Brady always found each plate a new experience. His practice, founded on long apprenticeship and tedious work, had now become almost instinctive and habitual, and the long hours were now reaping their rewards. There was no further need to solicit sittings; his subjects came to him.

In the latter part of June, 1849, Daniel Webster was expected in New York. His fight on the Senate floor against the Southern Whigs had made him a national figure. To Philip Hone, ex-mayor of New York, "Daniel Webster was a living New England legend of his time, a master of the spoken word, outspoken, quick tempered, a product of America, and made of granite." A gentleman farmer referred to as the Squire of Marshfield, Webster was the great constitutional lawyer of his time and one of the nation's most eloquent statesman. Convinced "that wealth and intelligence went hand in hand with playing a dominant role in political life," Webster was a Federalist with no patience for the Democratic Party because "the contagion of Jeffersonian democracy threatened to pervade every place and corrupt every manly and generous sentiment."

The many sides of Daniel Webster were not altogether lost on his friends and contemporaries. According to Emerson (perhaps an apocryphal quote), "Webster lived by three rules—First, never to do today what you can defer to tomorrow; secondly, never to do yourself what you could cause others to do for you; and thirdly, never to pay a debt today." Webster indeed had an unusual personality. Naming everything he owned, he called his favorite shotguns Mrs. Patrick and Wilmot Proviso and his trout rod Old Kildare.

Some said Webster cared more for pleading before the Supreme Court than he did his congressional role. His oratorical skill, second to none, was likened to the best camp-meeting preaching of the period. Harriet Martineau, the English journalist and commentator, wrote: "I have watched the assemblage while the Chief Justice was

meantime, Macready was hustled away in disguise. The mob turned on the soldiers, throwing rocks, until in desperation the Seventh Regiment fired into the crowd to quell the riot. At least fifty people were killed or wounded and some newspapers placed the figure as high as two hundred.

It was generally believed that Forrest had a hand in the riots, although this was never proved; certainly he did nothing to stop it. William Winter, in his examination of this strange personality, wrote "Forrest brooded upon himself as a great misunderstood genius, and looked upon the world as a sort of animated scum." In time the Astor Place Riot was forgotten, and Forrest made a fortune playing to packed houses in Boston, Chicago, and New York at $2,500 a night. In spite of a stroke in 1865 he continued performing until old age caught up with him and he died alone in Philadelphia, in 1872. He left his entire estate as a home for aged actors, still known as the Forrest Home.

Brady's interest in new methods extended beyond black and white daguerreotypes; he experimented with

William Lloyd Garrison, the New England Myth.
An antislavery zealot, Garrison wrote such
inflammatory articles that he earned a severe beating
by a mob of "seemingly respectable people."
Garrison burned a copy of the U.S. Constitution in one
of his wilder, less rational moments, shouting, "it was
a covenant with death and an agreement with hell!"

From a photograph by Mathew Brady.

Wendell Phillips, Abolitionist. *(below right)*
Though less frenzied than his associate, William
Lloyd Garrison, Phillips was a self-appointed
guardian of the public's morals. In 1860 he
characterized Lincoln as "the slavehound of Illinois."
Later he espoused such causes as women's rights and
the labor movement.

From a photograph by Mathew Brady.

delivering a judgment. . . . Webster standing firm as a
rock, his large, deep-set eyes wide awake, his lips com-
pressed, and his whole countenance, in that intent still-
ness, which easily fixes the gaze of the stranger."

Charles Stetson, owner of the Astor House and a close
friend of Webster, arranged for Webster's sitting at
Brady's gallery. He told Brady that if Webster agreed to
pose, he would signal Brady by waving a handkerchief
from a window on the Vesey Street side of the Astor
House. On the third day Webster was in New York, a
handkerchief was seen waving frantically from a window
of the Astor, and at once everything became active. Sky-
lights were reset, plates made ready for fuming, and
cameras placed in position. Moments later, Webster and
Stetson were seen walking down Broadway toward the
gallery. The climb up the stairs had caused Webster to
breathe heavily, but he announced himself flamboyantly
in his best courtroom voice. Holding his hand out before
Stetson could introduce him, Webster exclaimed: "Mr.
Brady! I am here, sir! I am clay in the hands of the potter!
Do with me what you will, sir! I am at your service!"

Brady didn't lose his composure at this onslaught; as

Webster walked into the gallery, Brady sized up the formidable figure of a rather portly man of medium height, immaculately dressed. A high beaver hat made him seem taller than he actually was, and the white stock around his neck, offset by a near ankle-length coat of fawn cloth with black velvet collar and brass buttons as large as silver dollars, also accentuated his height.

The strong face, high cheek bones, and bright, deep-set dark eyes, bore out Senator Berrian's remark, that Webster's face "held a catacomb full of ancient wisdom, that nobody was so wise as Webster looked—not even Webster himself."

The studio smelled faintly of iodide crystals, burning candlewick, and alcohol. Webster took his place before the camera. Brady studied Webster's image on the groundglass as he prepared to make the plate, noting what Philip Hone had put into words: "The noble intellect began to arrange itself, and the bright eye to gather up its lightnings, piercing but benignant, as those which radiate the darkness of a summer evening." Brady then removed the lenscap and began to count. After a minute and a half he recapped the lens, removed the plate holder from the camera, and handed it to his assistant. Two more plates were made, and the sitting was over.

With Webster's sitting, Brady's most motivating ambition—to produce a lasting pictorial history of the great men of the age—was well on its way toward fulfillment. Wealth had not been his main objective, though a modest share had come his way. Celebrities in all walks of life now frequented his reception rooms.

PART III THE PHOTOGRAPHIC ERA

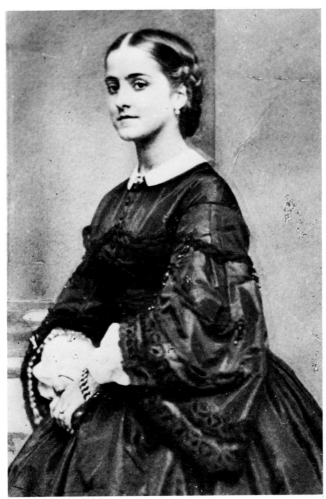

1850–1895

CHAPTER 3

The Photographic Era

THE 1850s BEGAN as the "heyday of magnificent innovation." The discovery of gold at Sutter's Mill in the Territory of California changed not only the old order of finance, but changed the old order of practically everything. One innovation was the dramatic transition in photography, from the daguerreotype to the wet plate; a method which made possible the unlimited production of photographic prints from a single negative. Scott Archer's discovery revolutionized photography, and sounded the death knell of the daguerreotype.

California's insistent demands for statehood triggered the great Congressional Debates of 1850, which included the extension into the territories of the institution of slavery which, for some thirty-five years, had been subtly but surely dividing the nation. The right of individual states to maintain and expand slavery into the rapidly populating western territories was the heart of the debate.

The Compromise of 1850, a slapstick remedy calculated to calm things down between the Northern and Southern factions, was but an ambiguous political sop, disregarding the moral basis of the problem. In fact, it was around this moral question that all the subsidiary problems clustered—Southern fear of Northern domination; Northern resentment of a way of life less troublesome and duty-laden than its own. Worse yet, Southern resentment of the tariff-protected Northern industries fostered a most complicated process of intrigue, idealism, and anger which rapidly opened an ever widening fissure into a chasm between the two sections of the Republic. Clearly visible and close at hand was the possibility of secession. The next ten years would tell the story.

Meanwhile, California had become a "state of mind." The discovery of gold had a solid impact felt across the nation and as far as Europe. To George William Curtis, the editor of *Harper's Weekly*, the growing migration west to the gold fields "wore the mantle of insanity."

Brady's bonanza, however, was longer in coming. In 1850 he published his *Gallery of Illustrious Americans*, fulfilling his ambition to be recognized as the nation's leading photographic historian. The elaborately bound book, in superb gilt bindings, contained twelve beautiful

photo-lithographique plates executed by Francois D'Avignon, who, the French press said, "had incontestably no superior in the world as a lithographer." The book was greeted as a work of art by Monsieur Jomart, the most celebrated art critic in Paris.

In the United States the *Photographic Art Journal*, in its January 1850 issue, concurred: "The whole work surpasses in artistic beauty and typographical magnificence anything which has ever been published in this country or in Europe." The journal also praised its own typographer, William B. Smith, who had set the book. However, the public showed a willingness to praise but not to buy. Despite the low price of $15.00 for this extraordinary volume, and the large number of copies being ordered from different parts of Europe, the book didn't sell well at home.

As a publishing venture, the handsome book didn't recover its original production cost; but as an historical document and showcase for Brady's work, the book had no peer. The financial losses did not deter nor discourage Brady from investing in other photographic enterprises and experiments, even though the book reflected six years of backbreaking labor in establishing his reputation and gallery.

Brady still did not chafe under the endless routine of the gallery. He obviously enjoyed picture-taking and was adept at introducing and adapting new techniques. More important, Brady was well aware that photography was his key to high social mobility, that photography gave him the physical mobility he would not have in some other profession or trade. Moreover, his stubborn independence and insistence on producing only work of superb quality brought him a reputation second to none.

Brady was now thirty, and the future still looked promising. Deserving a vacation, and always the practical man, he decided Europe would provide a change of scene and relaxation, as well as the opportunity to exhibit his work at the Crystal Palace of the Great Exhibition of 1851 in London, first of the world's fairs.

Brady's apparent intention, when he reached Paris, was to show his work to Daguerre. Before leaving for Europe, he had the opportunity of photographing two

prominent people of the American concert and theatrical stage; Jenny Lind, the Swedish Nightingale, and Edwin Booth, eminent Shakespearean actor making his first appearance at the National Theater in New York.

Jenny Lind arrived in New York City in September, 1850, to give her first concert at Castle Garden. A unique concert hall, this former military fortification, erected in 1808 as the Southwest Battery of New York Harbor, was a circular fortification of brown stone and granite.

Jenny Lind, Europe's singing sensation, was a coloratura soprano who had retired from the operatic stage in 1849 for the concert hall. The buxom Jenny was thirty and at the height of her career when she arrived in New York to begin her concert tour of the United States. P. T. Barnum became her manager, and her contract with him called for at least two hundred concerts nationwide at $1,000 a performance.

Probably the most photographed theatrical personality of her era, Jenny Lind was a bonanza for New York's daguerreotype operators, who sold her portraits at from five to twenty-five dollars each. Jenny created a sensation wherever she performed and always raised picture sales.

Barnum made a fortune as her manager, and she herself grossed over $850,000. Brady sought out his friend, Barnum, to arrange for a sitting for Jenny when she arrived in New York. Usually extremely cooperative, Barnum was strangely reluctant and in the end flatly refused to allow her to sit for her portrait.

However, luck was on Brady's side. A young man from Chicago came into the gallery for a portrait of himself and casually mentioned that he was a former classmate of Jenny's in Sweden; he had known her since childhood. Brady explained the difficulty he was having with her manager, Barnum, in obtaining a sitting. The young man promised he would write Jenny at once. More than a week passed, and Brady received a letter saying that he could expect Jenny to be at the gallery within the week.

On the day she was expected at Brady's gallery, word of her coming had somehow leaked to the press; crowds began to collect in front of the gallery's Broadway entrance. When Jenny's carriage arrived, the crowds jammed the entrance, and only through the combined efforts of the police and her driver was she able to reach the entrance in safety. Later, the press noted: "One of the most beautiful specimens of art that we have recently seen is a portrait of the Swedish Nightingale, which for perfect correctness and beautiful execution stands unrivaled."

Edwin Booth, brother of John Wilkes Booth and youngest son of Junius Brutus Booth, the famed Shakespearean actor, arrived in New York City in March, 1851, following a tour of the mining camps and western theaters, to make his debut at the National Theater. Before leaving for Europe, Brady photographed Booth, the youngest of this celebrated theatrical family and recognized as the leading tragedian of the American theater.

With the important sittings of Jenny Lind and Edwin Booth behind him, Brady sailed for Europe aboard the S. S. *Arago* to visit prominent galleries in England, France, and Italy. *The Photographic Art Journal* reported: "Our friend M. B. Brady, Esq., sailed for Europe last Saturday, to visit the World's Fair in London. Before his return he will go to Paris and visit celebrities of that city. He takes out some exquisite Daguerreotypes to exhibit to M. M. Daguerre and Neipce; these will establish his reputation for exquisite pictures in Europe as firmly as it is here." Brady's visit with Daguerre in Paris was not to be. On July 12, 1851, the very day Brady sailed from New York, Daguerre died at his home in Bryn-sur-Marne.

In Paris, Brady was entertained by Emperor Napoleon III of France, who also sat for his portrait. Brady made a beautiful portrait of Carlotta, daughter of Leopold I of Belgium, whose husband, Maximilian, was later placed on the Mexican throne by the French Army.

Most important on Brady's European agenda was the International Exhibition at the Crystal Palace in London. Prominent American daguerreotypists—Mathew B. Brady, Martin M. Lawrence, and the Mead Brothers of New York; John D. Whipple, and Southworth and Hawes of Boston; and M. A. Root of Philadelphia—were competing against all the leading daguerreotypists of England, Austria, France, and Germany.

In a preview, the *Photographic Art Journal* reported: "Mr. Brady sends about thirty groups (forty-eight in all) which for uniformity of tone, sharpness and boldness are

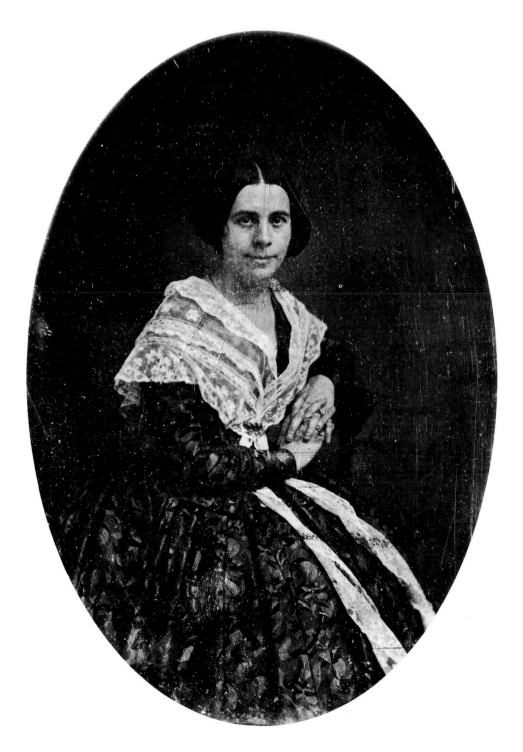

Jenny Lind, circa 1850.
Named the Swedish Nightingale for her amazing
vocal range as a coloratura soprano, Jenny Lind
received seven hundred thousand dollars for ninety
concerts, under Barnum's management, and
returned home a very rich lady, indeed, having
grossed over $850,000.

From a photograph by Mathew Brady.

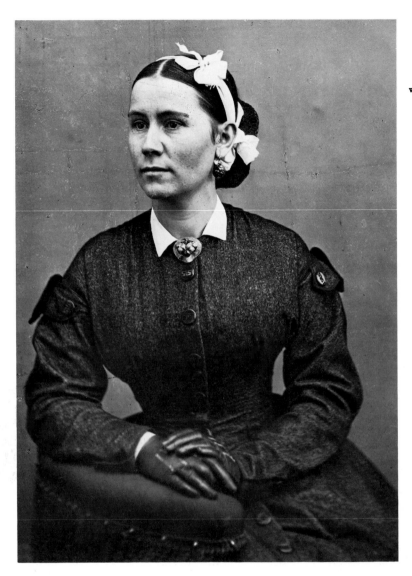

Clara Walters.
After making her debut in St. Louis, Clara Walters came east to play theaters in Washington and New York. During the Civil War, she played the Broadway Music Hall in a lively play entitled, *The Battle of Bull Run*.

From a photograph by Mathew Brady.

Prize Medal Awarded Mathew B. Brady in 1851.
Brady won this gold medal for general excellence at the Crystal Palace of the London World's Fair in 1851.

unsurpassed. Two or three of them we notice especially as very fine—the head of Mr. Perry—a group of females—and the head of the eccentric carman, John Street."

The jury awarded only three medals, all being presented to the Americans: M. M. Lawrence, J. D. Whipple, and the ubiquitous Mr. Brady, who received his medal for "collective excellence" for his portraits of William Cullen Bryant and former President Zachary Taylor. Whipple received a gold medal for an unusual daguerreotype of the moon, which he photographed through the lens of the Harvard University telescope. It was a forerunner of astronomical photography.

When news of the award winners reached New York City, Horace Greeley, hyperbolic editor of the *New York Tribune*, announced: "In daguerreotypes we beat the world!"

During his sojourn in Europe, Brady traveled to Rome, Naples, and Florence, where he visited the Pitti Palace. Here the custodian discovered the celebrated New York daguerreotypist was a visitor and showed Brady one of Brady's own daguerreotypes, saying the plate was kept on permanent exhibition "as a specimen of the excellence of American daguerreotypes," and that before coming to the Pitti Palace the plate had been shown in Rome, Vienna, and other European capitals.

In London, Brady met Scottish photographer and chemist, Alexander Gardner, an expert in the newly discovered collodion "wet plate" process developed by Frederick Archer in 1851, which made it possible to photograph in the negative on glass, from which an unlimited number of positive prints could be produced. By this

Horace Greeley, Editor.

Testy, carping editor of the *New York Tribune,* a reformer of everything from diet to the women's position in a democratic society, Greeley wanted, more than anything, to be a statesman—but the politicians and the electorate wanted no part of his policies.

From a photograph by Mathew Brady.

B·3251

facility alone, the new process would make obsolete the daguerreotype process of a single positive image.

Brady's meeting with Gardner was fortuitous. Brady recognized Gardner's talents, and the efficiency of the Archer process as well. Whether or not it was at Brady's urging, Gardner migrated to the United States in 1856. Gardner was Brady's senior by several years. Of a moderately well-to-do family, he had received a good education in Scotland, including in his studies such disciplines as bookkeeping, statistics, and chemistry. He also was adept at the new Pitman system of writing shorthand. There was little doubt that Gardner would be the ideal man to manage Brady's photographic business.

Brady returned in May, 1852, and immediately made plans for his new gallery at No. 359 Broadway, at Tenth Street, over Thompson's Saloon. The most completely equipped daguerreotype studio in the United States or Europe, certainly no gallery in New York City would equal it for luxurious appointments and furnishings.

Whereas the 1840s saw the start of the great western migration and the founding of new and greater fortunes, the social and economic advancement of the 1850s included the arts, which flourished in the United States as never before—not the least being advances in photography. Literary talents like Nathaniel Hawthorne, Herman Melville, Henry David Thoreau, Ralph Waldo Emerson, James Russell Lowell, and Henry Wadsworth Longfellow emerged. In this era were founded *Harper's Weekly, Frank Leslie's Illustrated Weekly, Godey's Lady's Book,* the rapidly growing *New York Times, New York Inquirer, New York Herald, New York Tribune,* and many other newspapers, staffed by imaginative journalists such as Henry Raymond, founder of the *New York Times,* Lawrence Gobright of the Associated Press, Richard Grant White, Whitelaw Reid, James Gordon Bennett, and George Alfred Townsend.

Such press luminaries haunted Brady's gallery looking for their stories and interviews. And so with the first

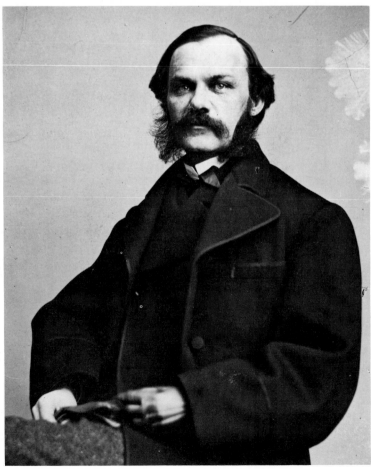

Nathaniel Hawthorne, Novelist. *(left)*

Descended from John Hawthorne, a judge in the Salem witchcraft trials, Hawthorne was said to have been cursed. The famed author of *The Scarlet Letter* had a "decided taste for low life, for pedlars, . . . stage agents and tavern haunters." To him "all things, all persons . . . have been like shadows flickering on a wall."

From a photograph by Mathew Brady.

Henry J. Raymond. *(below left)*

Founder and editor of the *New York Times*, Raymond was a powerful supporter of President Lincoln in good times and bad.

From a photograph by Mathew Brady.

Lawrence A. Gobright. *(facing page upper left)*

Veteran correspondent of the Associated Press Gobright, a brilliant journalist in every sense of the word, was present by invitation at important conferences of President Lincoln's cabinet when all other journalists were excluded.

From a photograph by Mathew Brady.

Richard Grant White, Music Critic. *(facing page upper right)*

An acute, learned, and brilliant student of Shakespeare, White was averse to writing. After taking a fling at medicine and the law, he became music editor of James Watson Webb's *Morning Courier* and *New York Enquirer.* Handsome and athletic, White detested New York, but lived his entire life by "toilsome incongenial occupation."

From a photograph by Mathew Brady.

Whitelaw Reid. *(facing page lower left)*

War correspondent at Shiloh and Gettysburg, later reporting the trial of Andrew Johnson, Reid became managing editor of Greeley's *New York Tribune* in 1868. At Greeley's death Reid was, at thirty-five, head of the most powerful newspaper in America. "In making a newspaper," he said, "the heaviest item of expense used to be white paper. Now it is the *News.* By and by, let us hope it will be brains!"

From a photograph by Mathew Brady.

James Gordon Bennett, Editor. *(facing page lower right)*

"This obscene, foreign vagabond; the loathsome and leprous slanderer," Bennett was called by his competitors, but the public read his *New York Herald.* Bennett fought everybody—clergy, merchants, politicians, and foreign dignitaries. This onetime penniless immigrant lived in luxury and indulged his enormous vanity.

From a photograph by Mathew Brady.

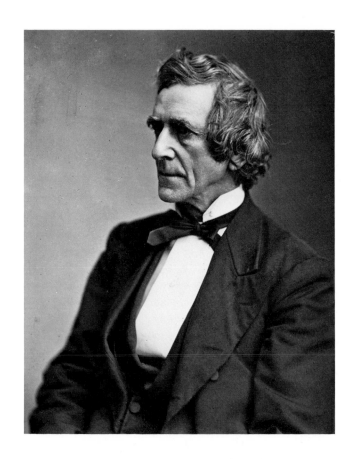

Franconi's Hippodrome, circa 1853. *(below)*
Located at Twenty-third Street and Fifth Avenue, patterned after the Roman Colosseum of Caesar's time, the Hippodrome featured elephants, camels, chariot races, and gladitorial contests later presented by P. T. Barnum's Circus.

Courtesy New York Historical Society.

Brady's Tenth Street Gallery in 1853. *(right)*
Brady opened his new gallery when he returned from Europe in 1852. The largest, most elaborate gallery of its kind in either Europe or New York, the gallery occupied a large building at 359 Broadway, over Thompson's Saloon.

From an engraving in *Frank Leslie's Weekly.*

glorious flourishes of the new era, Brady began in 1854 with a new collection of diverse characters and personalities who would patronize the new gallery: the Codfish Aristocracy, writers, artists, doctors, beautiful women of the theater and politics, clever rascals, shrewd politicians, hard-headed industrialists, and, of course, troublemakers.

The rapid commercial expansion in New York City in midcentury was reflected in the entertainment industry. Franconi's Hippodrome opened in May, 1853, with all the atmosphere of the Roman Circus Maximus. On the northwest corner of Broadway and Twenty-Third Street the Hippodrome, a huge tented arena, seated ten

thousand and featured entertainment later presented by P. T. Barnum in his "Greatest Show on Earth." Its first extravaganza, "The Field of the Cloth of Gold," featured chariot races, wild gladiatorial contests and elephants, camels, and beautifully caparisoned horses playing major roles. The *New York Herald* reporter described the audience: "a deep mass of human beings, exceeding in number any assemblage . . . ever seen inside a building in this city, not excepting even the audiences attracted by the Jenny Lind Concerts at Castle Garden."

A month later the Latting Observatory opened, in connection with the first American World's Fair, on the present site of Bryant Park. In its Crystal Palace Brady

exhibited his daguerreotypes and came away with top honors. Whipple of Boston received a silver medal for his paper photographs.

Brady's new gallery was completed sometime in July of that year. Extending from Broadway down Tenth Street about one hundred and fifty feet, it shared the neighborhood with the Lorillard House, Grace Church, "resort of the pious fashionable," and the new A. T. Stewart Department Store. For the business of fashionable photography there was no better site in the entire city.

Brady had spared no expense. Gas lighting fixtures, specially designed, hung from the spacious walls and ceilings and heaters were strategically located to keep the large rooms comfortable. A wide circular stairway, thickly carpeted in red and forest green pile, led to the reception room expensively carpeted with soft, velvety-green pile, spotted with gold flakes. Green was the predominant color—emerald brocade walls matched the upholstered Sheraton chairs, sofas, and luxurious divans trimmed in gold piping. Even the stairwell skylights gave off a soft emerald light.

The Operating Room was equipped with huge, tinted skylights and cameras of various sizes, from the multiple-lensed camera for taking visiting card photographs to the giant 17 × 21-inch studio floor cameras resting on pedestals. Props, Corinthian columns, risers of several sizes, ornate furniture, and background draperies were placed about the huge room. Large white reflectors for side lighting completed the studio equipment, ready to create any kind of stage atmosphere or background.

The gallery was Brady's design, and he had overlooked nothing. A private entrance for ladies arriving in formal dress even led directly to the Operating Room to obviate a walk through the public gallery.

The gala opening began with a private showing for the press and a gathering of prominent guests, leading art connoisseurs, city officials, and personal friends. The most fashionable, magnificently attired women of New York and Washington "leveled their lorgnettes at the senators and representatives whose portraits hung in their elaborate gold frames on the deep green walls." Brady's distinguished guests wandered through the spacious lounge, studying the faces of the Grinnels, Taylors, Aspinwalls, and presidents, past and present— Van Buren, Polk, Tyler, Pierce, Fillmore, and Buchanan. "And the ladies were well represented," noted a reporter; "the likeness of Miss Hosmer, the New England sculptor, brought forth the remark, 'that woman should have been a

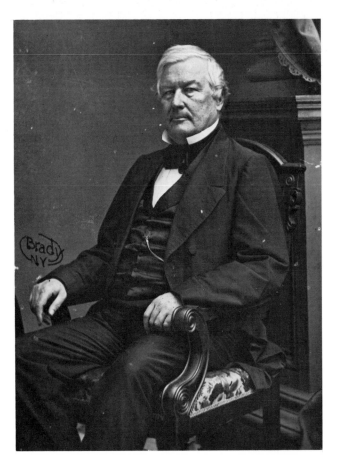

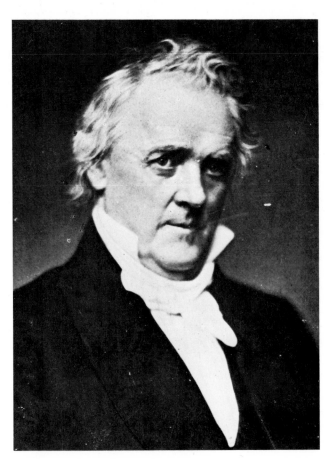

70

Harriet Lane Johnston, 1860. *(right)*
President Buchanan's charming, tactful, and
statuesque orphan niece, Harriet Lane assumed the
duties of First Lady. Well liked, she discharged her
duties as hostess of the White House with
commonsense and grace.

From a photograph by Mathew Brady.

President John Tyler, circa 1846. *(facing page upper left)*
"President without a party," John Tyler, scored
remarkable achievements. He reorganized the navy,
rid his administration of waste and extravagance,
founded the Weather Bureau and National
Observatory, annexed Texas, and settled the
boundary dispute with Canada.

From a photographic copy of a
daguerreotype by Mathew Brady.

President Franklin Pierce, circa 1855. *(facing page upper right)*
An easy-going, pliant man, Pierce dealt in patronage
and offended no one. As a politician, his ability to
face both ways, anathema to American politicians,
spelled doom at the polls for a second term.

From a photographic copy of an original
daguerreotype by Mathew Brady.

President Millard Fillmore. *(facing page lower left)*
A farmer's son, born on the New York frontier,
Fillmore entered politics as an Anti-Masonic
representative and was elected to the New York
Legislature in 1828. Vice president to President
Zachary Taylor, Fillmore presided over the slavery
debates of 1850. Upon the sudden death of Zachary
Taylor he assumed the presidency.

From a photograph by Mathew Brady.

President James Buchanan, circa 1860. *(facing page lower right)*
Fifteenth president of the United States and an inept,
weak man, Buchanan, a bachelor, was elected by a
very organized Democratic Party in 1856. State
Rights Southerners in his cabinet schemed and
overthrew his decisions. By 1860, Buchanan's
administration had fallen apart, and he with it.

From a photograph by Mathew Brady.

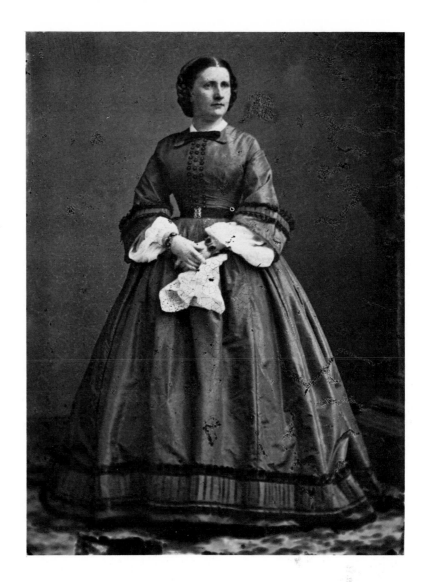

man!' And fierce Charlotte Cushman in Gypsy costume;
and the present lady of the White House; a too-plump,
rosy-cheeked Harriet Lane, with her intellectual face and
her English 'embonpoint.' How quietly she looks down on
you, just as her eyes rolled over the crowded hosts on
'Levee Nights' in her Uncle's saloon!"

Brady's portrait of the beautiful Ada Douglas, wife of
Senator Stephen Douglas, stole the show that night. "It
was scarcely less beautiful than the original," one reporter
noted, "with her soft hazel eyes and her dewey lips . . .
sweet Ada Douglas!" Gossip, on the otherhand, pro-
claimed Mrs. Douglas vain, heartless, and ambitious.

As befitted New York's prince of photographers, Brady
had himself become something of a celebrity and social
prize. Not long after the opening of his new "Broadway
Valhalla," a short article appeared in the *Brooklyn Daily
Eagle*:

. . . The world may differ as to the merits of Brady, compared
with other artists, in his particular line, but for my part, I

71

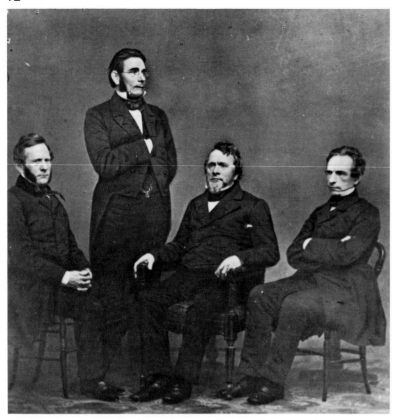

The Harper Brothers Publishing Group. *(left)*
James Harper (standing) began his publishing business in 1817, later going into partnership with his brothers. Harper Brothers originated the first illustrated news monthly magazine, which employed many sketch artists, among them: Alfred Waud, Frank Schell, and Frank Vizatelli. James Harper was elected reform mayor in 1844 and served with distinction. Seated, from the left: Fletcher, John, and Wesley Harper.

From a photograph by Mathew Brady.

Caleb Cushing. *(facing page left)*
Former attorney general in President Franklin Pierce's cabinet, Cushing, a converted Whig, was a brilliant pleader of his time. A political acrobat, Cushing was adept at finding precedents and arguments for whatever course of action the chief executive cared to take.

From a photograph by Mathew Brady.

Dr. Lewis A. Sayre, 1854–56. *(facing page right)*
First American Public Health Officer, Dr. Sayre, brilliant Chief Surgeon for Bellevue Hospital in New York City, also held First Chair of Orthopedic Surgery in America at Bellevue Medical School.

From a photograph by Mathew Brady.

candidly and honestly, believe him to be the first daguerreotypist in the world, and his triumphs at the World's Fair in London is pretty conclusive evidence that I am not alone in my estimate of Brady's talents. I see he is commencing, too, in the photographic line, (and mark my predictions) it will not be long before he is 'at the top of the tree' in this branch of art. His photographic specimens, even now, are splendid. He deserves a call. A Lover of Art.

Dated July 7, 1854, this article proves that Brady was already experimenting with the collodion process a good three years before Alexander Gardner joined him as manager of the New York galleries.

Among the important sitters Brady photographed in his new gallery was Dr. Lewis Sayre, surgeon to Bellevue Hospital in New York City. Sayre's specialty was diseases of the bones and muscles, but he reached beyond his own field. He introduced new methods in the diagnosis and treatment of croup, the scourge of young children. His work in the treatment of paralysis of the voluntary muscles and disorders of the nervous system brought him worldwide fame. By 1854, when he sat for Brady's camera, he was acknowledged leading orthopedic surgeon in America.

"If I made up my mind that if what I was taught agreed with my experiences as to what I found," Sayre wrote, "I

would adopt it, otherwise not." Dr. Sayre established the Bellevue Hospital Medical College in 1861, where he served with distinction in the First Chair of Orthopedic Surgery in America. Well aware of the deplorably unsanitary conditions in the city's slums; he had no compunction whatever in taking on the politicians responsible.

As first American Public Health Officer, Dr. Sayre's abilities were challenged in 1849 by an outbreak of cholera in New York City. In 1832 the first cholera epidemic had claimed the lives of 3,500 victims in the city before it was brought under control. Two years later, the disease struck again, though with fewer fatalities. Dr. Sayre advocated compulsory vaccination, "a vaccine prepared from causative organs, Vibro Comma, killed by heat, which gives protection for several months."

But the physical ills of New York's citizens weren't the only problems faced in the 1850s. Almost from the city's earliest beginnings, it felt the sting of political corruption, graft, and downright thievery. The local election in November, 1854 was a case in point; the long-suffering public gave the office of mayor to Fernando Wood, one of the most corrupt public officials to hold that office prior to William Marcy Tweed, boss of Tammany Hall.

Wood, a wealthy man of easy conscience, started life as

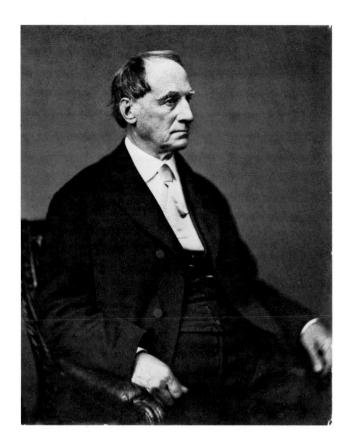

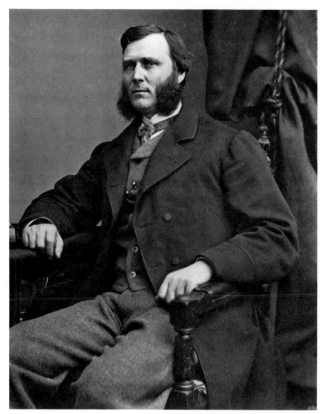

a cigarmaker and tobacconist. During the gold rush he prospered as a ship chandler and real estate speculator, a penchant he carried to City Hall when he sold the city useless property at exorbitant prices. Wood's reputation for slipperiness and political graft was widely known, and as mayor he developed and refined these techniques. Virtually all Wood's schemes for controlling elections and robbing the city were later improved upon and employed by Mayor "Boss" Tweed on a larger scale. The only difference between Wood and Tweed was that Wood left some money in the city treasury for legitimate purposes. Tweed took it all.

When the Democratic Convention met in 1852 to choose a presidential candidate, it became abundantly clear that if the Democratic Party, already in bad odor, was to survive, it would behoove the Convention to select a pliant diplomat and statesman. The international issues included boundary disputes with Great Britain; problems with France over Louisiana; and the issue with Spain over Cuba. The party was faced with the unpopularity of the slavery advocates among the Southern Democrats and the issue of the extension of slavery into the rich territories recently acquired by the United States. The Missouri Compromise had proved a failure.

James Buchanan, Stephen Arnold Douglas, William L. Marcy, and Lewis Cass brought about a deadlock at the Convention, broken only when New England and the South threw their votes to the dark horse candidate, Franklin Pierce of New Hampshire. Pierce was a man with pleasant manners and geniality offending no one. The issue of slavery had been smoldering for thirty years. Though slavery was mainly associated with the Democratic Party and its large block of slave states, all states took a stand on the issue. The even balance of power was upset by California's entrance into the Union. And it naturally followed that all aspiring candidates carefully avoided the issue and walked this political tight-rope, so as not to offend either the Northern or Southern blocs in convention. After a supremely apathetic campaign, Pierce carried every state but four against Winfield Scott, the Whig candidate, and John P. Hale, the Free Soiler.

Pierce immediately began the systematic disintegration of his administration by giving cabinet posts to all his opposing factions. He offended the North by futile attempts to appease the slave-holding South. His appointment of Caleb Cushing as attorney general was greeted with hostility. Cushing, a "political acrobat," possessed that ability to face both ways which has always spelled political suicide for any American politician.

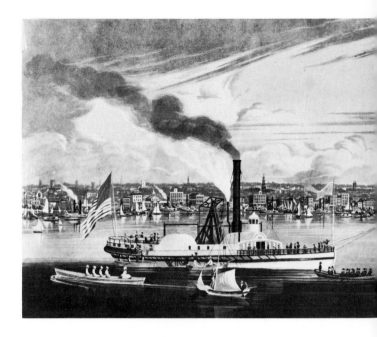

Alexander Gardner, and his brother James, arrived in New York City in the spring of 1856 to take up his duties as general manager of Brady's galleries. A heavy-set Scotsman with handsome rugged features and exceptionally long hair and beard, Gardner was stable and systematic in his personal habits and business dealings. He was also married and the father of two children.

Shortly after accepting his appointment as Brady's manager, Gardner employed his own brother as his personal assistant, and together they began to improve the functions of both galleries. Although it was a time of political and economic turbulence, Brady's galleries prospered. Gardner also undertook experiments to improve the quality of the process which Brady had begun four years before. The galleries turned out upwards of thirty thousand portraits a year, ranging in price from $25 to $750 for the life-sized, hand-colored, imperial enlargements.

After the introduction of the wet-plate collodion photographs, daguerreotypes all but disappeared from the photographic scene by the end of the year, despite their former popularity. Nevertheless, Brady continued to advertise extensively in the leading New York papers, calling the public's attention to the cheaper daguerreotypes then being made by his competitors, explaining that his reason for maintaining his high prices was that his output was superior in quality. It was part of a gradual phasing out of daguerreotypes until the new collodion process proved itself commercially.

Meanwhile, in New York City small events of consequence were taking place. The first model tenement house was built at Mott and Elizabeth Streets, and Henry Kirke Brown's bronze equestrian statue of George Washington was erected in Union Square, the first statue of the nation's most illustrious soldier and first president in New York. Castle Garden, the city's entertainment center and opera house, whose walls had once echoed with the voices of Jenny Lind and Adelina Patti, was transformed into the city's immigrant processing station. Work had also begun on the construction of New York's Central Park, designed by Frederick Law Olmstead and Calvert Vaux.

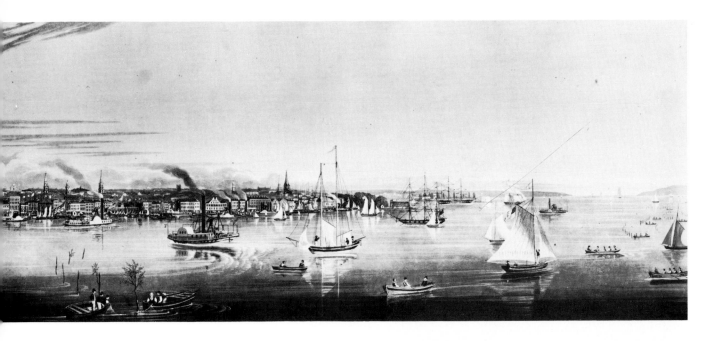

New York City, 1850.

The population was 515,394, and the "suburbs" consisted of Brooklyn, Williamsburg, Jersey City, and Hoboken.

Courtesy New York Historical Society.

The Beautiful Adelina Patti.

With an operatic repertory at fourteen, Adelina became an international operatic star at seventeen. Lovely and talented, she never sang a note without being paid for it; her earnings amounted into the millions.

From a photograph by Mathew Brady.

Madame Ristori and Family.

One of the leading tragediennes of the European stage, Adelaide Ristori was photographed by Brady in the New York gallery. She is seated in the center; her family is unidentified.

From a photograph by Mathew Brady.

General John C. Frémont, USA.
Named The Pathfinder for his western explorations,
Fremont was a controversial figure in American
politics. He had planned to run against Abraham
Lincoln in the latter's bid for a second term in 1864,
but then withdrew.

From a photograph by Mathew Brady.

Park Row, Rynders resembles Arthur Conan Doyle's union goon, Boss McGinty, head of the vicious Scowerers of the Pennsylvania coal fields in the Sherlock Holmes mystery, *The Valley of Fear.* Rynders and his cohorts all paid homage to Mayor Fernando Wood. Under Wood's administration crime was politically acceptable.

In 1856, America's political institutions were crippled by religious and sectional hatred and by bigotry of all kinds. Four political parties were still struggling for public favor and support—the Whigs, Know-Nothings, Democrats, and the newly formed Republican Party. By the middle of the year the Whigs had vanished, absorbed by the Republicans and Democrats. The Republicans met in Philadelphia and nominated John C. Frémont, The Pathfinder, remembered for his western explorations. They wrote a platform that promised the abolition of slavery and Mormonism.

The Democrats convened in Cincinnati and nominated James Buchanan of Pennsylvania on a platform stressing states rights but opposing sectionalism. Of all the Democratic contenders for presidential office, Buchanan was most available, in the narrow political sense of that word—he had spent the turbulent years of 1853 to 1856 far from the domestic turmoil, as United States Minister to London. Buchanan, Pennsylvania's favorite son, was a stiff, unimaginative, rather limited man, whose legalistic mind was conciliatory in temper. Only the generous and gracious withdrawal of Stephen A. Douglas enabled the convention to name Buchanan by acclamation.

The Know-Nothing Party met behind closed doors in Philadelphia, nominated Millard Fillmore for president and Andrew Jackson Donelson as vice president, and endorsed the Kansas–Nebraska Act. Fillmore thus became the candidate of prejudice and bigotry.

And so, the Republicans, Democrats, and Know-Nothings carried their battle to the people in a furious three-party campaign, waged against a backdrop of national friction and a local civil war in Kansas, where John Brown murdered five proslavery settlers in Pottowatomee Creek, nearly precipitating open warfare. Frémont and his running mate, Senator William L. Dayton of New Jersey, referring to "bleeding Kansas," made

But these dignified events were to be overshadowed by overtones of violence in a dispute over the disposition of the Old Municipal Police Force, and the institution of a newly created Metropolitan Police supported by Mayor Fernando Wood. A riot at City Hall in June was followed a month later by a deadly feud in the Bowery, New York's Tenderloin, between two rival gangs, the Dead Rabbits and the Bowery Boys. There was no apparent connection between the two riots, but the police riots probably set the stage for the rival gangs to carry on their warfare within a stone's throw of fashionable Broadway. The filthy streets of the Tenderloin had a nightmarish quality. Murderer's Alley and Paradise Square were the hang-outs of the toughest hoodlums, thieves, killers, prostitutes, and fences. The ruler of this district, also called The Five Points, was Captain Isaiah Rynders, a political hack and former United States marshall who owned a saloon on

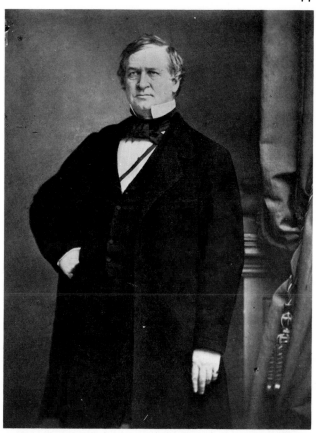

William L. Dayton.

Once a Republican candidate for vice president on John C. Fremont's ticket, Dayton of New Jersey was a thorough-paced Whig lawyer, whose talents were more diplomatic than political.

From a photograph by Mathew Brady.

capital of the violence and of the physical assault by Representative Preston Brooks of South Carolina on the "officially sacred person of Senator Charles Sumner of Massachusetts."

The Democrats opened their campaign with an unmerciful attack on Frémont, proved his illegitimate birth, and spread an untruthful report that he was a Catholic, when in fact he was an Episcopalian. They maintained that Frémont and the "Black Republican" platform he was running on were incitement to disunion, that he was an untrustworthy, evil character. They claimed that Frémont stood for infidelity and abolition and warned that a Republican victory would mean immediate, "absolute and eternal separation."

The Republican battlecries condemned the Democrats for attempting to force Kansas into slavery and called for "Free Speech, Free Soil, Free Press, Free Men, Frémont, and Victory." They attacked Buchanan's proslavery leanings and started a canvass for votes, the like of which had not been seen since William Henry Harrison "rolled into the White House on a barrel of hard cider." Wide Awake companies of semimilitary fifers and drummers marched through nearly every town and city in the country to get out the Republican vote. Antislavery newspaper editors wrote headline stories attacking the Slave Power in Washington, and spread even wilder tales of atrocities in Kansas.

Never did so many speakers take the stump on behalf of a candidate. Even Ralph Waldo Emerson and William Cullen Bryant joined the Fremont crusade, contributing campaign speeches. Abraham Lincoln made more than ninety speeches in behalf of Frémont. In one speech he said: "It is said our Party is a sectional Party. It has been said in high quarters that if Frémont and Dayton are

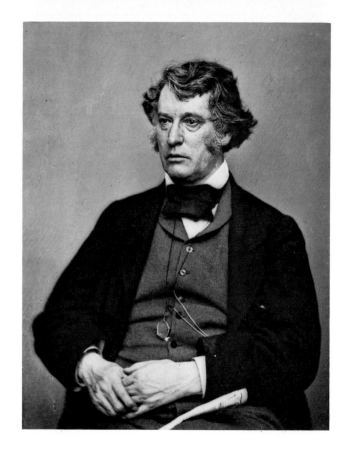

Senator Charles Sumner of Massachusetts, circa 1861.

Intellectually arrogant, Sumner carried a pathological hatred for almost everybody. He continually intrigued against President Lincoln in his personal campaign of "rule or ruin."

From a photograph by Mathew Brady.

William Cullen Bryant, Poet and Editor.
Law student and Phi Beta Kappa at Harvard, Bryant (seated, right) called the law "a wrangling profession," and promptly dropped it for a profession of letters. With Bryant as editor the *Evening Post Republican* surpassed in culture and scholarship Raymond's *New York Times* and Greeley's *New York Tribune.* Seated at left is Ralph Waldo Emerson. From a photograph by Mathew Brady.

elected the Union would be dissolved! The South do not think so. I believe it! I believe it! It is a shameful thing that the subject is talked of so much."

On election day, excitement ran high. In Philadelphia, one newspaperman noted: "Flags cross every street and meet the eye in every direction; music in open carriages, with placards announcing political gatherings; ward meetings; mass meetings and committee meetings guesses at the result, with all other accessories of the highest political excitement, are all you hear in the city."

When the result of the election was announced, Buchanan had won, with Frémont a very close runner-up. The Know-Nothings were defeated, destroyed by their own platform of religious prejudice. The Democrats congratulated themselves for having saved the Union; the Republicans congratulated themselves on their remarkable showing as a new party. W. H. Furness of Philadelphia characterized the Republican defeat as a victory and predicted the Republicans would carry the presidency in 1860, which, of course, they did.

The 1856 election set the stage for the Civil War to come four years hence.

The November election gave New York's mayoralty to Daniel Tiemann. Fernando Wood, though defeated for re-election, remained in City Hall politics, and the apparently honest Tiemann was no match for the very slippery Mr. Wood and his associates who still lurked in the corridors of City Hall.

Daniel F. Tiemann, a self-made, courageous man with a bent for politics, began his career as a drug store clerk after school hours. He held the job for six years while getting his education. His father owned a paint business, and young Tiemann later went to work for him. Upon his father's retirement, Tiemann, at twenty-five, became a partner in the firm and reorganized it as D. Tiemann & Company. Under his guidance the company prospered, giving him the opportunity to dabble in politics.

A Democrat, Tiemann got himself elected to New York's Board of Aldermen, and then made his first political mistake. A teetotaler, Tiemann banned the sale of spiritous liquors at City Hall, an act which stunned his colleagues on the board. It must have been acceptable to the public, since he was re-elected and held the post for the next five years. As mayor, Tiemann tried to reform

Daniel F. Tiemann, Mayor of New York, 1856.
Tiemann unwittingly exposed corruption in land sales to the city and, as a a result, was compelled to buy back City Hall, including the mayor's chair, with his personal funds at a sheriff's sale. Tiemann originated the custom of placing street names on corner lamp posts. From a photograph by Mathew Brady.

City Hall—a difficult assignment at best. His policies met powerful resistance, especially from ex-mayor Fernando Wood, who remained a member of the City Council. However, the most embarrassing moment of his administration came from an unexpected quarter.

A Wall Street broker, Robert Lowber, had been making small fortunes selling questionable land to the city at exhorbitant prices and splitting the graft with his inside man, Fernando Wood, who had sanctioned the deals while in office. On one deal Wood had agreed that the city would pay Lowber $196,000 for some land actually valued at about $60,000. Lowber, however, hadn't counted on Wood losing reelection, and before Lowber could collect his money, Tiemann assumed office. A shrewd businessman, though naive in politics, Tiemann uncovered the swindle, and refused to authorize the payment.

Mayor Tiemann, however, didn't realize how far-reaching Wood's influence went in city politics. Undoubtedly at Wood's insistence, Lowber promptly instituted suit against New York City for the sum of $228,000, which included damages, interest, and legal fees. The suit went to court and with the presiding judge in his pocket, Lowber won the suit.

At the Mayor's office, the City Comptroller blythely informed Tiemann that the city had no funds to meet the judgment. Upon learning this, Lowber called the sheriff to collect the money. Compelled by law to carry out the court's decision, the sheriff seized city property and put it up for auction to satisfy Lowber's judgment. When the sheriff announced to Tiemann that he was going to "auction off City Hall and all its contents, including the Mayor's chair," to satisfy the judgment, it was said that "bullets of sweat" ran down Mayor Tiemann's face.

Around City Hall rumor had it that Councilman Wood was to be at the auction, that he would bid for the building, buy it, and then make the grand gesture of allowing city officials to use the building. Daniel Tiemann was indeed a rich man, but Wood was richer. Tiemann placed his bids at the auction through a clerk, desperately worried that Wood might outbid him, and New York's City Hall was knocked down to him for $50,000, a nominal sum considering the real estate value of the surrounding prop-

erty. Wood never appeared at the auction, and Mayor Tiemann became the only mayor in the nation to purchase his own City Hall.

Sometime after, the city made good on its obligations to Lowber, at the original swindle prices agreed upon with Wood, and bought back its own City Hall from Mayor Tiemann. At the end of his two-year term as mayor, Daniel Tiemann returned to his own business firm, older and wiser in the ways of politics. Years later, in 1872, Daniel Tiemann ran for, and was elected to, the New York State Senate, where he served for many years.

In August of 1857 a financial panic struck the nation, triggering a general suspension of specie payments and bringing widespread hardship to New York's poor who staged mass marches through the streets of the city calling for bread and work. The New York Militia was called out to protect lives and property from the threats of roaming, disorderly mobs. Slowly, order was restored and specie payments were resumed by the banks. The Corporation for the Construction of Central Park voted to spend $250,000 to give work on the project to the needy.

President James Buchanan and Cabinet, 1860–61.
An inept President, James Buchanan was a pathetic figure. Four of his cabinet members were defectors, and his secretary of war was also a thief. Left to right, standing: Lewis Cass, President Buchanan, Howell Cobb, Joseph Holt; seated: Jacob Thompson, John B. Floyd, Isaac Toucey, Jeremiah Black.

From a photograph by Mathew Brady.

In Washington President Buchanan's inaugural ball was followed by other impressive social gatherings. The White House was completely redecorated and money seemed plentiful. In the winter season the capital was filled with Southern grandees—planters and merchants, who vied with the great Southern political figures in splendor and entertainment and the cost of their wives' silks, satins, and bonnets. Among them were a number of Southern Ultras who were still dreaming—as they had been for twenty years—of Southern empire, of a new Athens, a gracious land in which a race of magnificent slave-holding gentlemen could patronize poets, artists, and philosophers, and live a life of ease.

Encouraged by political events, they redoubled their efforts toward separation, aided and abetted by their practical-minded fire-eating spokesmen, Robert Rhett, Edmund Ruffin, and W. L. Yancey, who never wearied of exploiting the "wrongs" that the South was suffering at the hands of the Yankee money-grubbers. The money panic of 1857 strengthened their case. They pointed out with glee that the Southern economy had stood firmer than that of the North, which was indeed true.

Early in 1858, the obvious subservience of President Buchanan to his "Directory" of self-willed Southerners, was highlighted during the congressional battle over the admission of Kansas to the Union. Buchanan owed his election to this block, and he had to follow their lead. The new state constitution of Kansas, framed by a local convention, was rigged to exclude antislavery opinion altogether. The constitution had been rejected locally by a poll from which proslavery men had abstained. Free Soilers, Republicans, and Douglas Democrats all had united in opposing the admission of Kansas under such terms.

Buchanan showed his true colors by recommending to Congress that the new state be received and he used every political trick at his command to coerce reluctant Democrats into support of the measure. He dismissed Douglas's followers from government jobs, refusing them appointments to office, and stripping others of patronage. Buchanan also saw to it that Douglas lost his chairmanship of the Senate Committee on Territories.

In Illinois, meanwhile, in 1858, Abraham Lincoln challenged Stephen A. Douglas for his senatorial seat. Shabbily dressed, unconventional but able, earnest and oddly appealing, this country lawyer fought the great Douglas in a series of debates on the slavery question. Douglas based his arguments on law; Lincoln argued from a moral principle. And although he lost the senatorial contest to Douglas, his words and attitude won approval throughout the North.

CHAPTER 4

Washington 1858

WASHINGTON ON the surface in 1858 was a dull country town of large and small hotels, paltry two-story dwellings, empty lots, prodigiously wide, unpaved, tree-lined avenues, and a rash of gigantic buildings. When Congress was in session, Washington bulged at the seams, overrun with smart women, smart politicians, smart soldiers, smart cabbies, and even smarter scoundrels, political manipulators, and adventurers. To George Alfred Townsend, Washington, D.C. was a place where Senator Stephen A. Douglas "might drink at Willard's Hotel bar, with none so poor to do him reverence—and the sleepy Negroes upon their hacks would only give him the attention of one eye." Badly in need of paved streets and a sewer system, the American capital was a very dismal, dirty, and Democratic settlement.

Underneath it all, a current of dissension and intrigue ran throughout the entire governmental body; and there were those in high places whose aims bordered on nothing less than high treason, who held secret disunion assemblies in private houses, out of sight of prying eyes, promoting their New Cause.

Unquestionably the South had legitimate grievances, such as the Federal Tariff Regulations, but those grievances were hardly serious enough to call for sedition, secession, and war. Radicals like Senator Louis T. Wigfall of Texas, who rattled his verbal sabre in a fog of inebriation, not only embarrassed their own faction, but exposed secessionist aims prematurely. Speaking of the South in a loose moment, Wigfall said: "Give us till November to drill our men, and we shall be irresistible!" The cat was out of the bag before the election was even underway.

Such was Washington in the summer of 1858, when Mathew Brady opened his new gallery—the National Photographic Art Gallery—at 625–627 Pennsylvania Av-

Washington City on the Eve of the War, July, 1861.
Tree-lined Pennsylvania Avenue and white government buildings form a backdrop for the Washington Canal and the army's cattle and horses grazing in the foreground. Smaller buildings on the right are typical of the dwellings in the 1860s.
From a photograph, probably by Mathew Brady, possibly by his assistant, Alexander Gardner.

Maggie Mitchell, American actress, 1860. *(left)*
Born in New York City in 1831, Mary made her debut in Newark, New Jersey, in the role of Topsy in *Uncle Tom's Cabin*. Famous in America as *Fanchon the Cricket,* the diminutive Maggie played wherever a city theater or town "op'ry house" could collect an audience.

From a photograph by Mathew Brady.

Brady Advertisements for the Washington Gallery, 1858. *(facing page left)*

William Winston Seaton. *(facing page upper right)*
Dean of American newspaper proprietors of the 1850s, Seaton was owner and editor of the *National Intelligencer,* of Washington, D.C. Virginia gentry and a Whig with an instinct for public service, Seaton also became a very capable mayor of Washington City.

From a photograph by Mathew Brady.

Cyrus West Field, 1868. *(facing page lower right)*
An enthusiast of his time, Field envisioned a telegraphic link between Newfoundland and Ireland. Fulfillment of his dream of an Atlantic cable left him memories of a chivalrous dream, but no fortune.

From a photograph by Mathew Brady.

enue, near the fashionable National and Brown's hotels. The *National Intelligencer* reported: "In a casual visit to the interesting rooms of this gentleman, we were fairly astonished at the perfection of the counterfeit present-ments of many friends which met our view. If faithful and natural expression, unexaggerated features, beautiful coloring and spirited individuality, prove the sun to be the true artist, then, really this collection of exquisite portraits, this photographic collection of fair women and grave and reverent seignors may legitimately be classed in the domain of art."

Brady quickly related himself to the contemporary life around him, as he had done in New York. It was politic to do so. In the past fourteen years, he had built a reputation in photography second to none, and he meant to maintain it. By 1858, at thirty-four, he owned three elaborate galleries and was a comparatively wealthy man. Brady brought Alexander Gardner and his brother to Washing-ton to operate the gallery in his absence.

Brady's National Photographic Art Gallery occupied the upper three stories of a building which also housed a drug store and a bank. As with all his galleries, the walls were covered with portraits of celebrities, framed in heavy black walnut or in gold. There were Daniel Webster, Henry Clay, John C. Calhoun, and oil portraits of his earlier daguerreotype triumphs, James Fenimore Cooper, Washington Irving, along with other photographs, finished in india ink, of Amos Kendall, William Seaton, and George Peabody. A life-sized likeness of William Wilson Corcoran, finished in crayon, dominated the lot. Brady's work in photography on porcelain was a likeness of Mrs. August Belmont, and a portrait in watercolor of Maggie Mitchell, one of New York's favorite actresses. As in the New York galleries, Brady also had sidewalk speci-men cases which displayed smaller versions of less famous people such as John W. Forney, publisher of the *Sunday Morning Chronicle* and the *Daily Morning Chronicle.*

On the floor above the reception room, the artists

worked in the finishing and mounting rooms, retouching and coloring portraits in oils, watercolors, india ink, or crayon, then popular. Only positive retouching was done in all the galleries; until negative retouching became a matter of normal procedure, negatives remained as they were. Enlargements, made with the aid of the sun and the Woodward Solar Enlarger, could bring a print up from 6 × 9 inches to 17 × 21 inches. This enlarging camera, invented by David Woodward of Baltimore, was a fixture in all the Brady galleries.

The Washington gallery apparently enjoyed the same success as his galleries in New York, and with further expansion of his business on his mind, Brady remained in Washington during the summer months of June and July. He returned to New York for the celebration of the laying of the Atlantic cable, the work and promotion of Cyrus Field, of whom Brady made a portrait that same week.

A moderately successful New York paper merchant with a taste for geography and travel, Field had conceived

Marshall Owen Roberts, Financier. *(left)*
By 1848, Roberts had already amassed a fortune as a ship chandler, railroad promoter, and general trader. He was held in high esteem in Wall Street, but critics said "there was larceny in everything he did." Roberts was also a heavy feeder at the public trough.

From a photograph by Mathew Brady.

Brady Makes the Front Page of *Harper's Weekly.* *(facing page left)*
The sketch artist, perhaps inadvertently, included Brady's Gallery prominently in the background of his drawing of the Atlantic Cable Parade up Broadway, September 11, 1858. The ship model, carried by the sailors, represents Commodore Perry's flagship, *Niagara* in the Battle of Lake Erie in 1814.

Harper's Weekly.

The Inimitable George Law. *(facing page right)*
An Irish immigrant from County Down, Law carried a hod during the construction of the Erie Canal, then set himself up as an independent contractor and made a fortune. Sensing the coming importance of railroads, Law left the contracting business, bought railroads, and rose high in the counsels of the Mohawk & Hudson.

From a photograph by Mathew Brady.

of a telegraphic link between Ireland and Newfoundland. Neither engineer nor financier, he nevertheless had the enthusiasm and faith in his idea to induce some hard-headed businessmen like Marshall Owen Roberts and George Law, self-made millionaires who had come up the hard way, to invest in his project. Some of these financiers dropped out, but Roberts and others, digging into the enormous profits they had made during the California gold rush, decided to take their chances. After twelve years of trial and error, the work was successfully completed on August 16, 1858.

To celebrate the tremendous event, New York lighted City Hall and set up a thrilling fireworks display in the park to be followed by a parade up Broadway. Brady constructed a huge framed transparency, fifty by twenty-five feet, containing the portraits of Cyrus Field, Samuel F. B. Morse, and Benjamin Franklin. The entire transparency was hung across the front of Brady's gallery and illuminated by six hundred candles! Incredible as it was, just how Brady had kept his light source from blowing out, or from burning his building down, is open to speculation; contemporary sources neglect to mention.

City Hall didn't fare so well. Either as a result of sparks from the fireworks, or from smoldering residue of the flares used to light up the building, a fire broke out, destroying the cupola, the greater part of the dome, and almost the entire upper story, with much damage to the Governors Room. The fire was brought under control, and two weeks later a second celebration was staged, with messages coming from Queen Victoria in London and President James Buchanan from Washington. The cable broke down, and it was not before 1866 that another cable was improved upon and placed in operation.

Sometime in 1858, Brady met Juliette R. C. Handy, the daughter of Colonel Samuel Handy of Somerset County, Maryland, and the granddaughter of Levin Handy, a Commodore during the Revolutionary War. Her father, a well-known lawyer, had come to Washington at the request of President Andrew Jackson. Their courtship was short, and they were married in the old E Street Baptist Church in Washington by the Reverend William Sampson, who had married many members of the Handy family. After a reception at the National Hotel, Brady and Julia, as she was called by her family, entrained for New York and took up residence at the Astor House, their home for the next few years.

Meanwhile the business of the galleries prospered, and among his important clients which he photographed personally, was the great Adelina Patti, the international opera star.

Patti was an American discovery. In 1852 at the age of eight, she had made her debut at the Lyceum Theater in New York City, appearing on the same bill with Ole Bull, the great Swedish violinist. Together they made a concert tour of the United States. Born in Madrid and brought to America by her parents, who settled in New York City, Adelina had, from babyhood, been devoted to singing. Taught by her brother and brother-in-law, both celebrated vocal teachers, she had an operatic repertory before she was fourteen.

Brady made a photographic study of the great Patti in the new Broadway gallery in 1859, in connection with her appearance at the Academy of Music, where she sang the title role in *Lucia di Lammermoor*. Patti was then seven-

Agnes Perry, Actress. *(left)*
One of the more cultured actresses of the day, Agnes Perry played in New York and across the country, and was a repertory favorite for years.

From a photograph by Mathew Brady.

Jane Coombs, Actress of the 1860s. *(facing page)*
As did Ella Jackson and Clara Walters, Jane Coombs, a versatile actresss, played both burlesque and legitimate drama. She was an all-time favorite with theater-goers everywhere.

From a photograph by Mathew Brady.

teen, already an international star in the great operatic tradition. Surprisingly enough, Patti had no P. T. Barnum to guide her as personal manager. She handled her own engagements, earnings, and finances which amounted to millions.

Despite its political chaos, the decade of the fifties was a time of astonishing theatrical brilliance, particularly in the careers of actresses such as Agnes Perry, Emma Webb, Charlotte Cushman, Maggie Mitchell, and Jane Coombs. And of course, there were the Shakespearean actors, Edwin Booth, Edwin Forrest, and Tyrone Power, as well as the ubiquitous Mr. Mitchell, who owned a theater, sold seats at 12½ cents, and produced such popular skits as, *High Life Below the Stairs, The Cat's in the Larder, The Captain's Not A-Miss,* and a little burlesque number entitled *The Savage and the Maiden.* Occasion-

ally, Mr. Mitchell appeared on his stage dressed as a ballet dancer, to mimic life in New York.

Amid the glamour and light-heartedness in New York and Washington, the capital of the nation was shaken by the murder of young Philip Barton Key, son of Francis Scott Key, author of the *Star Spangled Banner,* by Congressman Daniel E. Sickles of New York. Young Key's murder involved the young wife of Congressman Sickles, a gentleman of loose personal morals, and a voracious ambition. In 1850, Sickles had been appointed to the Corporation for New York City and, as a member of Tammany Hall, Sickles began to pull his political wires for a still higher post. At thirty-three, he married Theresa Bagioli, a pretty seventeen-year-old daughter of an Italian music teacher. Their married life started out well enough; but in 1856, Sickles ran for Congress on the Democratic

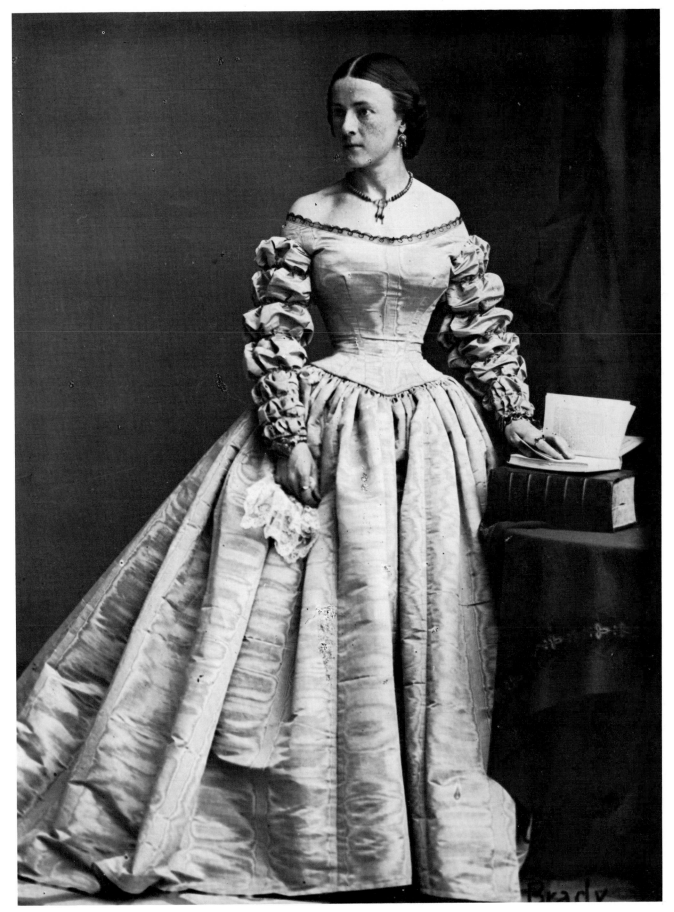

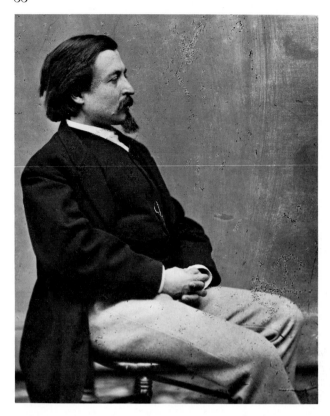

Thomas Nast.
Greatest political cartoonist of his time, Nast was the nemesis of crooked politicians. His biting cartoons of the Mayor "Boss" Tweed Ring, sent Tweed and his cohorts to prison.

From a photograph by Mathew Brady.

ticket and won. Sickles and his wife and daughter moved to Washington and took up residence.

Sickles's life remained serene for two years, until he discovered that his wife was having a serious love affair with Philip Key, and the revelation sent him into a rage. Apparently without any thought given to his own numerous marital infidelities, Sickles forced his wife to sign a confession of guilt. He then armed himself and went out looking for Key, whom he found in Lafayette Park. Sickles walked up to him, aimed his revovler, and fired point blank, killing Key instantly.

The murder trial that followed, with its sensational overtones, subjected the congressman and his mortified wife to all that would be classified later as yellow journalism. Sickles didn't seem to be perturbed, but the publicity had a terrible effect on his wife. Being a lawyer himself, Sickles had his wife's signed confession introduced into evidence at the trial and got himself acquitted on the grounds of temporary insanity. The plea set a precedent for legal defense in subsequent murder trials and is used to this day in court.

In December of 1859 Fernando Wood was re-elected mayor of New York City, at a time when the city and the nation were crying out for honest leadership, ability, and wisdom. The population of Mayor Wood's constituency on Manhattan Island was now 814,000, and the assessed value of the city's real estate was $398,000,000. From lower Manhattan to Fourteenth Street the area was densely covered with buildings and businesses. From that point to the vicinity of Forty-Second Street, the building density thinned out, and except for the villages of Yorkville, Harlem, Bloomingdale, Manhattanville, and Carsenville, the region was mostly occupied by farms. New York's population lacked unity of purpose and action, not surprising considering the ethnic differences in the population. The city government, in the hands of professional politicians, was still inefficient and corrupt, and there was a notable lack of municipal pride.

On February 27, 1860, Abraham Lincoln arrived to speak at Cooper Union on the question of slavery. Before a large audience, he addressed himself to the question of

Abraham Lincoln at Fifty-one.
Lincoln posed for Brady's camera in the New York gallery at the time of the Cooper Union speech. Note the immobilizer raised onto a taboret because of Lincoln's great height.

From a photograph by Mathew Brady.

Henry Kirke Brown, Sculptor. *(facing page)*
A New Englander, Brown at fourteen was an itinerant cutter of silhouettes. Having studied the works of Donatello and Verrochio in Italy, Brown returned to America, where he executed bronzes of Lincoln, the equestrian statue of Washington, and Winfield Scott, "a soldier of three wars." Scott's statue was cast from a captured Mexican cannon.

From a photograph by Mathew Brady.

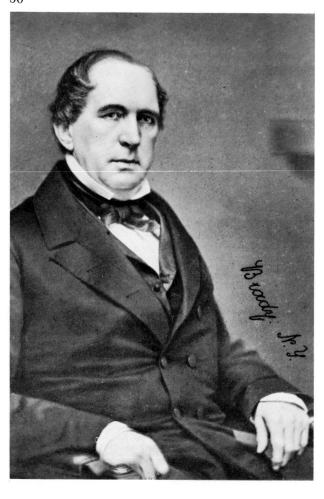

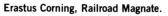

Erastus Corning, Railroad Magnate.

An able and farsighted railroad man, Corning unified short-line railroads of New York State into the great New York Central and was its president until 1864.

From a photograph by Mathew Brady.

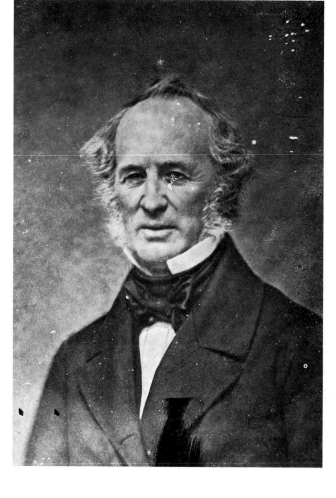

Cornelius Vanderbilt, Financier.

A ruthless adversary in business, Vanderbilt's career was financial acquisition. He had flair in all his operations, be it stock watering, or unfair competition. To his competitors, his frankness was arrogance; his passion for efficiency, the trick of a clever salesman. He never made the social register, his main ambition.

From a photograph by Mathew Brady.

the repeal of the Missouri Compromise, the bill which permitted slavery in that state, denying it to the other, new border states. Lincoln said "Near eighty years ago we began by declaring that all men are created equal; but now from that beginning we run to the other declaration that for some men to enslave others is a sacred right of self-government. They are as opposite as God and Mammon; whoever holds to one must despise the other."

Later, Lincoln was brought to Brady's gallery by R. C. McCormick and some members of the Young Republicans Club, where Brady made three photographs. Although there is some controversy about the matter, it is

believed that one of these, a full length pose, Brady made for Henry Kirke Brown, the noted sculptor, for his statue of Lincoln later placed in Union Square.

Photographing Lincoln undoubtedly presented Brady with problems, but by the same token only a photographer like Brady, who was supremely confident of his professional abilities, could handle such problems. Lincoln's suit, low shirt collar, and loose necktie, nothing more than a thin black ribbon, had to be rearranged before the picture could be made, and Brady recalled: "I had great trouble in making the natural picture. When I got him before the camera I asked him if I might not

arrange his collar, and with that he began to pull it up. 'Ah,' said Lincoln, 'I see you want to shorten my neck.' 'That's just it,' I answered, and we both laughed."

The following day, when Lincoln's speech appeared in the papers, the pictures were in great demand, being published in *Frank Leslie's Weekly* and by Currier & Ives.

As the *New York Times* reported of Brady's Broadway gallery, "The great financiers are represented by Erastus Corning, two of the Messrs Brown of Wall Street, and Cornelius Vanderbilt—commonly called by persons who desire to impress you with their intimacy with the great 'Kurnele' Vanderbilt—whose portrait by the way, is one of the best-looking in the gallery; there is an air of aristocracy about the face which does not altogether accord with the 'Kurnele's' beginnings, but there is also a shrewdness which is quite in keeping with the little trifle of $50,000 a month which the Commodore is said to receive as a bonus for *not* running his Nicaragua steamers."

The *Times* was referring to Cornelius Vanderbilt's dubious association with William Walker, "the grey-eyed man of destiny." Walker, a lawyer, medical doctor, journalist, Forty-Niner and a filibusterer of genius, had planned to capture Nicaragua, and eventually "federalize" all of Central America. With fifty-seven mercenaries, Vanderbilt's help and money, and the use of his steamship lines, Walker actually captured the capital of Nicaragua, dictated a peace, and hoped his coup d'etat would be recognized by the United States in 1856, acknowledging him as dictator and master of the Nicaraguan State.

But Walker went too far by scheming with Charles W. Morgan and E. D. Harrison to acquire Vanderbilt's steamship lines, underestimating Vanderbilt's ruthlessness in dealing with those who crossed him. Vanderbilt in retaliation presented Walker with a full-scale war, rousing up all of Costa Rica, Honduras, Guatemala, and El Salvador. Vanderbilt won. Later Walker tried to recapture his dictatorship but he was arrested and executed by his subjects.

The Democratic Convention opened in Charleston, on April 23, 1860, amid great excitement and bitterness. The tone was grim. On the sixth day it adopted the Douglas minority ballot by a vote of 165 to 138; the secessionist bloc walked out of the Convention Hall. Failing to unite on a candidate, the Democrats adjourned, reconvened in Baltimore on June 18th, and nominated Stephen A. Douglas of Illinois, known as the "steam engine in britches," for president, and Herschel V. Johnson of Georgia as vice president, pledging the Party to stand by the Supreme Court's Dred Scott Decision for the return of fugitive slaves. The Southern secessionist bloc, dissatisfied with the convention's choice of Douglas, bolted the Party, met in Baltimore ten days later, and nominated John C. Breckenridge of Kentucky for president, and Joseph Lane of Oregon as his running mate. It adopted a platform reaffirming the extreme proslavery view.

On the third week in May, 1860, the Republican Convention opened at the Wigwam—a barnlike convention hall—in Chicago to blaring bands and cheering throngs parading through the streets with blazing torches. It was more than a brilliant festival; it was a rally for battle, an army with banners.

At the Illinois State Convention, only three weeks before, Lincoln's friend, John Hanks, had paraded down the aisle carrying two old weather-beaten rails he and Lincoln had cut in 1830. The banner over the rails read:

Abraham Lincoln, the Rail Candidate for President 1860. Two Rails from the lot of 3000 made in 1830 by John Hanks and Abe Lincoln, whose father was the first pioneer in Macon County.

The reaction was tremendous, the crowd of almost 3000 cheering wildly as Lincoln was carried to the speaker's stand on the shoulders of his friends. The Republican platform was filled with vote-winning issues: free homesteads, departmental honesty, internal improvements, communications with the Pacific Coast—all measures opposed by the Democrats.

But Lincoln was not the only candidate; many others were running. Indeed a nomination of Lincoln seemed doubtful.

George Ashmun, permanent president of the convention, rapped his gavel, made from a piece of oak from Commodore Perry's flagship in the Battle of Lake Erie,

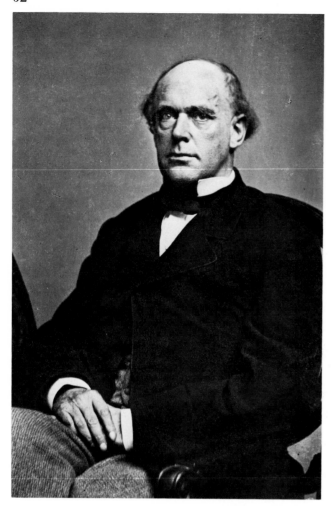

Salmon Portland Chase.
Secretary of the treasury in Lincoln's cabinet, Chase was a political manipulator with a heavy, overworked ambition to sit in the White House. With Secretary of State Seward, Chase intrigued against President Lincoln; and then intrigued against his cohort, Seward. His underhanded manipulations got him nowhere.

From a photograph by Mathew Brady.

Mathew B. Brady and the Artists, circa 1860.
Most likely made in the Washington gallery, this group photograph shows Brady seated (center) with Clark Mills, the sculptor. The painter, Charles Loring Elliott stands at the left. The other well-groomed gentlemen, although unidentified, are believed to be Bancroft Davis, the historian, and I. W. Forney, editor.

From a photograph made in the Brady gallery.

and opened the convention, saying: "All the auguries are that we shall meet the enemy, and they shall be ours!" The race narrowed down to a battle between William H. Seward of New York, Salmon P. Chase of Ohio, and Abraham Lincoln of Illinois, which produced a deadlock, until Massachusetts cast four votes for Lincoln, breaking the deadlock. Others followed and Lincoln's tally rose to twenty-three and a half votes, against Seward's eighteen. All Lincoln needed now was two votes to be nominated. An eyewitness reported: "A profound stillness fell upon the Wigwam. The men ceased to talk, and the ladies to flutter their fans; one could hear distinctly the scratching of pencils and the ticking of telegraphic instruments on the reporter's tables. Then suddenly something happened. The Chair recognizes the delegate from Ohio. 'Mr. Chairman . . . the State of Ohio votes four votes for Abraham Lincoln.' Suddenly a teller shouted one word. 'Lincoln!' "

Outside a cannon roared the signal of Lincoln's nomination to the State House. That night Chicago went wild. A

telegram sent to Albany to Seward, saying, "the wildest excitement prevails in regard to the nomination of Lincoln. State Street is a burning sea of tar barrels. The whole of the heavens are a red glare; cannon are firing, music is playing, and the people are shouting on State Street and Broadway."

Meanwhile the Washington gallery flourished, a showplace where visitors could spend a pleasant hour studying the displays of Brady's previous work, both in color and in black and white. There was, for example, a large shadowbox for displaying stereographic views, which included three-dimensional scenes of Niagara Falls, French comics, and other interesting subjects.

The working studio in Washington, where the actual pictures were taken, was located on the top floor under several large skylights, the sun being the primary light source. The roof of the studio, reached by a stepladder, also contained racks for holding printing frames of all sizes, the sun being also the light source for printing. As in

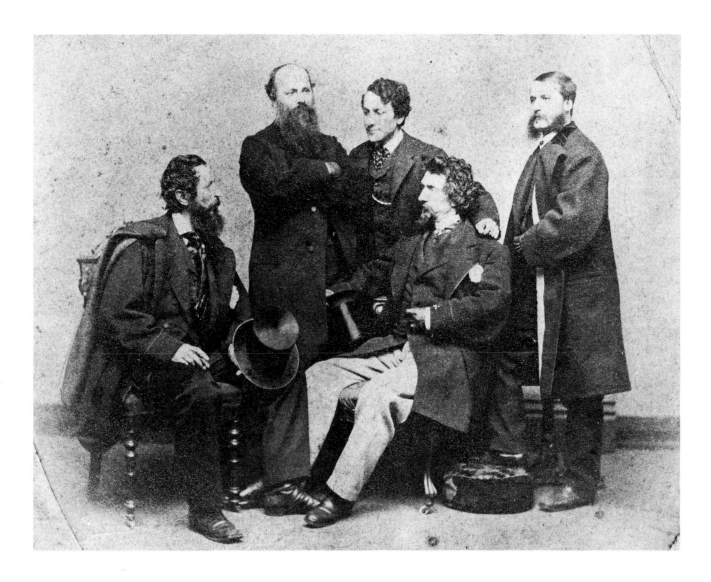

the New York galleries, the operating room contained two or more cameras on movable stands. Later, Alexander Gardner introduced a four-lens camera for the taking of visiting cards, enabling the camera operator to make four negatives at a time.

The service dark room and printing room contained twelve additional camera lenses, probably of different focal lengths, camera tubes for lens extensions for close work the usual darkroom sundries and a gas-fired negative dryer.

Studio properties included chairs for posing, a large gold clock, with the name M. B. Brady on the face, its hands set at ten minutes to twelve, resting on an ornate marble-topped table with some leatherbound books, including the *Annals of Congress*, and a picture album or two. Red draperies, a painted backdrop screen, and a large, wooden reflector, painted white to provide fill light, side lighting and balanced front lighting, completed the heavy working equipment.

The prime feature of the Washington gallery was the chair figuring prominently in almost every important Brady photograph. The chair had belonged to Abraham Lincoln, when he was in the House of Representatives. When new chairs replaced the old, Lincoln acquired his chair and gave it to Brady, it remained a fixture in the Washington gallery.

The unpredictable weather usually dictated the gallery appointment schedule. On sunny days, appointments were arranged for the morning hours from eight until around noon. No sittings were scheduled for rainy days. Gray, cloudy days called for longer exposures and fewer sittings since more time was needed to make a good picture.

Staff personnel for the gallery included two photographers, a darkroom man, a receptionist, an errand boy, and several women framers. Artists who created pictures in oils, watercolors, india ink, or pastels, worked on a freelance basis, and received the highest pay for assignment—$11.00 per week day, and $16.66 for Sunday work. The women framers received the lowest pay rates—$8.00

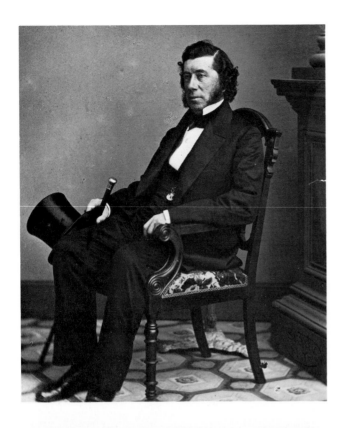

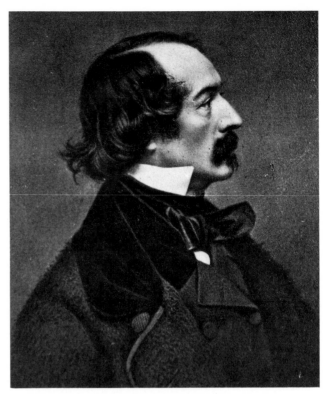

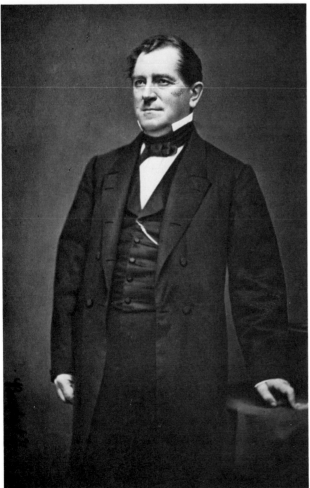

Hamilton Fish of New York, 1860. *(upper left)*
Whig Governor of New York State and later a member
of the United States Senate, Hamilton Fish didn't
consider the slavery issue one of political importance,
but he supported President Lincoln in a perilous time.

From a photograph by Mathew Brady.

Elisha Kent Kane, Arctic Explorer. *(upper right)*
As scientist, naturalist and surgeon, Kane organized
an expedition to find Sir John Franklin, lost in the
Arctic, and established the routes of future polar
expeditions.

From a photograph by Mathew Brady.

Dr. Isaac Israel Hayes. *(facing page upper left)*
Physician and Arctic explorer, Hayes sailed as
surgeon on Elisha Kent Kane's schooner, the
Advance, to the Arctic. In August, 1864, Hayes and
eight men started in a boat for the Danish outpost on
Greenland. Lost for three months and rescued by
Eskimos, Hayes, Kane, and Charles Francis Hall
opened the way to the North Pole.

From a photograph by Mathew Brady.

Joshua Reed Giddings. *(lower left)*
An orator of no mean ability, Giddings was an
implacable foe of slavery and worked powerfully in
Congress against it.

From a photograph by Mathew Brady.

Townsend Harris, Diplomat, 1860. *(facing page
lower left)*
As ambassador to Japan in 1860, it was said that
Townsend Harris knew the Japanese better than any
other foreigner who has ever lived.

From a photograph by Mathew Brady.

per week! Probably artists with reputations, such as Henry L. Darby, John Neagle, and Octavius Darley made their own business arrangements; it is hardly likely they worked for $11.00 a day.

Most of the portraits emanating from the Washington gallery are recognized as Brady's by the ornate gold clock, the floor covering, or the Corinthian column, which was used in almost every standing pose. This column could also be reversed to look Ionian! One of the studio features was the imported body rest from England. Fastened to the floor, it could be moved into various positions and locked in place by a series of points and base sockets, or receptacles, scattered about the floor. This was necessary to prevent body movement during long exposures. Patrons wanting oratorical poses, were given an additional arm rest for comfort.

Group photographs were always a challenge. Brady executed group pictures in sections, which required exceptional skill, both on the part of the photographer and laboratory technician, who had to match the separate sections. Additional chairs for large groups were sometimes borrowed from other photographers in the neighborhood. Though competition was heavy, there was a free exchange of equipment when the need arose.

By 1860, Brady was a comparatively wealthy man. The overall management of his galleries required that he spend a goodly portion of his time soliciting business; but this didn't preclude his taking over the camera when he wished. Though the Gardners managed the Washington gallery, Brady did a good deal of traveling between New York and Washington. Always a meticulous dresser, Brady had style. His wardrobe consisted of tailored jackets and a diagonal black coat, with a change of black and gray doeskin trousers and a merino waistcoat. Pictures of him show him wearing the light doeskin trousers and a black jacket, similar to the dark blazers of today. Most always he wore black boots, and his linen consisted of white shirts, dark ties, white handkerchiefs and a variety of silk scarfs. He used several soaps, lavender water, Congress water, and Atwood's Cologne. He was never

without two or more pairs of eyeglasses—and a bottle of Renault Brandy for incidental social occasions. He was the foremost photographer of New York and Washington society, and he dressed accordingly.

On October 11, 1860, Brady was in New York City. Edward, Prince of Wales, Queen Victoria's heir, was to arrive in the city. Edward's visit captured the attention of the entire country. New York turned out en masse and the leading photographers too sought royal favor. None was more determined than Jeremiah Gurney, Brady's chief competitor, who had also won prizes for his work and owned an impressive gallery on Broadway. Brady, however, made no overtures, confident that his international reputation made his election a foregone conclusion.

New York City officials, with the help of the seven thousand men of the Seventh Regiment, gave Edward a grand welcome. During the parade up Broadway to a special reception at City Hall immense throngs lined both sides of the avenue. At the end of the reception, the parade continued up Broadway to the Fifth Avenue Hotel where the Prince and his entourage were staying. That night, a torchlight procession of New York firemen, usually reserved for elections, entertained him with blaring brass bands, acrobatics, and demonstrations of fire-fighting, while the Prince watched from his balcony. The following evening, a sumptuous Diamond Ball was given in his honor at the Academy of Music, attended by hosts of socially prominent men and women of New York's Four Hundred. The Ball almost had its tragic consequences, however, when the floor collapsed under the weight of the dancing, fortunately before the Prince arrived. And it was five o'clock in the morning before Edward retired.

On the morning of October 13 the Prince's messenger summoned Brady to the hotel to arrange a gallery visit for the Prince. In spite of the gawking crowds, Brady arrived promptly and after a friendly conversation, he agreed to close the gallery to the public during the sitting.

Shortly before noon, Edward and his party drove down Fifth Avenue, amid cheering crowds, and crossed over to Broadway. True to his word, Brady had closed his doors to the public, even denying his closest friends admission

while Edward was in the studio. Still, a fashionably dressed crowd began to gather at the entrance to the gallery. Once inside, the Prince and the members of his suite were escorted through the reception room by Brady and expressed their amazement at the magnificent portraits of the nation's leading statesmen and other American celebrities, the Prince "pointing out to his followers those that were familiar to him by reputation."

The first plates Brady made were three Imperial groups of the entire party, with young Edward the central figure. Next, Brady made a full-length Imperial of the Prince, then portraits of the members of the Prince's suite, individually and in small groups of two and three.

The day being bright, the pictures turned out well, and when the proofs were shown to the royal party, "they were loud in their praise as to the perfection and accuracy of the apparatus in the gallery." Afterwards Brady asked the Duke of Newcastle why he had been chosen, above all the others, to make the royal photographs. The Duke replied: "Are you not *the* Mr. Brady, who earned the prize nine years ago in London? You owe it to yourself. We had your place of business down in our notebooks before we started."

Brady's overwhelming success, and his management of the Prince's visit, was immediately applauded by the press.

Brady managed his cards well. He did not make any preparations to secure the 'Youthful Guelph' as soon as he was advised of his intended visit—modest man—not he. And how immensely surprised he was when the Prince of Wales sent for him and merely intimated his intention of visiting Brady's splendid gallery. . . . How very fortunate that the Prince should have selected him, of all others . . .

We suppose that his fortune is made now. Of course, 'Upper Tendom' will have to visit Brady's. Of course, the Codfish Aristocracy will go nowhere else to get their photographs of the Little Tom Cods. Nothing but a veritable 'Brady' will hereafter answer for the parvenu set who could not make the floor strong enough to hold up the Royal Party when engaged in their Terpsichorean exercises.

Writing about this regrettable incident, some thirty years afterward, Ward McAllister, originator and chronicler of the Four Hundred, said that the "intense mortifi-

Edward, Prince of Wales, 1860.
Temporarily emancipated from Queen Victoria's apron strings, Edward visited New York City with an entourage of male chaperones, selected by his mother. One of the main purposes of his visit was to sit for Brady's camera.

From a photograph by Mathew Brady.

cation of the gentlemen of the Ball, when the floor collapsed," and his own "conscious embarrassment," was still felt after all that time. But there was a bright side to the affair of the Prince's visit. As a memento of his sittings, he gave Brady a gold ring and his wife an ebony escritoire embossed and inlaid with rich mother of pearl. Both of these gifts remained in Brady's possession until the day he died.

Prince Edward's trip to New York City was a pleasant diversion from the developing national crisis. President Buchanan's indecision, John Brown's raid at Harper's Ferry foreshadowing slave uprisings and insurrections in the South, and the growing Northern contempt of the attitudes of the South all made the upcoming presidential election a cause for deep concern.

To Southerners Lincoln, who had once joked about hanging an abolitionist, became the Devil incarnate, the symbol of the threat to their immemorial right. All over the nation, Republican clubs got behind their candidate: Wide Awakes, Lincolnites, Rail Splitters, Ever Readys, and Minute Men. Democrats had their own clubs: Little Giants, the Little Dougs, the Bell Ringers, and Clapper Rites.

At the State House in Springfield, Illinois, the night of November 7, 1860, Abraham Lincoln waited in his room for the returns of the election. The celebrating had already started, and the crowds assembled outside his house. Dispatches arrived every few minutes. All night long the crowd cheered for Lincoln. Cries of, "Where's Douglas?" "Hit him Again!" and "Ain't I glad I joined the Republicans," filled the night air, until it was finally announced that Abraham Lincoln had been elected by a plurality of 66,036 votes.

Thus ended the campaign of 1860. The South was bitter at the election of Lincoln. One newspaper, *The Atlanta Confederacy,* summed it all up:

"Let the consequences be what they may—whether the Potomac is crimson with human gore, and Pennsylvania is paved with ten fathoms in depth with mangled bodies, or whether the last vestige of liberty is swept from the face of America, the South will never submit to such humiliation and degradation as the inauguration of Abraham Lincoln!"

The headline of the *Chicago Tribune,* however, summed it all up differently: "Abraham Lincoln—The Winning Man!"

On that same night, November 7, news of Lincoln's election broke over Charleston, South Carolina, like an exploding shell. Her citizens went wild—Minute Men sprang into ready-for-action companies. Vigilante committees were formed. Men rushed to buy rifles and ammunition. Streetcorner orators openly called for secession, while Palmetto Flags waved defiantly over their heads. Restaurants and stores with the word *national* in their names changed it to *Southern* or *Palmetto.* Secession fanaticism took hold. At the Charleston Theater on Meeting Street, Charleston Volunteers performed drills and flourishes on stage for audiences, who preferred their

maneuvers to the songs of the great visiting opera star, Adelina Patti. Bonfires roared and crackled in parks and squares; Charleston declared a holiday.

And the State Capitol at Columbia, a member of the United States Congress, W. W. Boyce, arose in the legislature chamber and declared: "The way to create a revolution, is to start it. To submit to Lincoln's election is to consent to Death!" The controlling forces, North and South, no longer wanted compromise. In the White House President James Buchanan, worn down by a sense of his own inadequacy, ceased action utterly.

Strangely enough, the plain people of the nation, both North and South, were not hopelessly at odds—that charade was left to the politicians. The Southern hotheads were not the entire South, but their fanaticism and tight organization had the advantage over those who were more temperate. In the North, many men had voted the Republican ticket for reasons quite remote from their opposition to slavery—homestead legislation or protected manufactures.

Within six weeks of South Carolina's Ordinance of Secession, on December 20, 1860, a great wave of emotion swept six States out of the Union: Alabama, Florida, Mississippi, Georgia, Louisiana, and Texas. The border States were in a turmoil of mixed loyalties; the nation was faced with disintegration.

President-elect Lincoln had little to say to comfort the country during those turbulent months before his inauguration. Most insiders believed that William H. Seward would actually run things. The newly created Confederate States of America sent delegates to Montgomery, Alabama. In the North, the air rang with the charges that Buchanan's Directory had traitorously armed the South from federal arsenals, which was all too true. Buchanan, finally stung into action, purged his cabinet and served notice that he would uphold the Union and meet force with force.

Brady was a Douglas Democrat and a member of Tammany Hall, but with all the war fever in the air and the coming inauguration in Washington in March, Brady left for Washington, certain that most of the photographic activity would be there. He had made election pictures of Senator Douglas, for use during the campaign, and his next important assignment would be the Lincoln inauguration pictures made in the Washington gallery.

CHAPTER 5

"The Noblest Cause Is Fought Out Alone"

WASHINGTON NOW BEGAN preparations for the inauguration. In mid-February, Brady, too, made preparations. On February 23, 1861, Lincoln walked into the gallery for his first official photographs, accompanied by his close friend and former circuit-riding colleague, Ward Hill Lamon, now city marshal of Washington, and Allan Pinkerton, the well-known Chicago detective, who, oddly enough, "had once been engaged for years in the business of running slaves from where they were legalized property to where they were not." Lamon and Pinkerton had been charged with Lincoln's safety and had accompanied him from Springfield, Illinois.

George H. Story, a young artist and a personal friend of Brady's, had a studio on the floor above Brady's gallery, and the photographer had often called Story to pose some celebrity who had come to be photographed. Story had some pretty definite ideas about the current popularity of the Napoleonic pose; he thought it ridiculous. "In those days," he said, "the photographer knew but one pose for a man to assume . . . bolt upright with one hand thrust into the breast of his coat, and the other hand on the table;—it was laughable." Story jumped at Brady's request to assist him in posing his famous sitter and was in the studio when president-elect Lincoln and his friends arrived.

Lincoln sat before the camera quietly, seemingly in deep thought. According to a reporter for the *Washington Star*, who had been at the gallery, he "was dressed in plain black clothes, black whiskers—and how well trimmed," a different man entirely from the hard-looking pictorial representations seen of him . . . some of the ladies say he is almost good-looking." Lincoln's sadness and depression was written on his face, and his dejection had not gone unnoticed by young Story. "He did not utter a word," wrote Story afterward, "and he seemed absolutely indifferent to all that was going on about him;—and he gave the impression that he was a man overwhelmed with anxiety and fatigue and care."

While the studio was arranged for the sitting, Story studied Lincoln, and had noticed his mood. Lincoln then sat with his left hand raised, gazing at the floor, apparently immersed in deep thought. Story exclaimed, "Pose him? . . . Bring the camera at once!"

Ward Lamon, Marshal of Washington, 1861.
Loyal, loud, swashbuckling, and absolutely devoted to his friend, President Lincoln, Lamon's high principles offended many people. He hated abolitionists and secessionists with equal intensity; and he kept a tight control over the wavering civil affairs in a city of intrigue. No one dared to cross this six-foot-four, powerful giant.

Photograph by Mathew Brady.

99

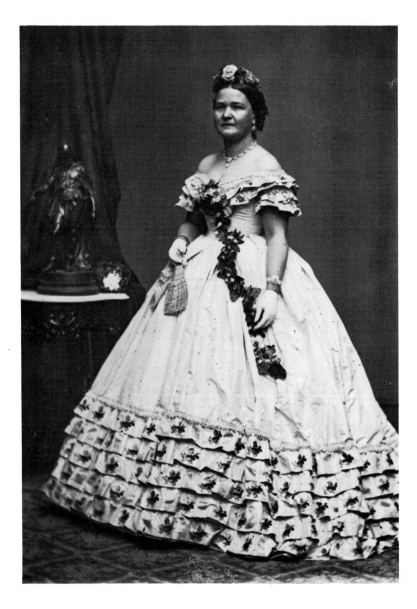

Mary Todd Lincoln, the First Lady, 1861.
Brady's photograph shows the First Lady dressed in her Inaugural Ball gown. The Lincoln's were never photographed together or if they were, no picture of them has ever come to light.

From a photograph by Mathew Brady.

The camera was hurriedly placed in position, and while Mr. Lincoln pondered, the plate was made. Story later wrote:

As soon as I saw the man I trusted him. I had received private information that undoubtedly there would be a war, and I knew that Lincoln was the man to handle the situation. There was a solemnity and dignity about him, and a general air that bespoke weight of character . . . At first meeting that was convincing. Honesty was written in every line in his face. In dress and appearance, he was elegant, his clothes being made of the finest broadcloth. Nor was he awkward despite his height. His hands and feet were small and shapely.

When the sitting had ended, Ward Lamon said: "I have not introduced Mr. Brady." Lincoln extended his hand to Brady, and said, "Brady and the Cooper Union speech made me president!"

While inaugural preparations were underway, Brady was engaged to photograph Mrs. Lincoln. Two pictures were made of the First Lady: one in her Inaugural Ball dress of pink silk, the other, in a striped silk dress elaborately trimmed with lace. The ubiquitous *Washington Star* reporter noted: "The peep afforded of Mrs. Lincoln, in passing from the carriage to the hotel, presented a comely, matronly, ladylike face, bearing an unmistakable air of goodness, strikingly opposite of the ill-natured portraits of her by the pens of some of the sensation writers."

On March third, the day before the inauguration, General Winfield Scott held a conference at his headquarters to plan the presidential procession. President Buchanan was to call upon the president-elect at Willard's Hotel and the two men were then to ride together, between double files of a squadron of District of Columbia cavalry. Sharpshooters were placed on the roofs of commanding buildings along the route, with orders to watch the opposite sides of Pennsylvania Avenue, and to open fire on any window in which a weapon appeared. A small force of Regular United States Cavalry, guarding the side streets

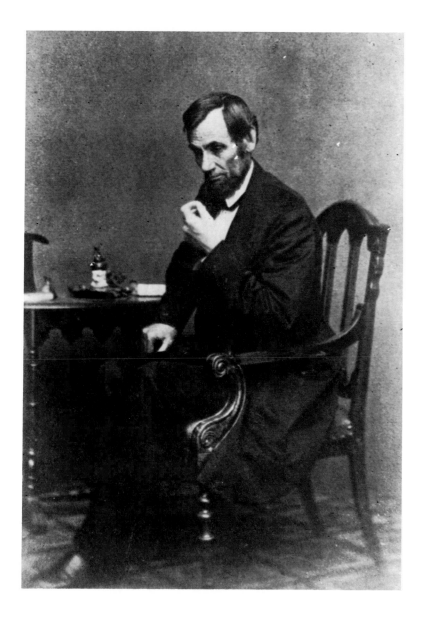

Abraham Lincoln's Pre-Inauguration Picture, 1861.
Posed in February, 1861, for Brady by George Story, an artist working in the same building as Brady's gallery, the picture shows the President-elect in a pensive mood.

From a photograph by Mathew Brady.

and crossings of Pennsylvania Avenue, was to keep in constant motion from one side to the other during the passage of the procession. A battalion of District of Columbia troops was placed near the steps of the Capitol, and riflemen were stationed in the windows of each wing of the building. Upon the arrival of the presidential party at the capitol, the troops were to be stationed in the same order, so as to return in the same formation after the ceremony.

To thwart any attempt to blow up the platform where the president-elect would take the oath of office, soldiers were placed under the steps during the night and at daybreak a trusted battalion of District troops formed a semicircle around the area to prevent entry from any direction.

At dawn on March fourth, crowds began to assemble on the Capitol grounds before the portico, and as the crowds gathered, plainclothes policemen moved among them,

watching closely for persons acting suspiciously. The day promised to be bright and pleasant. Twenty-five thousand people filled the streets of Washington, mostly massed near Willard's Hotel, waiting to see the president-elect.

Shortly before noon, President Buchanan arrived in his barouche at Willard's, alighted and disappeared into the doorway, returning a few moments later, arm-in-arm with Lincoln. The two men walked to their carriage on a path cleared for them by the cordon of policemen, and then the procession made its way down Pennsylvania Avenue, led by Major French, Chief Marshal, ministers of the Diplomatic Corps, the Army, Navy, Marines, and members of Congress, guarded by units of the Army and trusted squadrons of picked cavalry.

At the Capitol in the Senate Chamber they witnessed the swearing in of Hannibal Hamlin of Maine as vice president. Then a new procession was formed to escort Lincoln to the platform outside the east portico. A crowd

Abraham Lincoln's Inauguration.
The original photo of Lincoln's first inaugural was lost in Washington almost a century ago. The drawing from *Harper's Weekly* shows clearly that construction work on the Capitol was still in progress on March 4, 1861. This photograph depicts the second inaugural, in March 1864.

of more than ten thousand, who had been waiting all morning, cheered. Upstairs in the windows of the Capitol on each side of the inaugural platform, General Scott's sharpshooters surveyed the audience. On a high eminence in back of the platform, the actor John Wilkes Booth leaned over the rail and watched the proceedings.

From their position on the lawn in front of the portico, Brady and Gardner worked feverishly amid their darkroom tents and cameras, taking their photographs as rapidly and efficiently as their equipment would allow.

Lincoln, in his new black suit, black boots, and black top hat and carrying an ebony and gold-headed cane, took his seat. Edward Dickinson Baker, the senator from Oregon, stepped forward. "Fellow citizens, I introduce to you Abraham Lincoln, the president-elect of the United States." There was some light applause as Lincoln rose to deliver his inaugural address. "In your hands, my dissatisfied fellow countrymen, and not in mine, is the momentous issue of civil war," he concluded. "The government will not assail you. You can have no conflict without being yourself the aggressors. You have no oath registered in Heaven to destroy the government, while I shall have the most solemn one to 'preserve, protect, and defend it.' "

"To twenty million people," wrote the *New York Tribune* of Lincoln's inaugural address, "it will carry tiding, good or not, as the case may be, that the Federal Government of the United States is still in existence, with a Man at the head of it."

Chief Justice Roger Brooke Taney, famed for his Dred Scott decision, opened a Bible and held it out with a shaking hand. Lincoln laid his left hand on the Bible, raised his right hand, and repeated the oath after the Chief Justice. A battery of cannon thundered a salute to the sixteenth president of the United States. Ex-President Buchanan remarked to the new President as they rode together to the White House from the Inauguration: "If you are as happy, my dear sir, on entering this house as I am in leaving it and returning home, you are the happiest man in this country."

During the following few weeks, the South made good her threat of separation by seizing the United States

arsenals, post offices, custom houses, and shipyards within Southern territory. Fort Sumter in Charleston Harbor, South Carolina, watched fortifications being thrown up all about him. Anderson had reported to Washington, that his post was being breached by high-powered batteries; that his food supply was all but gone; that Confererate forces were waiting to shell him out. But Anderson waited in vain for instructions and assistance, since his superior, General Samuel Cooper, and Secretary of War John B. Floyd, had defected. By the time the federal government decided to reinforce Anderson, it was too late.

In Washington, the surrender of Fort Sumter caused a suspension of trade. Thousands of people walked around aimlessly, gathering in groups on street corners all day and all night, hoping for scraps of information. President Lincoln, confronted with a war he had tried to avoid, now called up 75,000 volunteers "to put down the rebellion," and, almost overnight, Washington City became a military base. With no provisions made to quarter men of the various regiments arriving daily, every government building, even the basements of the Capitol, became a barracks. One volunteer noted in his diary: "Pennsylvania Avenue was extremely dirty, and the cavalcades of teams of artillery caissons and army baggage wagons, with their heavy wheels, stirred up the muddy streets into a stiff batter for pedestrians. Officers in tinsel and gold trappings were so thick on the avenue that it was a severe trial for a private soldier to walk there." Another soldier ruefully declared that, "after a half-hour's walk, he had saluted two hundred officers," adding that "the brigadiers were more numerous on Pennsylvania Avenue than ever he would know them to be at the front."

Brady and Gardner enjoyed a landoffice business making pictures of the officers and soldiers who wanted their Cartes des Visites, a small visiting card photograph, to send home. This type of photograph was extremely popular at the time, and had become a feature of the gallery. In this work Brady was assisted by Captain A. J. Russell, Thomas Roche, and T. H. O'Sullivan, turning out the photographs in a way that resembled mass production. A four-lens camera was used, exposing four negatives at a

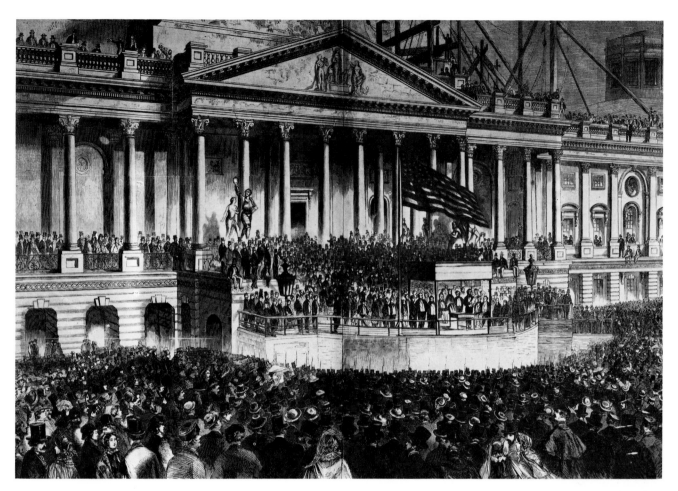

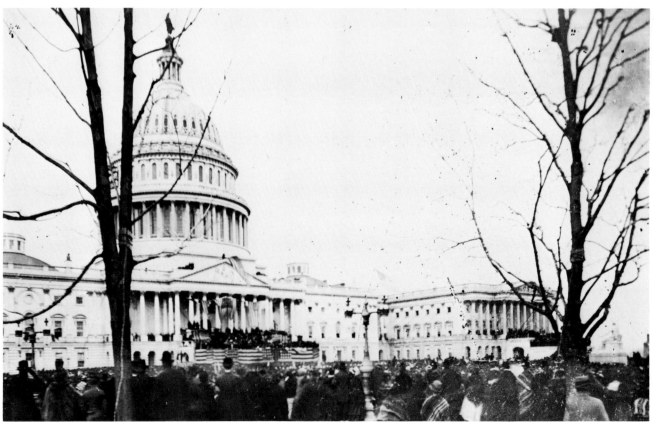

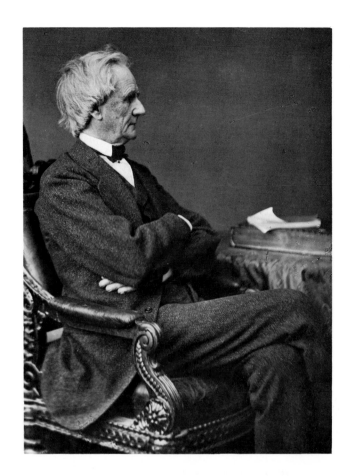

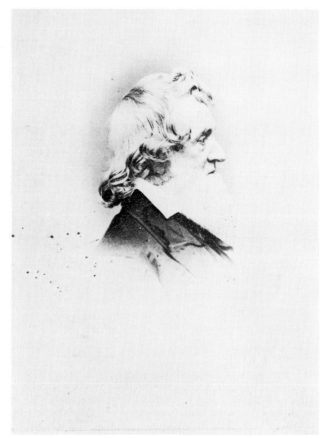

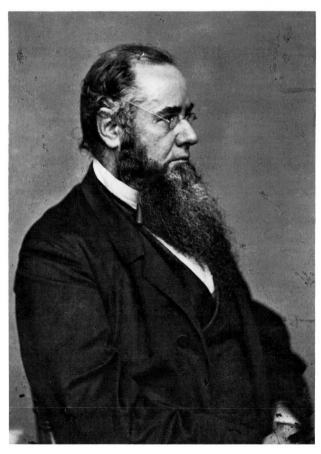

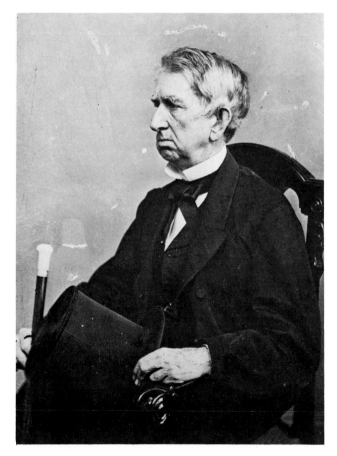

104

Simon Cameron of Pennsylvania.
(facing page upper left)
President Lincoln's first secretary of war used his
position to increase holdings with Northern
industrialists. Lincoln had been advised not to give
Cameron the post, because of his sleazy reputation.

From a photograph by Mathew Brady.

Gideon Welles. *(facing page upper right)*
Former newspaper editor, Welles, secretary of the
navy in President Lincoln's cabinet, ran that office
with rare skill despite his lack of nautical training. It
was said he "looked like Marie Antoinette on her way
to the guillotine."

From a photograph by Mathew Brady.

Edwin McMasters Stanton. *(facing page lower left)*
Secretary of war in President Lincoln's cabinet,
Stanton was a malign influence in cabinet meetings.
Double-dealing was his metier. He knew how to
bulldoze crooked army contractors. Stanton "got
things done!"

From a photograph by Mathew Brady.

William H. Seward, 1866. *(facing page lower right)*
Secretary of state in President Lincoln's cabinet,
Seward was a political manipulator who, with Salmon
Portland Chase, secretary of the treasury, intrigued
against Lincoln and each other.

From a photograph by Mathew Brady.

time, each 2″ × 1½″; the price for these card photographs
was $1.50 for six mounted prints. The sitter's name,
photographer's name, and gallery were lettered at the
bottom.

Among Lincoln's cabinet officers who sat for their
photographs to Brady that spring was Simon Cameron,
then secretary of war; Gideon Welles, secretary of the
navy; and Edwin McMasters Stanton, later war secretary,
who perfumed his beard.

Secretary of State William H. Seward hated to have his
picture taken, and only official pressure brought him to

Brady's gallery. It had been rumored that Mrs. Lincoln
intensely disliked him and wished her husband would
replace him with someone else.

In May, President Lincoln once again came to Brady for
another portrait. Lincoln was in his usual melancholy
mood, and with reason. Martial law had been declared in
Washington and fighting had already broken out in Balti-
more where secessionists tried to prevent a Mas-
sachusetts regiment from reaching Washington, attacking
them with rocks, sticks, and clubs.

Lincoln sat for six pictures, and the president's secre-
tary, John G. Nicolay, analytically noted his impressions:
"Large head, with high crown of skull; thick bushy hair,
large and deep eye caverns; heavy eyebrows, a large nose;
large ears; large mouth; thin upper and somewhat thicker
lower lip; very high and prominent cheekbones; cheeks,
thin and sunken; strongly developed jawbones; chin,
slightly upturned; a thin but sinewy neck, rather long;
large hands; chest thin and narrow as compared with his
great height; legs of more proportionate length, and large
feet. The picture was to the man as a grain of sand to the
mountain, as the dead to the living."

In June, Alexander Gardner asked George Story to fill
an order for a painting of Lincoln from a photograph.
Story accepted, but told Gardner he must have some
sittings. The President could not spare the time, but
replied if Story wished to go to the White House, he
would be welcome. Story was shown into a large room on
the second floor, where Lincoln acknowledged his pres-
ence, nodding him to a chair. As Story studied Lincoln's
face, he noted that it was in constant motion and partially
in shadow, which made it all but impossible to make
preliminary sketches for the oil. Eventually, with the help
of Brady's photographs, Story made his portrait. How-
ever, "Graphic art was powerless," wrote Nicolay, "be-
fore a face that moved through a thousand delicate grada-
tions of line, contour, light and shade, sparkle of the eye
and curve of lip, in the long gamut of expression from
grave to gay, and back again from the rollicking jollity of
laughter to that serious, faraway look with prophetic intui-
tions. There are many pictures of Lincoln; there is no
portrait of him."

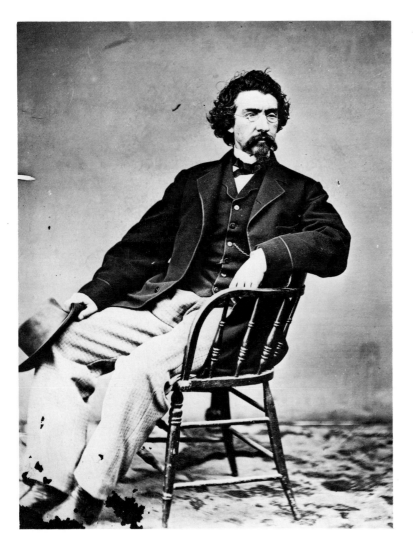

Mathew B. Brady as He Looked During the Civil War.
The photographer's hair and mustache, once black, is now streaked with gray.

From a photograph made in Brady's Washington Gallery.

Brady Family Group, circa 1858–60.
This charming picture shows Brady and his wife, Juliette R. C. Handy (seated left) sometime in 1850, *before* his marriage. Brady's sister, (name unknown, seated right,) died and Brady adopted her two children.

From a photographic copy of a daguerreotype made in the New York Gallery.

During the following weeks, 58,000 volunteer troops, including a regiment of regulars, were stationed in and around the base camps in and near Washington. Rumor that a battle would soon be fought somewhere close at hand caused an exodus of government employees, especially those of Southern persuasion.

It may have been at this time that Brady conceived his idea of becoming a "pictorial war correspondent," and the more he thought of it, the more daringly attractive the idea became. War pictures would be in demand before long, and he wanted to be the man to make them.

He mentioned his new venture to his wife, Julia. She didn't approve at all, believing that the operation of his galleries in New York and Washington was more important than following the armies with his cameras and exposing himself to the attendant risks. "My wife and my most intimate friends," he acknowledged, "had looked unfavorably upon this departure from commercial business to pictorial war correspondence." Against their advice Brady went to the War Department to see his old friend General Winfield Scott, Chief of the Army.

"I had long known General Scott," Brady said, "and in the days before the war it was the considerate thing to buy wild ducks at the steamboat crossing of the Susquehanna, and take them to your choice friends, and I often took Scott his favorite ducks. I made to him my suggestion in 1861. He told me, to my astonishment, that he was not to remain in command. Said he to me, 'Mr. Brady, no person but my aide, Schuyler Hamilton, knows what I am to say to you. General McDowell will succeed me tomorrow. You will have difficulty, but he and Colonel Whipple are the persons to see.' I did have trouble; many objections were raised."

Scott realizing how valuable military photography would be to the topographical engineers, told Brady, "This will be a great war, and needs younger men to conduct it. I therefore cannot give you any help. You ought to be with the topographical engineers, well up to the front. I will give you a letter to General McDowell."

Armed with Scott's letter, Brady sought General Irwin McDowell's tent in headquarters at Alexandria, Virginia, and had his audience with the new army commander.

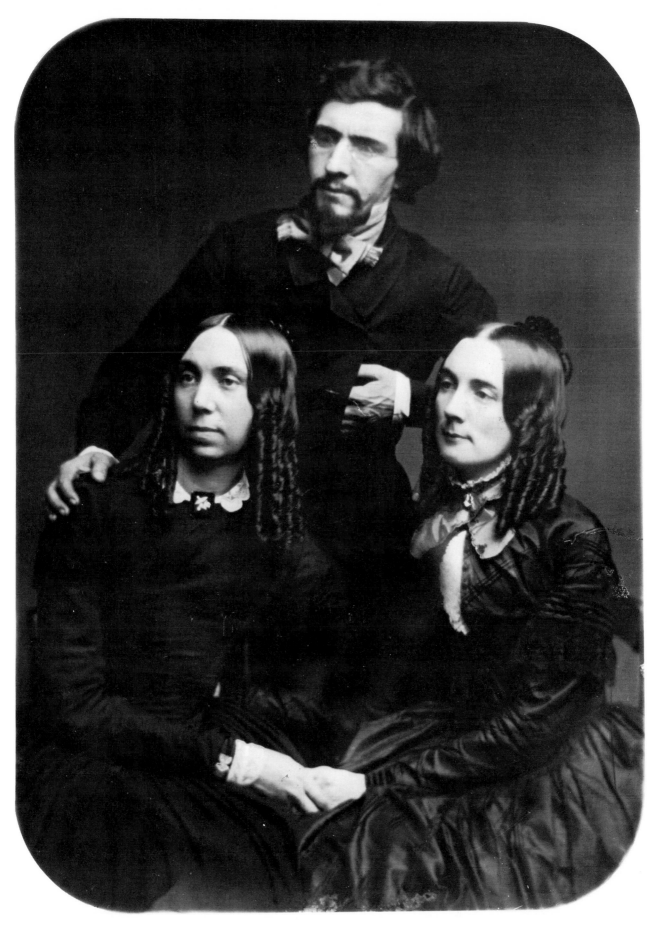

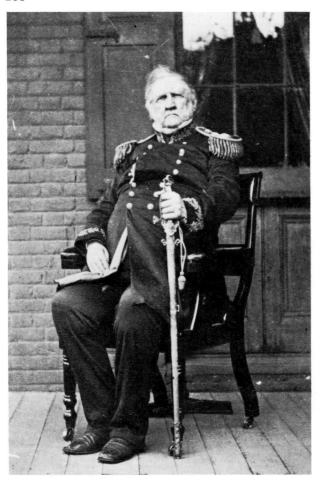

General Winfield Scott, USA, 1861.
A fine soldier, loyal and vigilant, Scott was too old to lead the Union armies in the Civil War. This is Scott when Brady came to see him for permission to follow the armies with his cameras.

From a photograph by Mathew Brady.

McDowell was courteous and impressed. He gave Brady written permission in the form of a pass. Years after the war, Brady told George Alfred Townsend. "Destiny over-ruled me! Like Euphorion, I felt I had to go, a spirit in my feet said *go* and I went—!"

A few days before General Scott resigned Henry Kirke Brown, asked Brady to photograph the General stripped to the waist. Brown had been commissioned to sculpt a statue of Scott to be placed in Scott Square, in Washington, D.C., and needed a photograph to work from. General Scott and his valet arrived at the gallery and while Brady and Gardner prepared the cameras, Scott's valet removed the General's shirt. Pointing to a deep scar on his broad shoulder, Scott told Brady that he had received the wound at the battle of Lundy's Lane in 1814. When the six-foot-four soldier stood up for a full-length picture, he almost put his head through the skylight. An overwhelming presence, Scott weighed three hundred pounds.

During Scott's sitting, Brady's receptionist, Miss O'Gorman, announced that the renowned British actress and author, Mrs. Fanny Kemble, and the Reverend Doctor Bellows, were in the reception room. Doctor Bellows had promised to bring Mrs. Kemble to Brady's for a picture. Excusing himself for the moment, Brady started for the reception room to greet his guests when Scott, still stripped to the waist, bellowed, "Brady! Don't leave me!" Apparently Scott's deep voice frightened his visitors away, for all Brady saw when he reached the reception room was Mrs. Kemble flying downstairs, followed by the Reverend Doctor. Brady never saw her again, for she left for England that day and never returned.

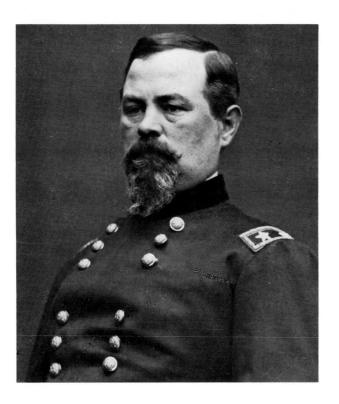

Brigadier General Irwin McDowell, July 1861.
An untried, inexperienced field officer, McDowell commanded an army of fifty-eight thousand raw recruits, many of whom had seldom fired a rifle. Hampered by a horde of sightseers, McDowell was roundly defeated at Bull Run and never held another important command.

From a photograph by Mathew Brady.

Mathew B. Brady Dressed for War, July 5, 1861.
"A spirit in my feet said 'go' and I went," Brady told George Alfred Townsend. This picture was made in Brady's gallery two days later.
From a photograph made in the Brady Gallery.

On the morning of July 16, 1861, Mathew B. Brady, dressed in a white linen duster and straw boater, mounted the wagon box of his traveling darkroom, with three days supply of food, chemicals, plates, and equipment, and took place in the lines of General McDowell's army for the twenty-five-mile march on Centerville, Virginia, where the Confederate Army was reported to be. With him were Al Waud, the sketch artist for *Harper's Weekly;* Dick McCormick, a newspaperman; and Ned House, a drama-critic-turned-war-correspondent. Brady's unique wagons were specially equipped for outdoor location work. They resembled old grocery wagons, with a step in the rear and a tarpaulin covering for rainy weather. A well at the rear of the wagon allowed for standing room between the work benches on both sides which had cabinets above for chemicals and equipment. On one side were tanks for silver nitrate baths, developing solutions, and a tank for fixing chemicals of ascetic acid and hyposulphite of soda. A tank in the upper front corner held clean water. Because of its weight and need for maneuverability, the wagon was drawn by two horses.

Brady's two wagons fell in with the rear of the army. The entire affair seemed less like an army going to battle than something out of a musical comedy. Heterogeneous in personnel and dress, to say the least, the Union Army presented an original and striking appearance. The 79th New York Highlanders marched in plaid fatigues and kilts; the 11th New York as Zouaves, in bright red pantaloons, white gaiters and blue kepis; the Fighting Sixty-Ninth stripped to the pants; the Michigan regiments as lumber jacks in red plaid shirts with sheath knives and horse pistols stuffed in their belts. The only professional soldiers in their entire army were two regiments of U.S. Regular Infantry, dressed in regulation uniforms of two-toned blue.

Most of these soldiers had never fired an army rifle, didn't even know how to load one, and few, if any, of the regiments had any idea of maneuvering or fighting in formation. Without a semblance of discipline, this untrained, crowd, composed largely of young boys, broke ranks, looted houses along the way, stopped to pick blackberries, talked back to their officers, and, in general, violated every regulation in the book. Of the 58,000 only the 2,000 regulars had any training. Colonel William Tecumseh Sherman remarked "there was no greater curse than an invasion by a volunteer army."

The July sun beat down unbearably out of a brassy sky. Even worse than the heat and the nature of the Union army, and what would later prove fatal, was the horde of civilians who followed in the wake of the army. There was going to be a Big Fight and they meant to witness it. Crowds of spectators, congressmen, senators, their wives in crinolines carrying lunch baskets, rode to the battle site in horse and buggy, on horseback, and in carts.

At Manassas, Virginia, the army crossed Bull Run Creek over the Stone Bridge and formed in a line across the great plain. "On to Richmond!" was the cry. The

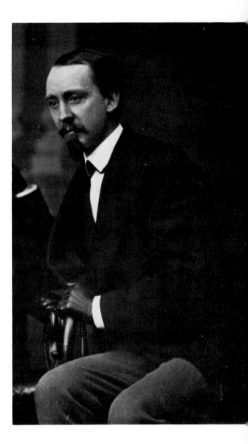

general feeling was that one battle would end the rebellion.

McDowell, the commanding general, for all his West Point training, had never commanded a large force, much less fought a big battle. He planned to destroy Beauregard's army along Bull Run Creek and seize rail junctions vital to the defense of Richmond. "It was one of the best planned and worst fought battles of the war," General Sherman said later.

When the battle began, civilian gaiety vanished quickly. Men, shot and mangled, screamed with pain, and horses with blood streaming from their nostrils ran about or lay on the ground hitched to guns, gnawing their sides in death.

Many of the Union volunteers terminated their service at the first burst from the Confederate batteries. The battle raged all day, swirling around the Henry House and the Henry Hill, and for awhile it seemed as if the Union troops, for all their inexperience, were going to win the contest. Brady and his companions set up equipment near Blackburn's Ford and the Stone Bridge and took pictures of the destroyed railroad bridge over Bull Run. They could see battlefield, now strewn with dead men and horses. Realizing the gravity of their situation, Brady and

his companions replaced the equipment in the wagons and drove a short distance back of the lines toward Centerville.

Victory seemed within the grasp of the Union army until Colonel Thomas J. Jackson's Confederate soldiers, kept in close formation behind a stone wall awaiting the advance of the Union columns, jumped from their hiding place and fired a disciplined volley into the charging blue troops. A slow withdrawal suddenly became a rout, the dazed Union soldiers streaming back across the Stone Bridge, overturning wagons and carriages in their panic. All efforts of the Union officers to avert panic went for nothing.

Brady and his companions, caught up in the panic, tried to extricate their wagons from the screaming mobs running in all directions. Their progress was slow, as the Warrenton Turnpike was choked with the vehicles of civilians, and the stragglers who had thrown away their rifles, cut horses from their harnesses, and made off on them. Darkness brought an end to the Confederate pursuit. Brady and his companions became separated; he drove into the woods and comparative safety. It rained and Brady, exhausted, fell asleep on the wagon seat.

After a troubled night in the wet woods, alone with the

Alfred R. Waud, English Artist, July 6, 1863.
(facing page left)
Brady's companion at Bull Run, Waud, a brilliant
artist and war correspondent, sketched most of the
important battles for *Harper's Weekly*. Though a non-
combatant, Waud wears the outfit of a Federal officer,
and carries a Navy Colt. He could have faced a firing
squad had he been captured.

From a photograph attributed to Mathew Brady.

Edward Howard House, July, 1861.
(facing page right)
Ned House, a drama-critic-turned-war-
correspondent, was one of Brady's companions at
Bull Run; the other was Dick McCormick, a
newspaperman.

From a photograph by Mathew Brady.

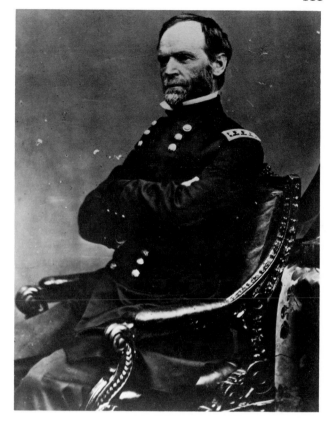

Major General William Tecumseh Sherman, 1869.
Colonel of a brigade at Bull Run, the very competent
Sherman said McDowell's battle "was the best
planned, and worst-fought," of the war.

From a photograph by Mathew Brady.

noises from the stricken battlefield, Brady continued on
his way to Washington. All around was the debris of battle
and a defeated army—haversaks, harness, broken wag-
ons, disabled gun carriages, and all the accoutrements of
fleeing soldiers. Across the Manassas Plain men and
women were searching for loved ones who had fallen in
battle. It was late afternoon when he reached
Washington. The city was swarming with dazed soldiers.
Washington was preparing for an invasion. Forts were
feverishly erected around the city, heavy artillery was
dragged through the streets by long teams of oxen.

The press had plenty to say about the battle and the
cowardice of the Union troops; not the least of the stories
was about Brady. The *Washington Star* reported

The irrepressible photographer, like the warhorse, sniffs the
battle from afar. We have heard that two photographic parties
were in the rear of the Federal Army on its advance into Rich-
mond, Virginia. One of these got as far as the smoke of Bull Run,
and was aiming the never-failing tube at friends and foes alike,
when with the rest of our Grand Army they were completely
routed and took to their heels, leaving their photographic
equipment and accoutrements on the ground, which the rebels
no doubt pounced upon as tropies of victory. Perhaps they
considered the camera an infernal machine. The soldiers live to

fight another day; our special friends to make their photographs
again.

The other party, stopping at Fairfax, were quite successful.
We have before us their fine stereo view of the famed Fairfax
Courthouse. When will the photographers have another chance
in Virginia?

Brady's loss was not as severe as this account would lead
us to believe. He managed to stick to the wagons with his
equipment and some exposed negatives, but he had to
ruefully admit: "Our apparatus was a good deal damaged
on the way back to Washington. Yet, we reached the
city."

Humphrey's *Journal of Photography* corroborated
Brady's account of the affair:

The public is indeed indebted to Brady of Broadway for numer-
ous excellent views of grim-visaged war. He has been in Virginia
with his camera and many and spirited are the pictures he has
taken. His are the reliable records of Bull Run. The correspon-
dents of the rebel newspapers are sheer falsifiers; the corre-
spondents of the Northern journals are not to be depended
upon; and the English correspondents are altogether worse than
either. . . .

Brady has shown more pluck than many of the officers and
soldiers who were in the fight. He went, not exactly like the

General Thomas Jonathan Jackson, CSA, 1863.
Brilliant strategist, Jackson earned the sobriquet of
Stonewall for his performance at Bull Run in 1861.
Seen here as a Liutenant General, Jackson was killed
at Chancellorsville in 1863, during a night
reconnaissance, shot accidentally by his own men.

From a photograph by Julian Vannerson, Richmond,
Courtesy The Valentine Museum, Richmond.

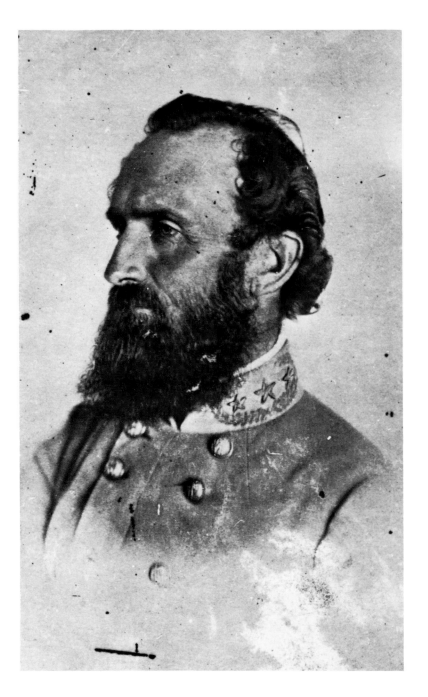

'Sixty-Ninth' stripped to the pants—but with sleeves rolled up
and his big camera directed upon every point of interest on the
field. Some pretend indeed, that it was the mysterious and
formidable instrument that produced the panic! The runaways
. . . did not get away from Brady as easily as they did from the
enemy. He has fixed the cowards beyond the possibility of a
doubt.

. . . this collection is the most curious and interesting we
have seen. The groupings of entire regiments and divisions,
within the space of a couple of square feet, present some of the
most curious effects as yet produced in photography. Consider-
ing the circumstances under which they were taken, amidst the
excitement, the rapid movements, and the smoke of the battle-
field, there is nothing to compare with them in their powerful
contrasts of light and shade.

The unexpected outcome of Bull Run and the frantic
search for a scapegoat to blame for the demoralized rout of
the Union army made it all too evident that the Lincoln
administration was totally unprepared to fight a long war.
More important, the army had to go through a long period
of intensive training before it could be depended upon.
The most observant summary of the entire military di-
lemma came from George William Curtis, editor of
Harper's Weekly: "As for blame and causes, they are in
our condition and character. We have undertaken to
make war without in the least knowing how."

CHAPTER 6

The Fiery Trial

BY SEPTEMBER, 1861, battles in the wild, mountainous regions of western Virginia were fought and won by the North under a young, West Point graduate, General George Brinton McClellan, a railroad president and engineer. President Lincoln, appointed him to the command of the newly named Army of the Potomac, relieving General McDowell.

McClellan immediately initiated a period of intensive training designed to forge the disorganized stragglers of Bull Run into an army. Ignoring the political intrigue and jockeying for position among the politicians surrounding Lincoln, particularly Simon Cameron, secretary of war, McClellan worked around the clock molding a fighting army, training a quarter of a million men and a competent staff.

And while McClellan formed his brigades and divisions, Ward Hill Lamon, the six-foot-four-inch, two-hundred-fifty-pound Marshal of Washington who was Lincoln's personal friend and bodyguard, set about correcting the chaotic civil affairs of the District. Lamon was an apt choice on Lincoln's part. Although his swashbuckling manner, and his hatred of secessionists offended many people, no harm would come to Lincoln as long as Lamon could swagger, make arrests, and sleep next to the President's bedchamber.

From July, 1861, to March, 1862, the army trained and went through maneuvers while the politicians chafed and fretted at McClellan's seeming inaction and unwillingness to engage the enemy. During these months, Brady toured the camps and made pictures of the various military units and installations in and around Washington.

At about this time Brady and Alexander Gardner, manager of his Washington Gallery, parted company. Gardner claimed that he, and he only, had conceived the idea of photographing the war. There is only Gardner's word for that. Brady was undoubtedly aware that Gardner was anxious to have his own business, and some friction must have developed between them.

Gardner recognized the need for mass production of pictures for the Cartes des Visites wanted by the soldiers and for the small photographs of commanders, staffs, military bands, and even groups standing before their tents. The popularity for these small photographs was so great that the Washington Gallery could not cope with the demand. Gardner suggested that Brady contract with Anthony & Company of New York, the largest photographic supply house in the country, to take over processing and distribution. With some reluctance Brady agreed, and Anthony & Company printed and distributed the card pictures of all the celebrities the Brady Gallery produced. Under the terms of this unusual contract, the Brady negatives became the property of Anthony & Company, which meant that any number of prints could be made, with no accounting for the number actually released. Brady, nevertheless, received about $4,000 a year in royalties from Anthony & Company.

When General McClellan assumed command of the Army of the Potomac, Gardner joined McClellan's staff as an honorary captain and official photographer, severing six years of association with Brady. Brady's new manager of his gallery was James F. Gibson, a qualified photographer with little business ability and questionable personal integrity. Under Gibson's management, Brady's business took a downward trend, which Brady apparently tried to rectify by doing a lot of the photography himself.

Between September, 1861, and the spring of 1862, Brady made his pictures in and about Washington, concentrating on the training camps and forts in the area, particularly the various regiments encamped around the District. Important among these plates were those of the Camp of Instruction for the training of signalmen located at Red Hill in Georgetown. Other photographic activities during the latter months of 1861 included many portraits made in the gallery, and at the army's base of operations at Arlington Heights and Hunter's Chapel, Virginia.

Military operations during the Civil War became very "modernized". Not the least of these modernizations was the introduction of aerial observation by Professor Thaddeus Sobieski Coulincourt Lowe and his balloons. A meteorologist, inventor, and an early experimenter with hot air baloons. Lowe was made Chief of the Aeronautical Section and operated his balloons throughout the war, becoming the first man in the country to make photographs from a balloon. Brady photographed Lowe's aerial

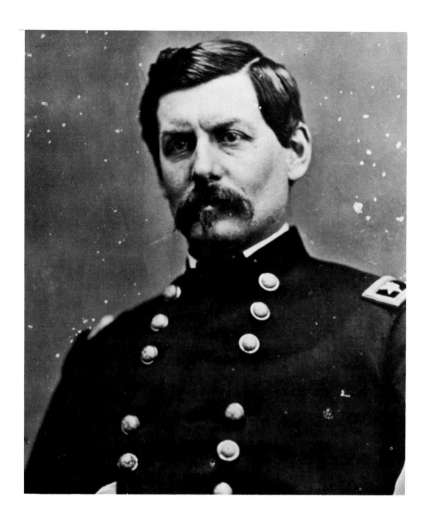

Major General George Brinton McClellan, USA. *(left)*
An enigma to himself as well as to others, McClellan was an excellent training officer, but no field commander. Indecisive and slow to act, he was removed by Lincoln after Antietam.

From a photograph by Mathew Brady.

War Photographers in the Field, 1862. *(facing page)*
The photographer on the left is believed to be David Landy (some say it is David B. Woodbury); the man on the right, Egbert Guy Fowx; the place, somewhere in Virginia. Their wagon carries a portable darkroom at the back.

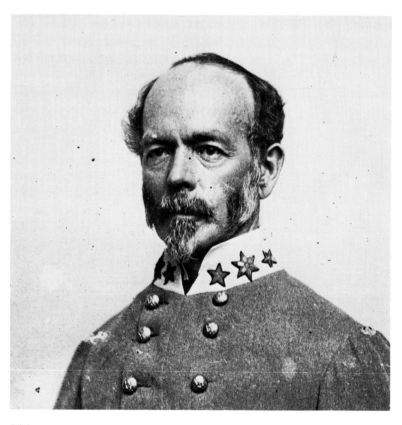

General Joseph Eggleston Johnston, CSA.
Considered one of the best general officers in the Confederate Army, Johnston, conspicuous at Bull Run, nearly fought Sherman to a standstill in 1864 in the latter's campaign to capture Atlanta, the South's key industrial city.

From a photograph by Julian Vannerson, Richmond,
Courtesy The Valentine Museum, Richmond.

experiments on the grounds of the Smithsonian Institution, but his main opportunity came during the battle of Fair Oaks, during McClellan's Peninsula Campaign.

With characteristic enthusiasm, Brady now began the actual photography of military operations in the field. He had early realized he could not possibly cover all the theaters of the war by himself, so by the fall of 1861 he had outfitted a corps of twenty photographers. His personal estimate of the cost of this venture—paying his men in the field and equipping them—amounted to more than one hundred thousand dollars. "I had men in all parts of the army," Brady had said to George Alfred Townsend, "like a rich newspaper." *The Camera and Pencil* reported that "Brady photographed 'war scenes' or 'incidents of the war,'" having eighteen or twenty assistants employed on the work for months." Brady confined his own operations in the field to Washington, Maryland, and Virginia, the next goal of the Army of the Potomac.

General McClellan's Peninsula Campaign was the result of iniquitous circumstances—political ineptitude and impatience, a rapidly-dwindling federal treasury, and an unwillingness of financiers to make loans to the Lincoln administration in view of the doubtful outcome of the war.

By January, 1862, tired of waiting months for McClellan to act since he now commanded the largest, best-equipped army in the world, President Lincoln issued McClellan a direct order to open his campaign against Richmond. This order put into operation a plan devised by McClellan to move his army by water to Fortress Monroe, and thence by water to the Yorktown peninsula to attack Richmond, stronghold of the Confederacy, from the east.

McClellan loaded his army on transports, reached his base, cautiously moved up the peninsula, and took Yorktown without resistance, since General Joseph E. Johnston had moved his forces further up the peninsula to Richmond. Stonewall Jackson moved his army into the Shenandoah Valley to threaten Washington, and compel McClellan to withdraw troops for the capital's defense. In a series of bloody battles called the Seven Days—hard-fought, useless engagements costly in casualties—McClellan was outmaneuvered, outguessed, and outfought by the brilliant soldiering of Lee, Jackson, and Longstreet.

115

Fort Corcoran, Washington, D.C., 1861.

One of a circle of forts constructed for the protection of Washington. Fort Corcoran, and earthen redoubt, boasted four large Columbiad cannon. The heavily-timbered structure on the right of the picture is the powder magazine.

From a photograph by Mathew Brady.

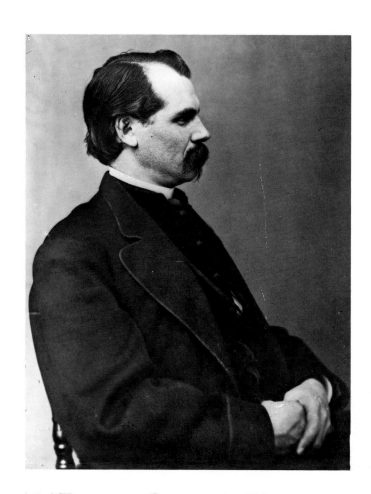

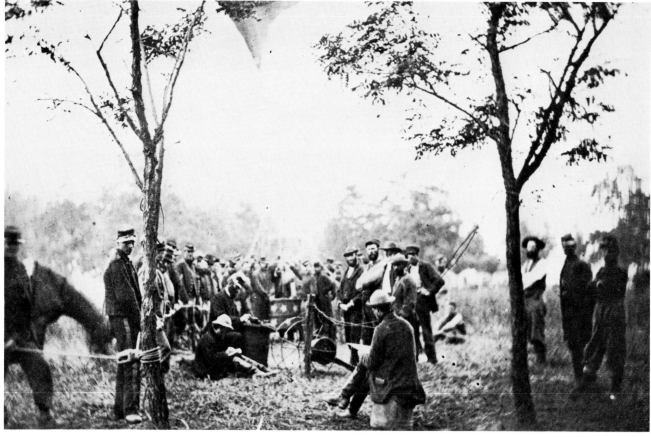

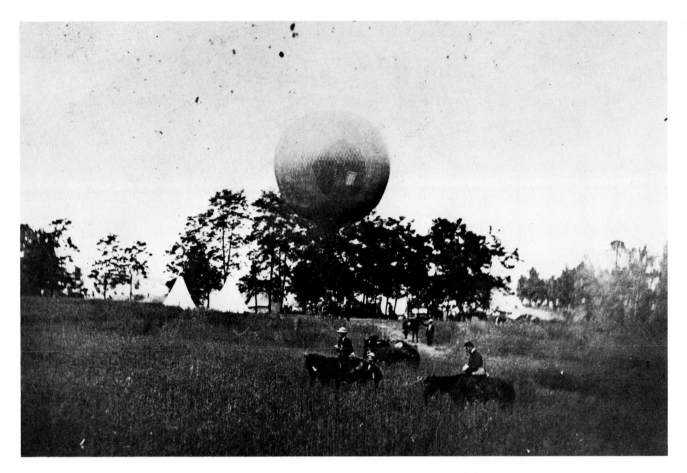

Recovery of the Observation Balloon, *Intrepid,* **Fair Oaks, June, 1862.** *(above)*

Balloon Camp at Fair Oaks, Virginia can be seen at the top of the hill. Both the *Intrepid* and its occupant, General Porter, were rescued.

Professor Thaddeus Sobieski Coulincourt Lowe.
(facing page upper left)

Lowe proved the value of aerial military observation. As Chief of the Aeronautics Section of the army, Lowe was made an Honorary Member of the Loyal Legion for his services during the war.

Major General Fitz-John Porter USA.
(facing page upper right)

Commander of the Fifth Corps in the Seven Days battles, at Fair Oaks, Porter went aloft to observe the battle. The balloon broke loose from its moorings and floated over the Confederate lines. Porter was later rescued.

Lowe's Balloon Camp near Fair Oaks, Virginia, June, 1862. *(facing page below)*

U.S. Army's observation balloon, *Intrepid,* prepares to reconnoitre the battle of Fair Oaks. Lowe stands at the right with his hand on the balloon. Artists and the press are on hand to record the events.

Watching a Battle Unfold from the Air, Fair Oaks, Virginia, June, 1862. *(right)*

"With the aid of good glasses," wrote a reporter who ascended "we were enabled to view the whole affair between these two powerful contending armies.

Photographs by Brady & Company.

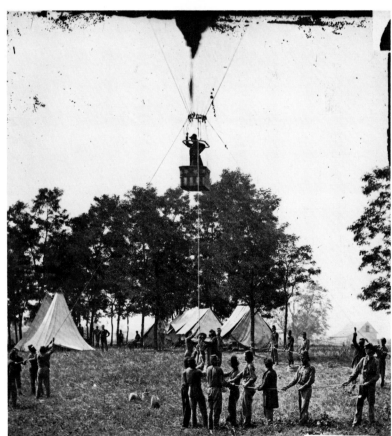

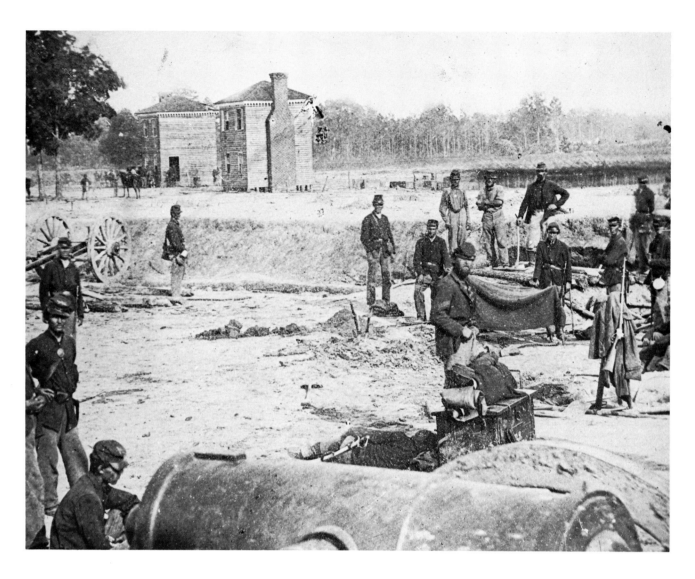

Brady joined the army aboard the transports, along with Winslow Homer and Alfred Waud, sketch artists for *Harper's Weekly*, and George Alfred Townsend, correspondent for the *New York World*. In June, 1862, they found themselves at Balloon Camp in a little valley near the battlefield of Fair Oaks, or Seven Pines. Gaines Mill had already been fought—and lost—and the Army of the Potomac had withdrawn and taken a stand to await the next onslaught.

Major General Fitz-John Porter, the highly competent commander of the Fifth Army Corps, was fascinated by the reconnaissance possibilities of aerial observation. He had made frequent ascensions with Lowe and had even learned how to make ascensions by himself. On this particular day, General Porter arrived at Balloon Camp and, for some unexplained reason, climbed into the basket and ordered the cables released and payed out with all possible speed. The great balloon, only partially inflated, swung upward into the sky, its basket rocking violently from side to side, while its loose, oiled-canvas folds

snapped and cracked like rifle shots. Suddenly the balloon cable, rotted by vitriol from the gas generators, snapped like a whiplash.

Everyone watched in wonder as the runaway balloon gained altitude with incredible swiftness. Lowe ran after the balloon, shouting, "Open the valve! Open the valve!" General Porter finally understood the shouts, and clambered into the rigging, reaching for the valve cord; but the high wind, whirling about the balloon, carried it out of his reach. To the amazement of all concerned—he could be seen along the entire lines of the Army of the Potomac— Porter descended into the basket and began calmly scanning the Confederate lines through a long, black telescope he found on the floor of the basket.

For awhile the balloon drifted eastward toward Union territory, then suddenly turned toward the enemy lines, floating over sharpshooters, rifle pits and trenches.

General Porter, apparently resigned to his fate, continued to scan the Confederate works and camps, and the big guns at Gloucester Point. Fortunately, none of the

Fair Oaks, or Twin Farm Houses, Virginia, June, 1862. *(facing page)*
The field after one of the sanguinary battles of the Peninsula Campaign. General Silas Casey's regiments can be seen as a blurred line in the right, middle background.

From a photograph attributed to Mathew Brady or James Gibson.

Military Field Hospital at Savage's Station, Virginia, June, 1862. *(below)*
Wounded men being treated. The surgeon in the right foreground treats a severe leg wound.

From a photograph by Mathew Brady.

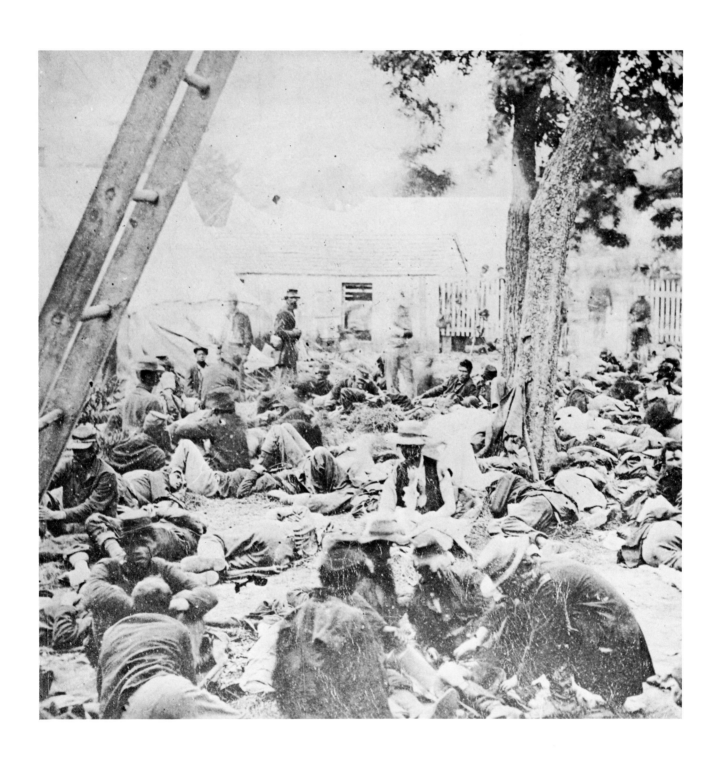

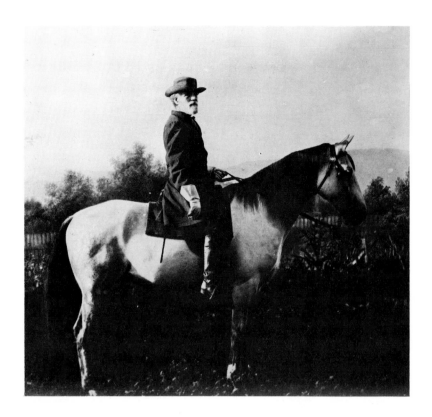

General Robert Edward Lee, CSA, Army of Northern Virginia, 1862.
Lee is seated on his favorite horse, Traveler, at the time of the battle of Antietam. To Confederate soldiers, Traveler was as familiar a celebrity as his master. From a photograph, probably by Julian Vannerson, Richmond.

Confederate guns could be elevated and brought to bear on the balloon; the popping of sporadic musket fire broke out at many points, without effect. A short time later, the frivolous air currents again shifted, and the balloon drifted back toward the Union lines, where it finally hovered over the camp. General Porter again climbed into the rigging for another try at the valve cord, and this time he was successful; the balloon slowly came down to earth.

In landing, the balloon struck one of the tents with great violence; the tent collapsed but no one was hurt. General Porter, shaken but otherwise unharmed, disentangled himself from the folds of the collapsed balloon and emerged to a noisy welcome from cheering soldiers and a band of musicians that happened to be on the scene.

McClellan's Peninsula campaign was a disaster and he began a withdrawal that ended six days later at Harrison's Landing, downriver from Richmond. On the morning of June 27, McClellan's forces were attacked by the entire Confederate army. Jeb Stuart's cavalry fell on his right flank and turned it at Old Church. McClellan then formed a new line of battle from Gaines House, along Mill Road to New Cold Harbor, and by three o'clock in the afternoon, the whole army had been driven back two miles. Wrote George Alfred Townsend: "Their fire never slackened or abated. They loaded and moved forward, column on column, like so many immortals that could not be vanquished. The scene from the balloon, as Lowe later informed me, was awful beyond comparison—of puffing shells and shriek-ing shrapnel, with volleys that shattered the hills and filled the air with deadly whispers."

After the final bloody action at Malvern Hill, McClellan managed to extricate his army, and made no further attempt to stop the Confederates. His quick change of base to the James River saved his army and wagon trains of supplies. When General Lee learned of this he said to his officers, "I fear McClellan is escaping me." After seven days of continuous fighting, McClellan's army, its morale shattered, was finished. And thus ended the grand enterprise of 1862.

For his failure to take Richmond, McClellan was removed, and was succeeded by General John Pope, who fought the Second Manassas battle—another disaster as great as Bull Run—and paved the way for Lee's invasion of Maryland. For the next three years, Brady, and his photographers, became familiar sights to the soldiers of the Army of the Potomac on the flaming battlefields of Antietam, Fredericksburg, and with Grant during the last eighteen months of the war. It was a strenuous existence. Years after the close of the war, his friend, Colonel Knox, asked him what had happened to his plates. Brady replied: "I don't know," adding sadly, "No one will ever know what those plates cost me. Some of them almost cost me my life!"

CHAPTER 7

At the Insistence of Mars

BY AUGUST, 1862, Brady had thirty-five bases of operation in the eastern theater of the war. These bases, with log walls and a canvas top, were furnished with equipment and supplies, chemicals, glass plates, and feed for the horses. Most were within a day's march of Washington, or a few hours by train or by water.

McClellan's removal left Alexander Gardner, his staff photographer, out of a job with the army. When Gardner had resigned his position with Brady, he had taken all his personal equipment with him. Now he opened his own gallery at 332 Pennsylvania Avenue. Though Brady had given him his first job in the United States, Gardner hired away from Brady not only his own two brothers, James and John, but also Brady's two top photographers, Timothy O'Sullivan and Egbert Guy Fowx.

These losses must have been painful to Brady, not to mention the business Gardner enticed away from him.

However, with characteristic determination Brady managed to pick up the pieces and went on with the picture-making for his projected album, *Incidents of the War*, a volume of scenes of wartime Washington, the White House, and local military and naval activity.

Among these scenes were the Seventy-first New York Volunteers quartered at the Washington Navy Yard; the sloop-of-war, *Pensacola* at Presidential salute off Alexandria; several plates of General Morrell's camp at Minor

Captain A. J. Russell's Photographic Headquarters in Virginia, 1864.
Chief photographer for the United States Military Railroad Construction Corps, Captain Russell is standing second from right, his hand on a camera. A teamster leans against the photographic wagon.
From a photograph by Mathew Brady.

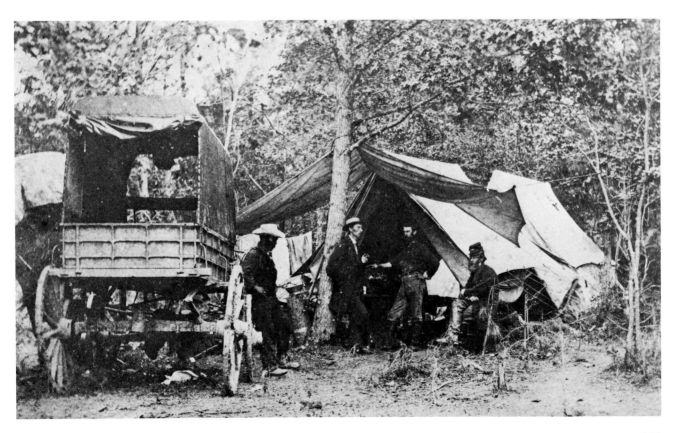

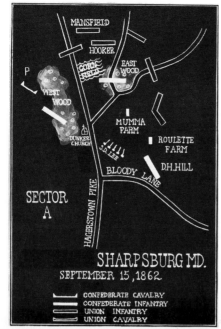

SECTOR
A

SHARPSBURG MD.
SEPTEMBER 15, 1862.

CONFEDERATE CAVALRY
CONFEDERATE INFANTRY
UNION INFANTRY
UNION CAVALRY

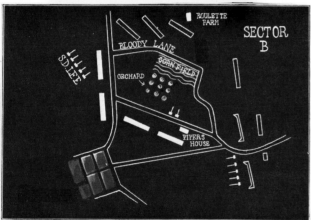

SECTOR
B

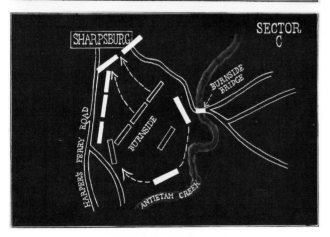

SECTOR
C

**Map of the Battle of Sharpsburg (or Antietam),
September 17, 1862.**

The battle, fought in one day, was called the
"bloodiest single day's action in the Civil War."
Twenty-seven thousand men on both sides were
killed, wounded, or missing. Maps depict three
sectors of the seven-mile-long line of battle.

Maps by the author.

Confederate Dead, Antietam, 1862.

A furious fight was waged at the post and rail fence
along the sunken road and the Hagerstown Pike. The
men were killed by enfilading fire of Union troops.

From a photograph by Mathew Brady.

Hill; and Arlington Heights, Virginia, where the Topographical Engineers of the army worked at mapmaking.

Brady also kept busily engaged with operations at his New York galleries, furnishing *Harper's* and *Leslie's Weeklies* with pictures of current events and people for their woodcuts, which appeared in newspapers as line-cut drawings traced from photographs. The art of photoengraving was unknown at the time; these drawings had to serve as news illustrations.

After the Second Battle of Manassas, Robert E. Lee's victorious army rested at Leesburg, thirty-five miles from Washington, assured that the Army of the Potomac was too disheartened to molest him further. There Lee learned that McClellan had been reinstated to the command.

It was fall and not the time to mount a major campaign. Lee wrote to Jefferson Davis that his army had been depleted by heavy casualties, that his food supply was practically nonexistent, his ammunition wagons were running light, his men lacked winter clothing and shoes. He was willing, despite all this, to chance an invasion into Maryland, where he hoped to capture supplies, recruit sympathetic Marylanders, and compel the federal government to come to the peace table. On September 4, Jefferson Davis issued orders for the march into Maryland.

The battle of Antietam, or Sharpsburg, was a strange military engagement, its outcome decided by fate rather than by fighting, although it was the bloodiest single day's action of the Civil War. Antietam battlefield lies in a little peninsula bounded by Antietam Creek and the Potomac River, a short distance upriver from Harper's Ferry. The Hagerstown Pike runs atop a ridge northward out of town, and within that area are several little valleys that drop eastward from the ridge toward Antietam Creek.

A copy of Lee's secret order of battle, No. 191, detailing every previously planned movement of each of Lee's units, was found on the Army of Northern Virginia's just vacated campground near Frederick, by a Union soldier pulling guard duty. He had sense enough to bring it to his captain. Lee's secret order was wrapped around three cigars.

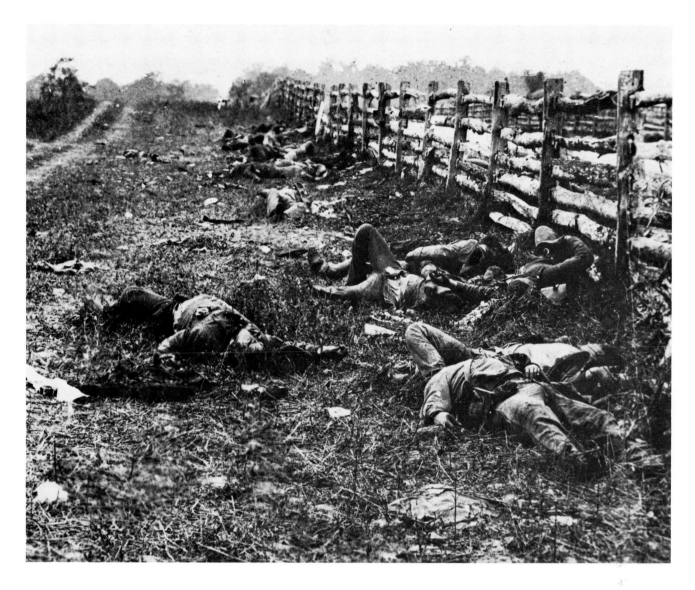

Up to this moment, McClellan, usually slow and indecisive, had no idea of Lee's intentions or whereabouts. Now, with Lee's order of battle in his hands, McClellan suddenly became aggressive, and Lee found himself in trouble. His army was divided, his every move circumvented. Not understanding the reason behind McClellan's sudden brilliance and divination, Lee hastily withdrew his force to the rear of the town of Sharpsburg, his back to the Potomac River, and formed a thin line of battle with his 18,000 men, the combined forces of Longstreet and Daniel Harvey Hill. The rest of his army was on the road, with Jackson's force at Harper's Ferry, twelve miles away.

It was all very dramatic—and deadly. Suddenly everything about this lovely countryside became of vital importance to Lee, especially when he found McClellan's host of 87,000 approaching into line of battle on the afternoon of September 16. By midafternoon, McClellan feinted at Lee's left, and ran head on into Hood's veteran Texas

regiment. During the night, Lee's army was increased to 25,000.

Before sunrise, McClellan hurled Hooker against Stonewall Jackson's left, destroying the brigades of Lawton, Hayes, and Trimble, opening a large gap in Lee's line. Then Hooker's men, climbing over a post and rail fence, moved down the Hagerstown Pike toward the Dunker Church, and engaged Hood's men in a desperate fight until their ammunition was exhausted. Mansfield then attacked them and drove them from the field.

At the critical moment, Lee ordered up the brigades of Walker and Anderson, four miles away; but the Hagerstown Pike, swept by a murderous, enfilading fire, proved a terrible obstacle. Federal troops of Sumner's Corps attacked again only to be thrown back. At midmorning, McClellan opened his second attack on the Confederate center. Then began the fearful struggle in the Bloody Lane, where enfilading fire again left windrows of Confederate dead and dying in the fence corners. McClellan's

125

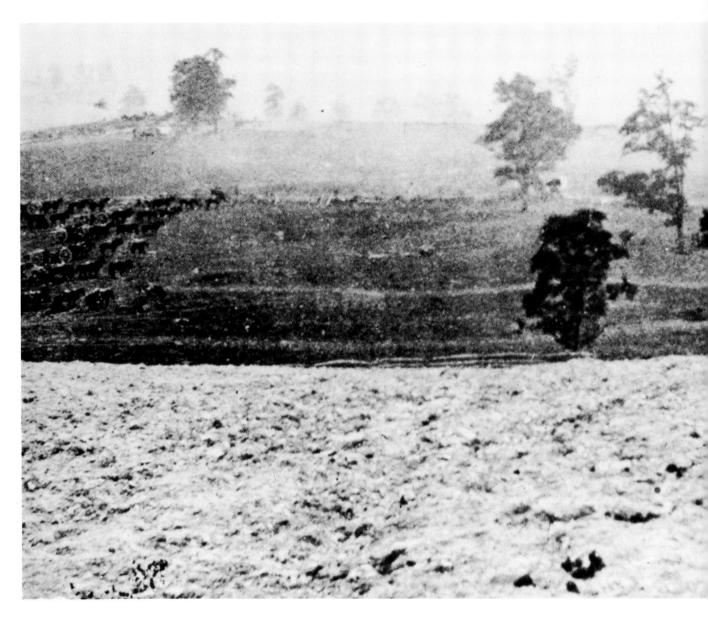

third attack came at 1:00 P.M., on the Confederate rights, near the lower stone bridge over the Antietam, and since called Burnside's Bridge. Once across, Burnside's men could have turned Lee's right flank; but three thousand Confederates of A. P. Hill's command, after a forced march of seventeen miles from Harper's Ferry, rushed onto the field, swept Burnside's men down the slopes and back across the bridge, and saved the day for Lee. The battle was over by sunset. McClellan, though he still had 20,000 men in reserve, apparently had no further interest in renewing the contest.

Brady witnessed the action from the Federal signal station on Elk Ridge within easy sight of the field and made a panoramic picture showing the smoke of the line of battle and the reserve artillery waiting to go into action. No other pictures made during the heavy fighting that day have been discovered.

By nightfall the soldiers of both sides, carrying lanterns, searched the stricken field, looking for friends amid the human debris of battle. It was said that the moon was red that night.

In the morning, September 18, both armies faced each other, inactive except for occasional, sporadic rifle fire; a bickering of pickets. McClellan's casualties were 26,043; Lee lost 13,385. Neither side admitted defeat nor claimed victory. Lee's army recrossed the Potomac and was gone.

Brady and the photographers went about their work, setting up bulky cameras, exposing their plates to the grisly sights. The contrast is striking. At this loveliest time of year, the fall air is clear, the surrounding hills bluish under haze and golden sunshine; all was marred by the grotesque, human wreckage. A week later, Brady's pictures appeared in his New York galleries. He called the collection "Death at Antietam."

126

Battle of Antietam, Maryland, September 17, 1862.
Only action picture of an engagement made during the entire war, Brady made this shot from Elk Ridge, Federal signal station. Smoke on the right is on the line of battle. Reserve artillery on the left await disposition.

From a photograph by Mathew Brady.

In October, Brady was again on the field of Antietam. He found himself at McClellan's headquarters where Lincoln had arrived unannounced to enquire of his wavering field commander why he had allowed Lee's army to escape.

Brady made a memorable and revealing photograph of Lincoln and McClellan in the latter's tent, neither looking too pleased with each other. Later, Brady made plates of McClellan, his staff officers, his secret service operator Allan Pinkerton, and Major General John B. McClernand.

The Union victory at Antietam gave President Lincoln the opportunity to issue the Emancipation Proclamation, and negated all threats of foreign intervention on behalf of the South. Because of McClellan's inaction following Antietam, Lincoln removed him permanently and appointed Major General Ambrose Everett Burnside, with instruc-

tions to bring Lee to battle. "I said I would remove him if he let Lee get away," said the President, "and I must do so."

As a rule, as if by agreement, no winter campaigns were mounted, except for cavalry patrols, since most of the roads into Virginia and elsewhere were all but impassable; but Fredericksburg proved the exception. Burnside, spurred on by Lincoln, moved the Army of the Potomac into Virginia. There was nothing subtle in his approach. Reaching the vicinity of Port Conway, Burnside concentrated his army on Stafford's Heights in Falmouth on the north side of the Rappahannock, opposite the old town of Fredericksburg.

The battle that followed was another carnage—this time with the casualty list heavily weighted with Union dead. Burnside, without any attempt at diversion or flanking attacks, sent wave after wave of infantry up the slopes

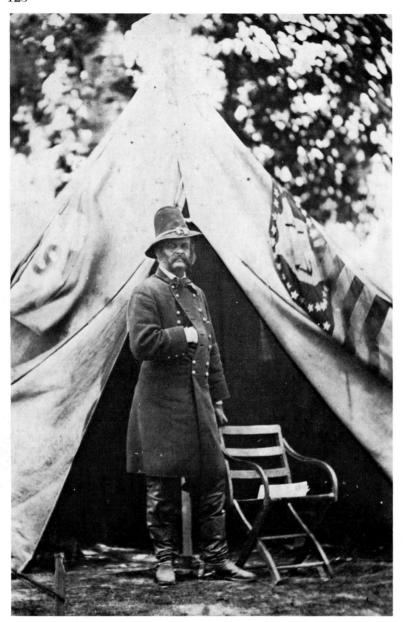

Brigadier General Ambrose Everett Burnside, USA.
Brevetted a Major General and given command of the Union Army by President Lincoln after McClellan's removal at Antietam, Burnside told Lincoln that he was unfit for the supreme command—and then proved it at Fredericksburg in December, 1862.

From a photograph by Mathew Brady.

Stafford's Heights, Falmouth near Fredericksburg, Virginia.
Burnside's heavy siege guns in December, 1862, placed in preparation for storming the town.

From a photograph by Mathew Brady.

Behind the Stone Wall on Marye's Heights, Fredericksburg, Virginia, 1862.
The Confederate army fought one of the bloodiest actions of the war at Fredericksburg. From an almost impregnable position behind this wall, Lee and his army fought Burnside, and later Sedgewick, to a standstill in December of 1862 and May of 1863.

From a photograph by Mathew Brady.

against massed riflemen protected by a breast-high stone wall. All day they attacked. Not one Union soldier penetrated the Confederate barracade. By nightfall it was over; 12,644 of the attackers were dead or dying (wounded without blankets died of exposure during the cold night). Burnside was done. He withdrew his army during the following night.

Brady witnessed Fredericksburg, made pictures of the field, and of the events that followed. May of 1863 found Brady again at Fredericksburg, this time with General Sedgewick's corps. His camera was placed far out on the trestle of the wrecked railroad bridge. The day was bright and sunny, with little military activity. A group of Con-

federates, standing on the opposite end of the bridge, showed an amused interest in his activities. Brady shouted across to them to pose, and they obliged good-naturedly; but they taunted him, shouting that the Union army could expect plenty of trouble.

Brady travelled many miles in the eastern theater, and pictures show him on many battlefields, such as the picture taken of him with Cooper's Battery in the trenches before Petersburg during the last year of the war. Brady recorded what he saw but also collected the photographs made by his other photographers as well. From the outset, he had always kept to his intended purpose of using these pictures as a pictorial supplement to the later *Offi-*

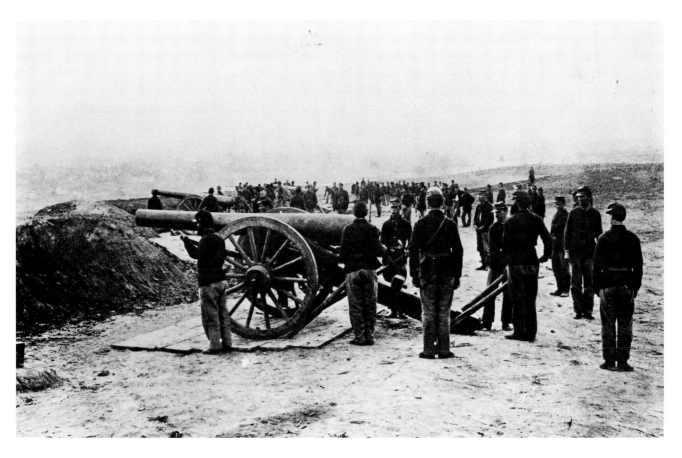

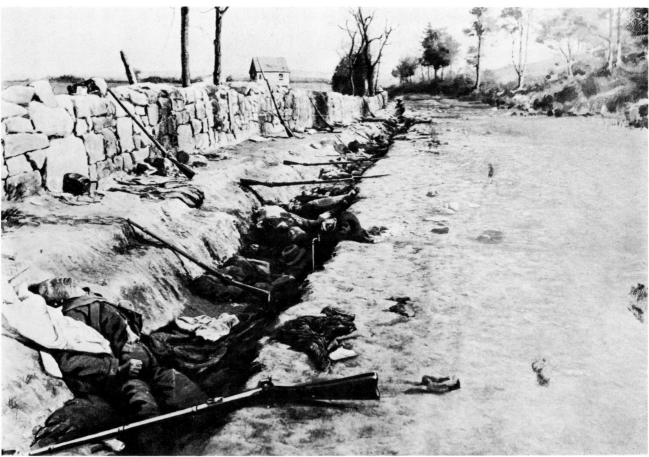

Fredericksburg—"Havoc!" the Work of a Shell.
Photographed after the battle, the dead horses and wrecked caissons testify to the heavy shelling.
From a photograph by Mathew Brady.

cial Records of the War of the Rebellion. This later proved to be a forlorn hope. The compilers of the *Official Records* didn't have the foresight he had.

Brady was not on hand to cover the fighting at Chancellorsville, forerunner to the famous battle of Gettysburg in July, 1863, since the Washington gallery needed his personal attention. Photographing the war was proving expensive; and it can be presumed that any excess profits, derived from both the New York and Washington galleries, was syphoned off to defray the expenses of the war photography.

While Brady was engrossed in his business during the summer of 1863, Lee's second invasion of the North culminated in the furious and bloody battle on the farmlands of Pennsylvania, near Gettysburg on the first three days of July. More than 38,000 were killed, wounded, or missing on both sides. Although Brady was not there during the fighting, a photograph shows him on the field after the armies had separated, making pictures of the ghastly battlefield. Around him teams tended the fallen of both sides.

A month later, Brady was faced with a serious economic problem concerning the Washington gallery. He discovered that profits had dropped to a meager $4,860 locally, and that the income from his contract with Anthony & Company had dropped to $246. There seemed to be no explanation for this sudden drop in sales. In September of 1864, apparently to save his gallery from certain failure, Brady took the unprecedented, and inexplicable, step of offering Gibson, his inadequate manager, a half interest for $10,000. Gibson accepted the partnership, paying Brady $5,000 in cash, the balance to be paid off in four promissory notes. It was only a temporary relief.

And so matters went for Brady during the winter of 1863–64. In November of 1863, he missed a chance for a great historical picture, when President Lincoln dedicated the battlefield at Gettysburg as a national cemetery. Undoubtedly, Brady would have made a better picture of the event than the only one we have, made by an itinerant photographer. At the time, Brady was in New York photographing the Russian Admiral Lessowsky and officers of the Russian Fleet, who were in the city being

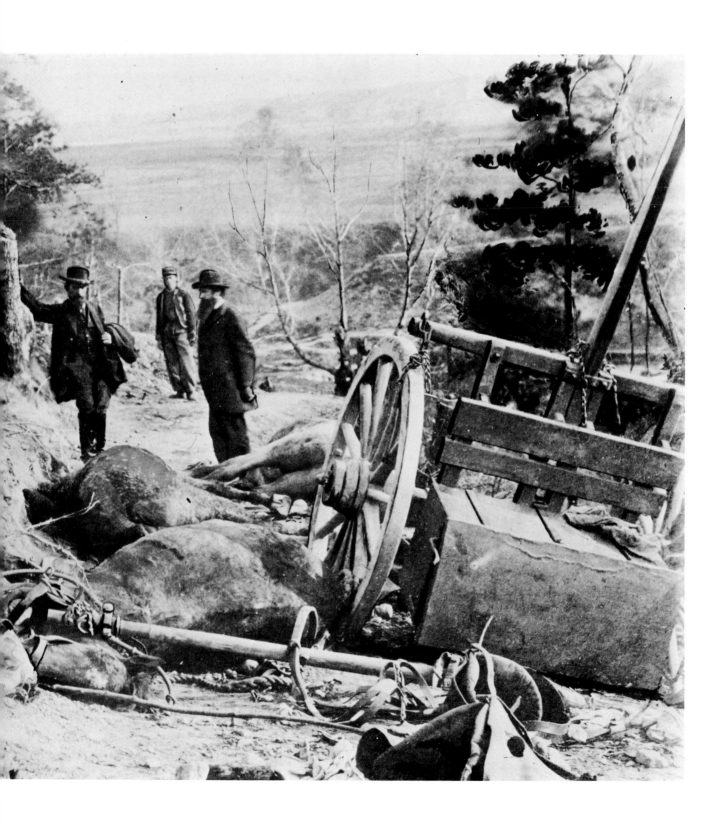

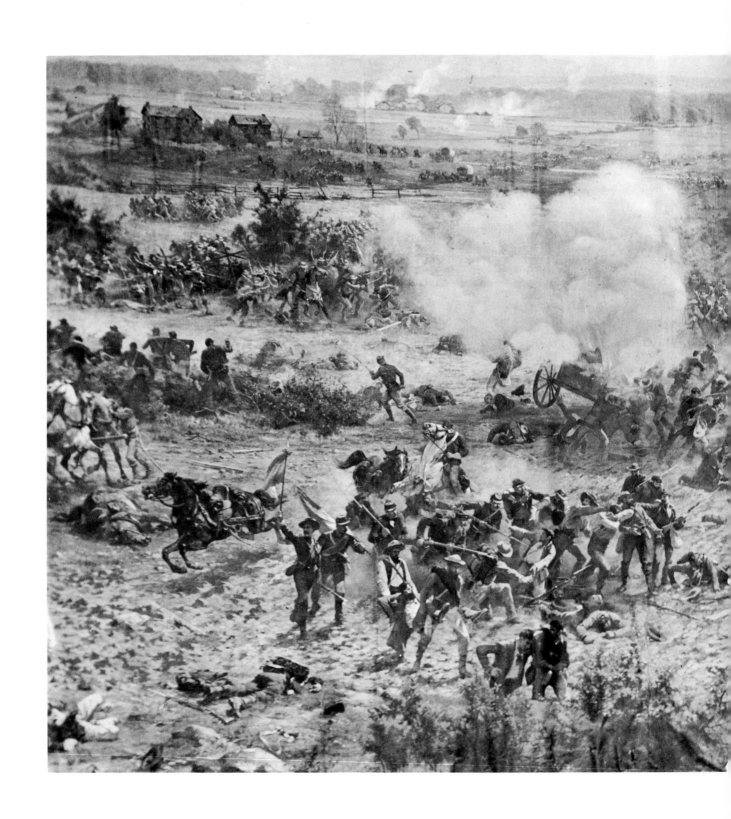

Battle of Gettysburg, July 1863.
Lee's titanic battle on the farmlands of Pennsylvania was a desperate, three-day action for both sides. Paul Philippoteaux's painting faithfully depicts "Pickett's Charge" of the third day. Lee lost the initiative after Gettysburg and never regained it.
From the painting by Paul Philippoteaux, Courtesy Gettysburg National Military Park.

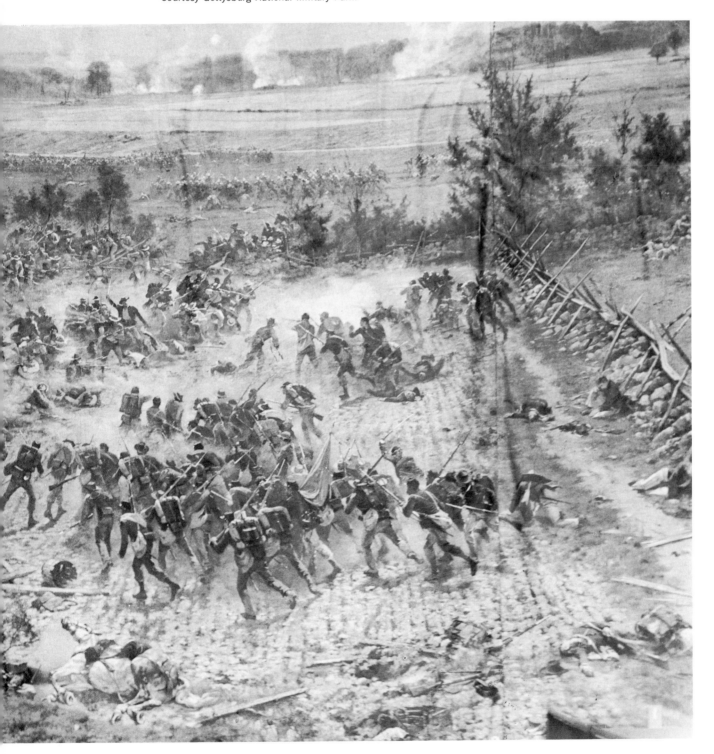

entertained by influential members of New York society.

On February 9, 1864, Brady received a surprise visit from President Lincoln and his young son, Tad, accompanied by two unidentified ladies. The President wore his best, black, broadcloth suit and highly-polished boots. A large gold watch chain, strung through the second buttonhole of his waistcoat, provided the only jewelry accessory to his dress. The boy, Tad, also dressed in a dark suit and, like his father, wore the very same type of heavy gold watch chain.

Brady made eight different portraits at this sitting, one of which was later used as the model for the engraving of Lincoln's portrait on the five dollar note, which Robert Lincoln said was "the best likeness of my father." Apparently Mrs. Lincoln never had a portrait made together with her husband, nor for that matter in any family group. If there is such a picture, to this day it has never come to light.

About this time, Francis Carpenter, a well-known painter commissioned to make an oil portrait of the president, was staying at the White House as a guest of the Lincoln family. Carpenter needed some stereoscopic studies of Lincoln at work in his office and requested that Brady make them. Brady sent two of his operators to the White House, and when they got there, they requested the use of a closet for developing their plates.

Carpenter, without giving thought to any inconvenience this request might cause, showed them to Tad's playroom, which the boy had fitted out as a model theater with a stage, curtain, parquette, and stalls. Brady's men installed their equipment in the room without disturbing any of the boy's playthings. While the photographers were making their plates of Mr. Lincoln seated at his desk in his office, one of Brady's operators burst into the room, saying apologetically that "Tad had taken great offense" at their invasion of his room "without his consent," and had locked them out, "taking the key and refusing all admission." At that moment, the angry boy stomped into the office, accosted Carpenter, screaming that he "had no right to allow the photographers into his room," that "they had no business in my room!"

Carpenter pleaded with the irate boy for the key, and

the President, seated at his desk, said quietly, "Tad, go and unlock the door." But the boy defied his father and started for his mother's room, followed by Carpenter still pleading with him. Unable to persuade Tad to turn over the key, Carpenter returned to the office. The President asked, "Has not the boy opened that door?" Carpenter shook his head, and replied that he could do nothing with him.

Rising from his desk, Mr. Lincoln strode angrily across the hall, a purposeful look on his face, and into the family's apartment. Moments later he reappeared with the key, and gave it to Carpenter, saying, "There, go ahead. It is all right now," and returned to his desk. While the photographers prepared for the picture, Mr. Lincoln, thinking an explanation was needed, turned to Carpenter and said: "Tad is a peculiar child."

Lincoln had won the bitter election in February, and had found the man he "could tie to," Major General Ulysses S. Grant; the man who could win the war for him. Grant had won resounding victories in the West and had come to Lincoln's attention when at the fall of Fort Donelson, he would make no terms other than "unconditional surrender." Following Grant's victory at Vicksburg, Lincoln requested Congress to restore the rank of Lieutenant General (full rank) of the Army. The bill became law on February 26, 1864, with Senate confirmation of Grant's nomination to that rank. It placed him over every other general officer in the army, including all his enemies.

No one in the East had seen Grant before, except Congressman Washburn from Galena, Illinois, Grant's hometown. On the day of Grant's expected arrival in Washington a group of newspaper reporters came to Brady's gallery to ask if he could tell them what Grant looked like. They wanted to waylay Grant at Union Station for interviews and needed a description of the famed general.

"I couldn't help them," said Brady, who had seen only a faded photograph of Grant in which just his mouth and beard were visible, "even though I had an inkling of the appearance of the lower part of his face." Nevertheless, Brady went to the station with them to single Grant out.

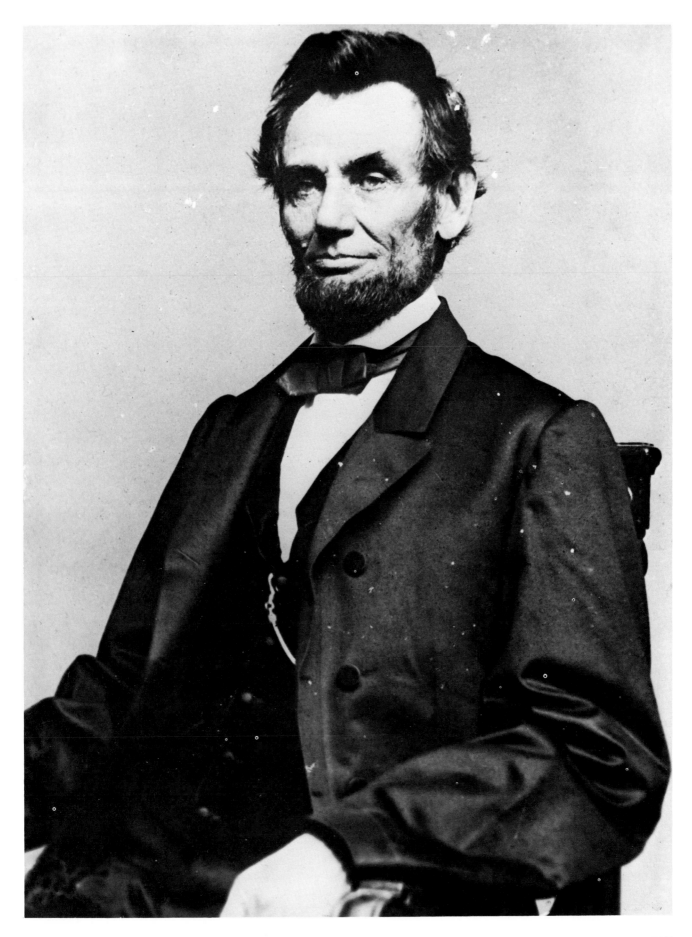

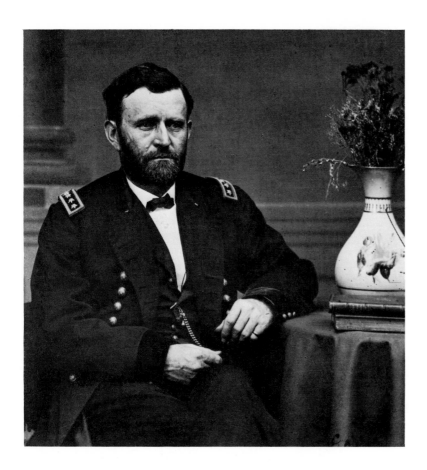

"I knew him by the lines of his mouth," Brady said afterwards, "and rushing up to the car platform, I grasped his hand. I introduced myself, and asked if he were General Grant. He replied in the affirmative." After introducing the reporters, Brady then asked Grant where he was going to stay while in Washington. "I don't know," he replied. "I know nothing about the hotels." Brady suggested Willard's Hotel. After showing General Grant and General Rawlins to their carriage, Brady and the reporters jumped into their own carriage and rode on ahead to announce their arrival. After Grant registered at Willard's, Brady asked: "General, the desire to obtain your portrait is so universal, I hope you will favor me with a sitting as early as you conveniently can." "Certainly," Grant replied. "I go away at one o'clock tomorrow, and I must pay my respects to the president and the secretary of war, but after that I promise you I will give you a chance."

The commissioning ceremony at the White House was short; Grant assured Lincoln he would "do the best I could with the means at hand, and avoid as far as possible annoying the War Department" and the president himself with unnecessary problems.

"I had the studio in readiness early," Brady recalled, "for we realized that with his departure from Washington, we might never have another opportunity like it again. We waited long after one o'clock, and had almost given him up, when a carriage drove up and Secretary of War Stanton jumped out followed hurriedly by Grant."

"It was now four o'clock when the two men came rushing up the stairs and into the gallery," recalled Brady. Grant had already missed one train, and was obliged to take the next. Hurrying into the studio, Grant took his seat before the cameras. As it was growing dark, Brady sent his assistant to the roof to draw back one of the shades from the skylight. Just as he got above the spot where Grant was seated, the man stumbled, both his feet crashing through the glass, sending a shower of large, glass splinters down about the General.

Grant sat motionless. "It was a miracle that some of the pieces didn't strike him," Brady said. "And if one had, it would have been the end of Grant, for that glass was two inches thick! Grant casually glanced up to see the cause of the crash, and there was a hardly perceptible quiver of his nostril, but that was all! It was the most remarkable display of nerve I had ever witnessed."

Stanton grasped Brady by the arm and dragged him into a closet, saying excitedly, "Not a word about this, Brady! Not a word! You must never breathe a word of what happened here today! The newspapers will say it was designedly done to injure General Grant! It would be impossible to convince the people that this was not an attempt at assassination!"

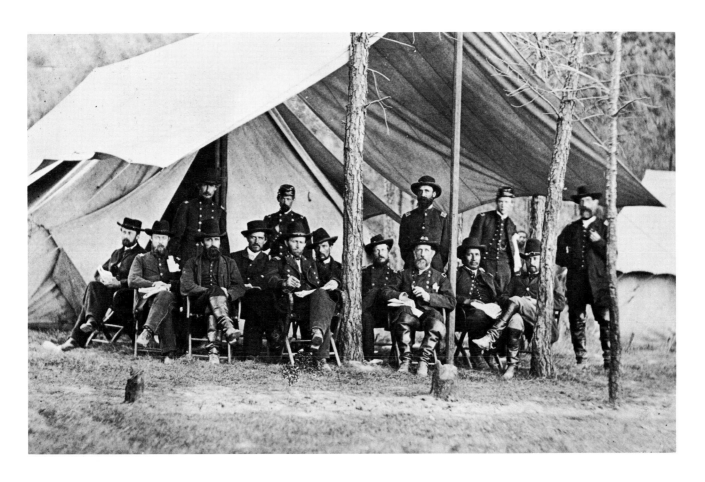

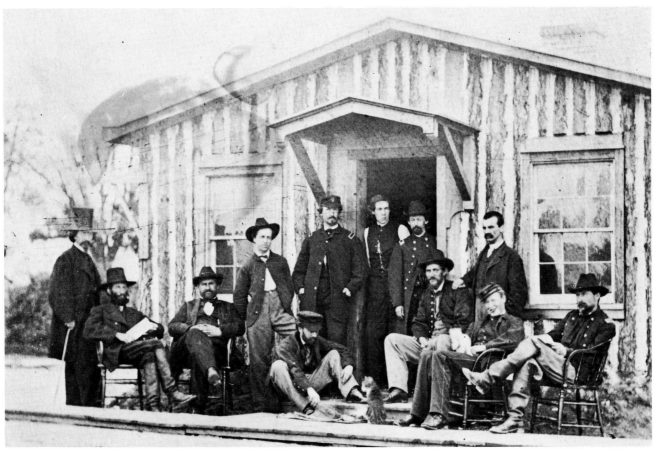

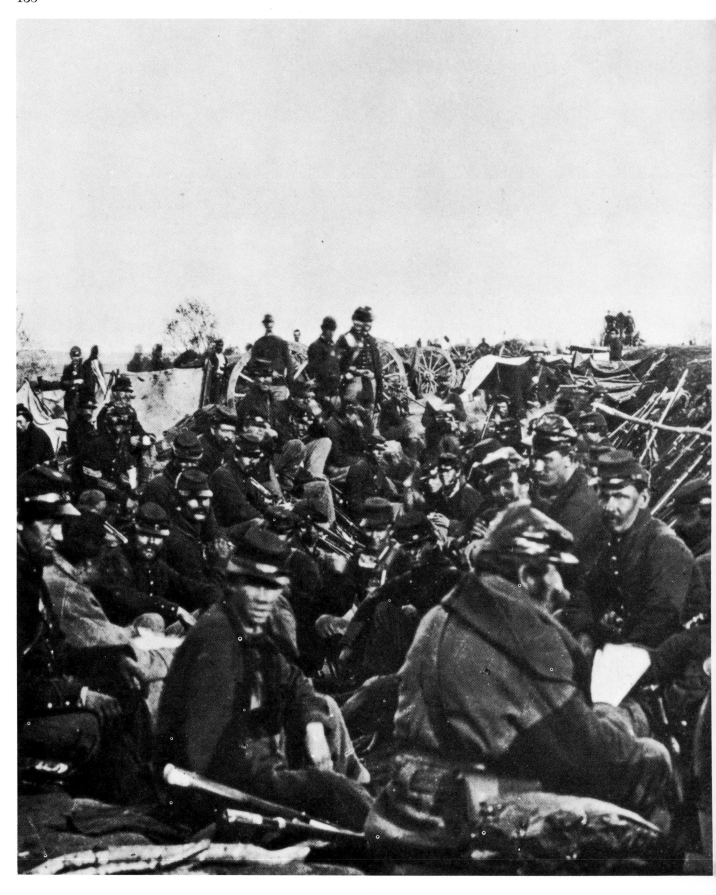

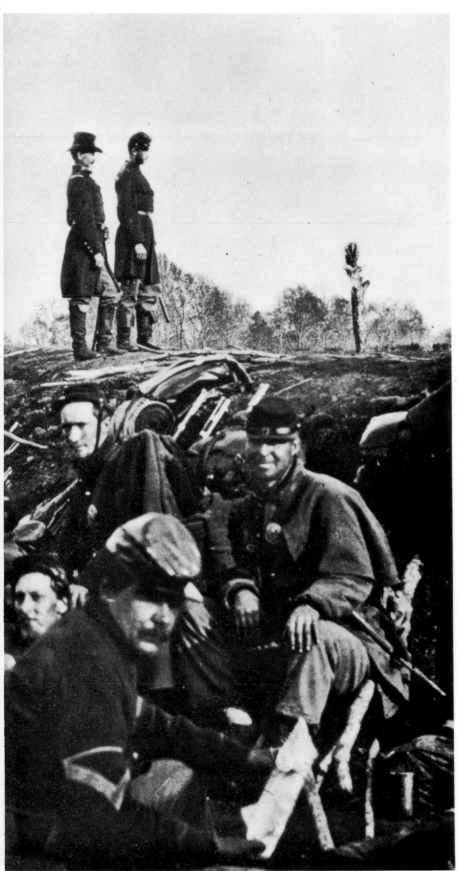

Army of the Potomac Before Petersburg, 1864–65.
A contingent of Grant's forces in the trenches during the last year of the war. Bloody fighting in this campaign eventually brought about the fall of Petersburg, and consequently Richmond. Since the men are warmly dressed, picture was probably made in the fall of 1864.

From a photograph by Mathew Brady.

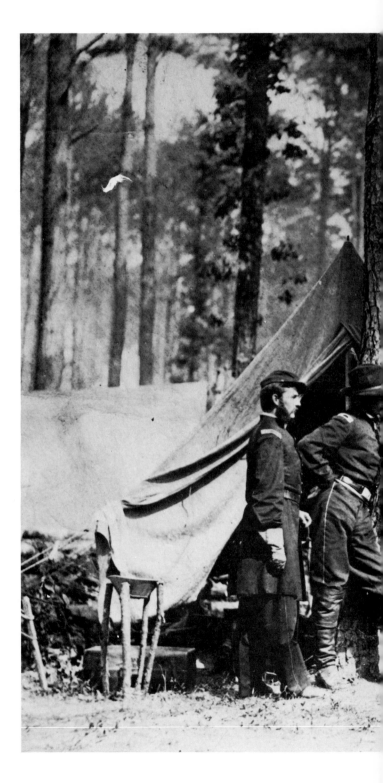

Mathew Brady at General O. M. Potter's Headquarters, near Petersburg, Virginia, 1864.
Dressed for work, Brady leans against a tree on the far right. General Potter stands hatless in full uniform in the center of the group.

From a photograph by a Brady assistant.

Brady managed to make several fine pictures of General Grant, and this meeting was the beginning of an acquaintanceship that lasted until Grant's death.

Grant assumed his duties immediately, and took direct command of the Army of the Potomac, appointing General W. T. Sherman commander of the Army of Tennessee, and General Phil Sheridan commander of all the cavalry. "My general plan now was to concentrate all the force possible against the Confederate armies in the field. Accordingly, I arranged for a simultaneous movement all along the line." What followed shocked the North; but the South was crushed by it. There followed the crucial and bloody battles of The Wilderness, Spottsylvania, the North Anna, and Cold Harbor, relentlessly moving southward against Lee's army and the Confederacy. With Sherman grinding Jackson down in the deep South, the fall of Atlanta imminent. With Grant battering the armies of Lee and Longstreet in front of Petersburg, it became only a question of time.

From May 5, 1864, to April, 1865, Brady and the war photographers spent most of their time in the field. The most active photographers in the eastern theater during Grant's last campaign, including Brady, were T. H. O'Sullivan, David Knox, David Woodbury, J. Reekie, Guy Fowx, and Captain A. J. Russell, engineer-photographer with the United States Military Railroads Construction Corps.

In that summer of 1864, Lieutenant James Gardner of Cooper's Battery in the front lines before Petersburg wrote:

Before noon when the sun had almost reached its height, Mr. Brady sought out Captain James Cooper, and inquired if he might take a picture of the battery in the act of firing. The Captain agreed. When Brady was ready, Cooper gave the command, and the gunners jumped to their posts. One mile over the ridge was Petersburg. To the Confederates entrenched there, the sudden activity in Cooper's Battery meant one thing—a period of bombardment. Suddenly, a shell burst nearby, filling the air with hissing, flying metal, scaring the horses. Oddly enough, the camera was uninjured. Cooper withheld his fire, and Mr. Brady finished taking his pictures.

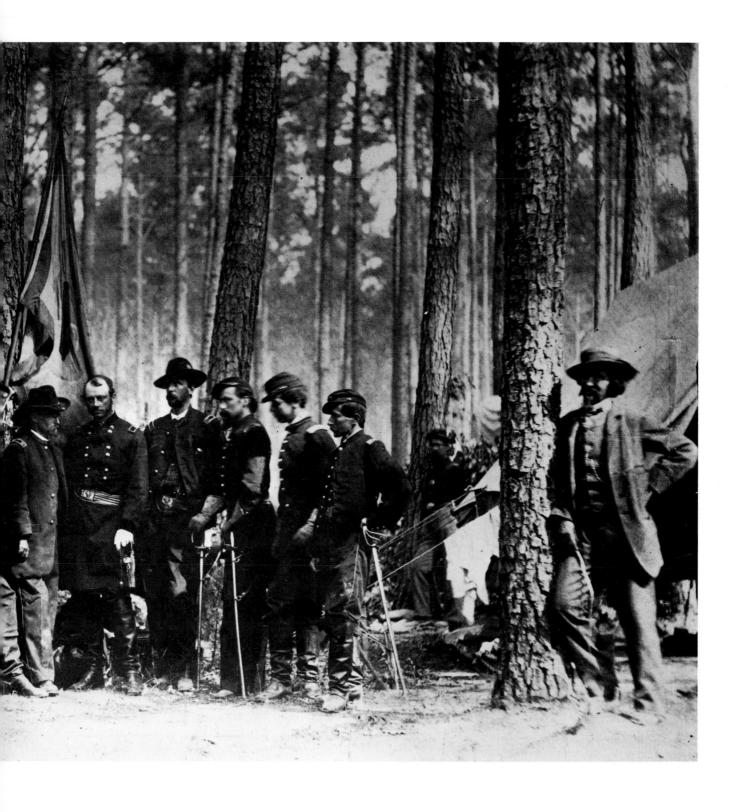

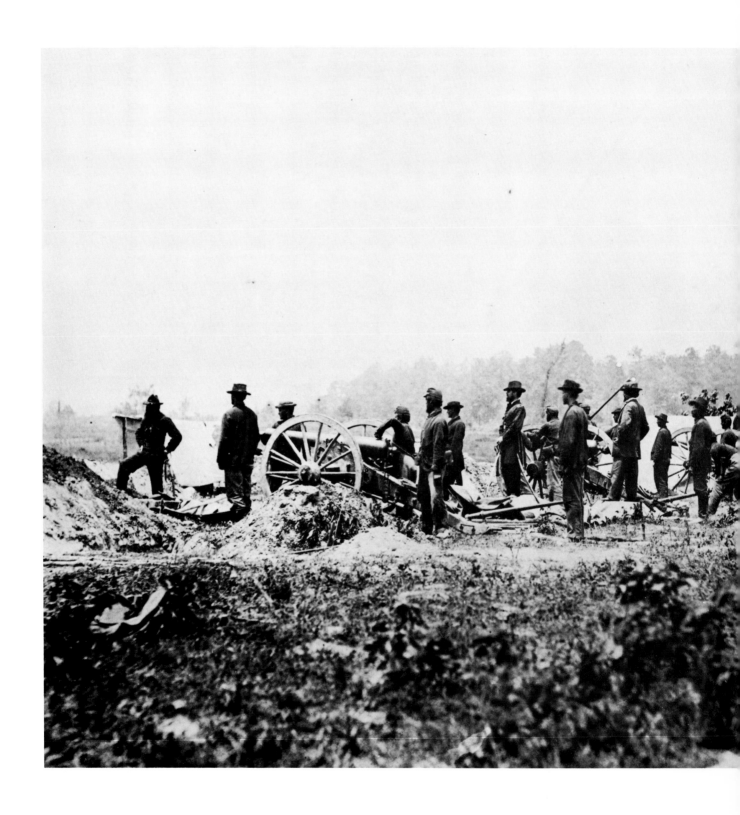

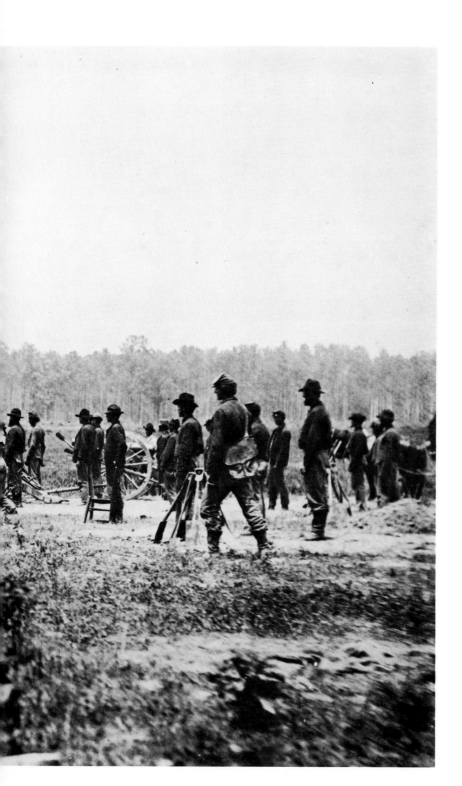

Brady at the Siege of Petersburg, Virginia, Summer of 1864.

Among many others, this photograph proves that, contrary to some opinion, Brady was in the field during the war. Artillery unit is Cooper's Battery. Brady is the civilian standing on the mound with his hands in his pockets.

From a photograph by a Brady assistant.

On April 3, 1865, at three in the morning, Lee's army evacuated Petersburg. That afternoon, General Godfrey Weitzell, of the Twenty-fifth Army Corps, entered Richmond, and all the leading men of the Confederacy got away that evening. Meanwhile, General Phil Sheridan's forces pursued Lee, fighting sporadic actions which ended, after an action at Five Forks with the envelopment of Lee's army. At noon, the head of the 2nd Corps closed within three miles of Appomattox Court House. The date was April 9, 1865. At the house of Wilmer MacLean, General Lee surrendered the Army of Northern Virginia to Lieutenant General Ulysses S. Grant.

Not a single photographer was on hand; everyone, including Brady, was in the field. One of the crucial moments in the history of the United States went photographically unrecorded.

Later, on or about April 12, a bright, sunny, warm spring day in Richmond, Mathew Brady arrived at the Lee residence on Grace Street and asked if he might photograph the General. He was refused with the utmost courtesy. Disappointed, but unwilling to allow the oppor-tunity of making one of the most important pictures of the war escape him, Brady went to see General Ould, whom he had known in Washington, and who was an old family friend of the Lees. "It was supposed that after his defeat it would be preposterous to ask him to sit," Brady had said to Townsend, "but I thought it would be the time for the historical picture. Of course I had known him since the Mexican War, when he was on General Scott's staff, and my request was not as from an intruder."

Ould promised that he would do all he could to per-suade Lee to let Brady photograph him. Brady was given one hour to make his pictures. And on April 13, a sitting was arranged on the back porch of the Lee home, where the General appeared dressed in the uniform he had worn at Appomattox.

"There was little conversation during the sitting," re-called Brady, "but the General changed his position as often as I wished him to." All the pictures show Lee with a stern countenance. When the sitting ended, Brady ex-tended his thanks, and with a bow General Lee shook Brady's hand and entered the house.

The Wilmer McLean House at Appomattox Court House, Virginia, 1865.
Here Lee surrendered to General Grant on April 9, 1865. No photographer was on hand to record this most important event of the war. It happened so quickly the photographers didn't receive word until it was over.

 From a photograph by Mathew Brady.

General Robert Edward Lee, April 13, 1865.
Brady made this photograph of the Confederate commander on the rear porch of his home in Richmond, several days after the surrender. It is one of six plates made at the time, and historically important.

 From a photograph by Mathew Brady.

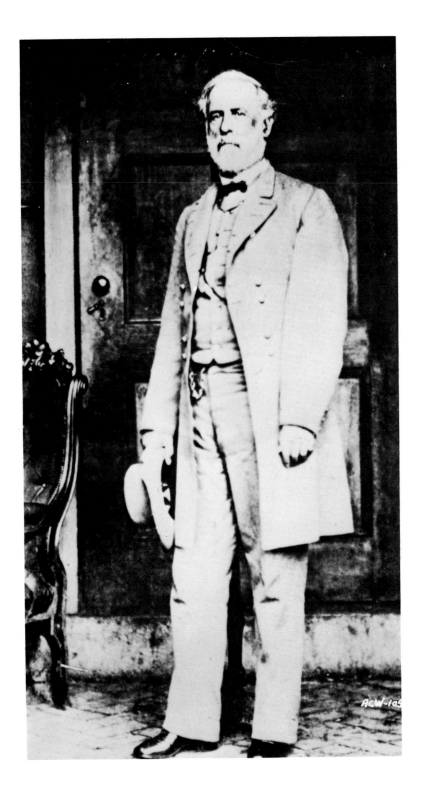

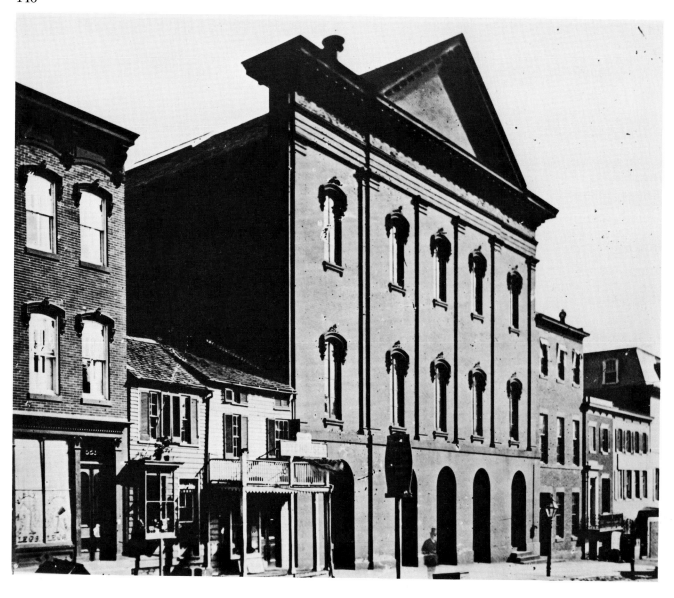

**Washington City's Most Renowned Theater, circa
1865.**

A Washington showplace in the 1860s, Ford's
Theater was the scene of the assassination of
President Lincoln on April 14, 1865. It was closed for
a number of years after the tragedy.

From a photograph by Mathew Brady.

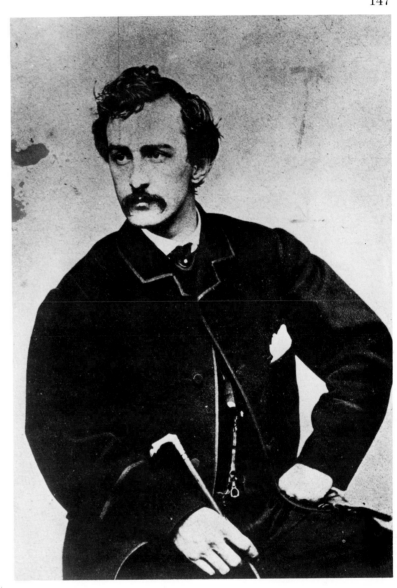

John Wilkes Booth.
This photograph of President Lincoln's killer was made by Brady sometime in 1864. Edwin Forrest, the actor, upon learning of the tragedy, said, "All the damn Booths are crazy!"

From a photograph by Mathew Brady.

On the next day, April 14, in Washington, another casualty was added to the toll of war. In Ford's Theater, at about 9:30 P.M., during the play, *Our American Cousin*, John Wilkes Booth, an actor, stealthily approached the private box in which the President and Mrs. Lincoln sat with their guests, Miss Clara Harris and Major Rathbone. During a temporary pause, while an actor was making his entrance, the sharp report of a pistol was heard. Suddenly, a man rushed to the front of the box, waving a long dagger in his right hand. He leaped from the box, on the second tier, to the stage beneath and ran across the stage before a stunned audience. Some people recognized him as Booth. Some say he shouted, "Sic semper tyrannis"; others didn't hear it. Reaching the stage door, Booth mounted a horse being held for him by a conspirator, David Herold, and together they fled into the night.

At 7:22 A.M. on the morning of April 15, Abraham Lincoln died. The pistol ball had entered the skull midway between the left ear and the center of the back of the head, passing nearly to the right eye. He was unconscious until his death.

At about 10:00 A.M., Vice President Andrew Johnson took the oath of office as president.

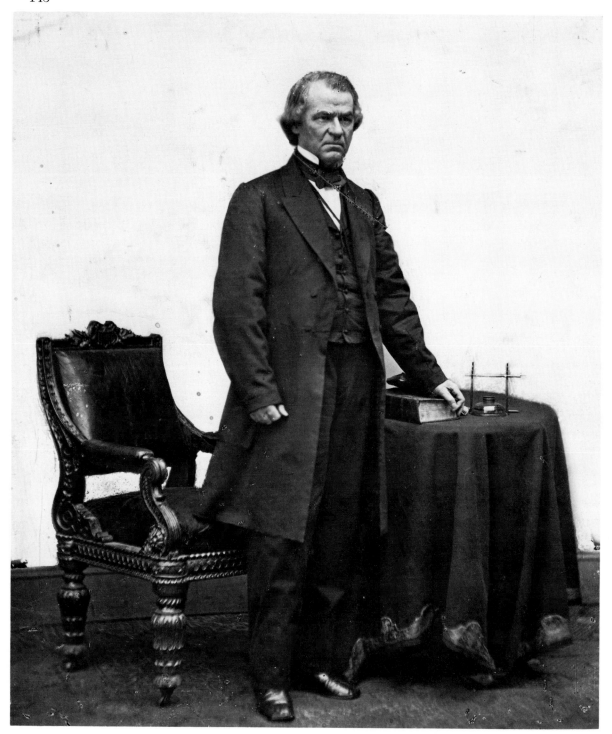

Andrew Johnson.
Vice president of the United States, Johnson
succeeded the assassinated Lincoln. A tailor from
Tennessee, who had risen to the White House from
poverty, the self-educated Johnson served notice to
the Radicals in Congress that the South would suffer
no further punishment.

From a photograph by Mathew Brady.

CHAPTER 8

Melancholy Aftermath

THE WAR which had cost a half-million lives had ended. It had been triggered by a group of extremists in Congress five years before. Yet, even before the sounds of the last shots died away, another conspiracy was already at work, planning a take-over of the vanquished South.

On the afternoon of the fatal April 14th, 1865, President Lincoln had held a cabinet meeting, which General Grant had attended, at which the President stressed that there would be a no-punishment policy toward the Southern people.

That same night, the new President Andrew Johnson—a simple, honest, self-educated man, and no fool—assumed the presidency. Apparently aware that extremists in Congress were already at work in a conspiracy to capitalize on the exhaustion of the South by treating it as a conquered nation, Johnson served notice that their plot would avail them nothing; that there would be no mad dance of victory over a half-million graves.

For better or worse, the United States were now bound in indissoluble union. The first five years of the Reconstruction were boom years. Capitalists and speculators talked in terms of millions as confidently as they formerly had talked of hundreds. With prosperity, greed had jumped on the bandwagon, and the morals of the business community hit an all time low. Reform, practical and spiritual, all but disappeared.

However, the largest problem before the nation was the administration of the peace. The Republican Party in Congress was dominated by Thaddeus Stevens of Pennsylvania, Charles Sumner of Massachusetts, and Benjamin Wade, an antislavery zealot from Ohio. Together they conspired to take over the South. Their ardent supporters were called the carpetbaggers, men from all over the nation who flocked to the conquered states and staffed the civil administration imposed on the South.

Among them was John C. Underwood of New York, who had been driven from his Virginia farm before the war for his views on slavery. Appointed Judge of the District Court of Virginia, Underwood felt that his instructions were to seize "the property of those who had engaged in the rebellion, and in the prevention of civil rights of negroes." He took full advantage of his position.

James Ashley, an Ohio Congressman incensed at President Johnson's opposition to exploitation of the South, proposed the idea of impeaching President Johnson. He was in the way. By 1867, the plan had matured and an attempt was made to carry out the plan.

While maimed Union veterans begged on street corners, and men in tattered gray uniforms headed homeward from Northern prison camps, business boomed, and financial speculation went merrily on.

The post-war years were unkind to Brady, and while he and others gambled in stocks and money-making schemes, the spectre of coming ruin seemed to dog him. Realizing that most people wanted to forget the war, that war pictures would be no longer popular and in demand, Brady reduced his war albums from $75.00 to $50.00; but even this reduction in price was no sales attraction. The small Cartes des Visite Brady had hated so much and the large imperials had been all but forgotten, having given way to the new cabinet photograph then popular in England.

The cabinet photograph, in which the negative was retouched, gained quick popularity in the United States. Brady introduced it to his patrons.

The commercial demands made on photography in the postwar decade created new techniques in all phases of photography, including artificial overhead lighting and exotic painted backgrounds, which Brady spurned. He was a purist who, to the end, practiced the old ways.

For the moment, however, there were more pressing matters to give him concern and disturb his peace of mind. One was the problem of copyright infringement. Two weeks after President Lincoln had died, Brady made some plates of the in-coming President Andrew Johnson and copyrighted his photographs on May 1, 1865. Apparently there were three poses, the first showing Johnson seated, in Brady's Lincoln chair, with his legs crossed. A close profile plate was made at the same time, along with a standing, full-length pose. In none of the poses does President Johnson appear happy.

A Washington photographer copied Brady's "seated pose" photograph of Johnson, evidently in anticipation of

Victory Parade of June, 1865.

Units of the Army of the Potomac stand momentarily at parade rest, awaiting the order to resume the march up Pennsylvania Avenue. Victory Parade was delayed for almost two months to allow for mourning of the death of President Abraham Lincoln.

From a photograph by Mathew Brady.

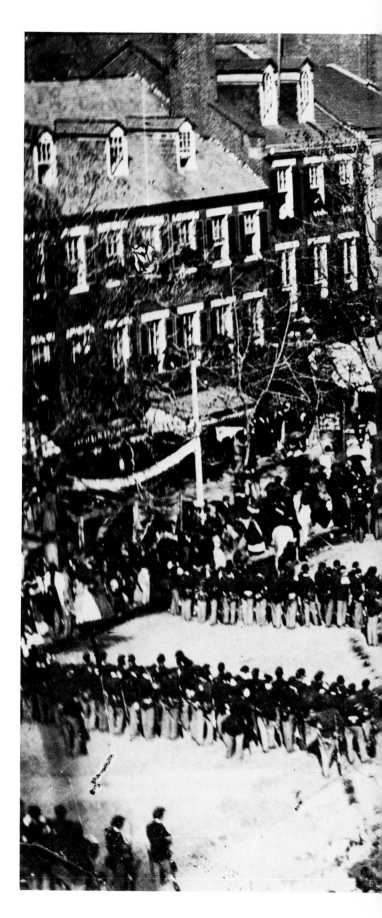

a quick, popular sale at the Victory Parade. Brady immediately brought suit for violation of copyright and won the case in the District of Columbia Court. The offending photographer was enjoined from making any further sales; but the court did not order the destruction of the copy negative!

In the meantime, because of the upcoming Grand Review, the trial of the Lincoln conspirators was postponed to late May, following the period of national mourning. The war was over. Victory was now being celebrated across the nation, and in the streets of Washington, in spite of Lincoln's death, there was evidence all around of a festive mood.

Brady made pictures of the Grand Review to the music of the military bands of the veterans of the Army of the Potomac and Army of the Tennessee; marching to "Dixie," a tune which the late President Lincoln had remarked was now "Federal property."

Meanwhile, Edwin M. Stanton, secretary of war, had begun a dragnet for Lincoln's murderer, John Wilkes Booth, posting a reward of $100,000. Then, as now, the crime had a covering of mystery which will probably never be removed completely. Most government officials wanted Booth taken alive, to force him to divulge the names of any possible conspirators. On April 26, however, a band of Army and Secret Service operatives, and Washington detectives, caught up with Booth and Herold in a barn on the Garrett Farm near Port Tobacco, Virginia.

Booth defied Lieutenant Colonel Conger's order to surrender, and Conger ordered the barn put to the torch. Herold, frightened, ran out of the barn, was caught, and was trussed to a horse. As the flames crackled around Booth a shot was heard, and Booth was seen to fall to the floor. Sergeant Boston Corbett, a reformed Bowery drunk, claimed credit for the fatal shot, and later became a hero as Lincoln's avenger. Neither then, nor thereafter, was Corbett disciplined for firing without orders.

Then followed the trial of the Lincoln conspirators in May. The trial was a summary courtmartial, a military tribunal, since many feared that the conspirators would get lighter sentences in a civil criminal trial. The military

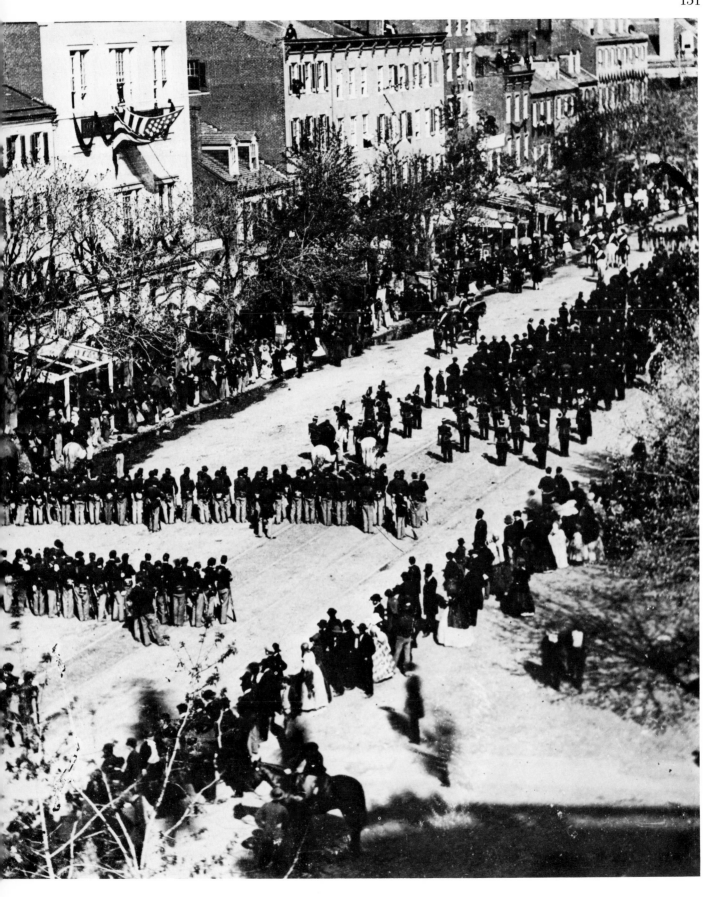

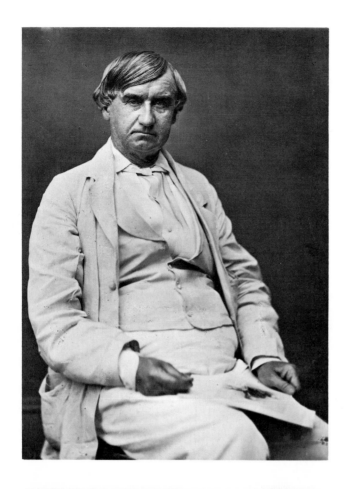

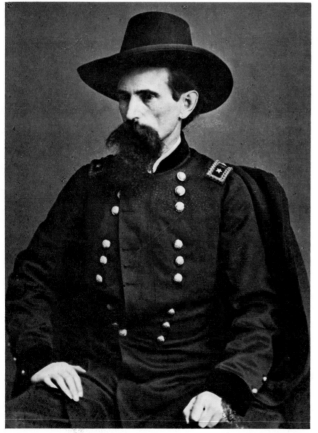

tribunal's findings would be final; there could be no appeal. The prosecutor was Assistant Judge Advocate John Armor Bingham, and no jurist was better fitted for the job. Among the judges were Judge Advocate General Jospeh Rush Holt and Major General Lewis Wallace.

The trial was held in an atmosphere of anger, rage, grief, and national frustration, with plenty of legal fireworks. In the end, the conspirators were found guilty as charged and convicted on all counts.

Even Mrs. Mary E. Surratt, who would have the dubious distinction of being the only woman ever hanged in the United States, was found guilty even though she wielded no weapon. The sentences meted out were varied. Mrs. Surratt, Thomas Payne, George Atzerodt, and David Herold received the death sentence. The remaining five—Samuel Arnold, Dr. Samuel A. Mudd, Edward Spangler, Michael O'Laughlin, and John Surratt, a former Confederate spy—received long prison sentences at hard labor in the military prison at Fort Jefferson in the Dry Tortugas, off Key West, Florida.

When one studies the evidence and compares it with the sentences, the court's rulings were harsh indeed. What must be borne in mind is that, of the four defendents sentenced to hang, only one used a weapon—Lewis Powell, who knifed Secretary Seward. Atzerodt, a hopeless drunk assigned by Booth to kill Vice President Johnson, threw his gun away and spent the night begging drinks in several barrooms. Mrs. Surratt, in whose home the plot to kill President Lincoln was hatched, and David Herold, the simple-minded admirer of Booth, had committed no bodily harm to anyone. He had held Booth's horse outside Ford's Theater. All were found conspirators and all died on the scaffold. There was an attempt, on the part of the defense, to arrange clemency for Mrs. Surratt; but at the last minute word came from the White House by courier—"Her, too!" he said.

The gallows was busy in 1865. In November, came the military trial of Captain Henri Wirz, infamous commandant of Andersonville Military Prison in Georgia. After the testimony of nearly two thousand Union soldiers, Wirz received the death sentence and was also hanged in the prison yard of the Old Capitol Prison.

Joseph Rush Holt. *(facing page above)*

Temporarily Holt presided as Judge Advocate General in the Lincoln Conspiracy Trial. One of the most loyal men in the Government, Judge Holt was accused of witholding evidence in Booth's diary.

> From a photograph by Mathew Brady.

Major General Lewis Wallace, USA. *(facing page below)*

Promoted for gallantry in action at Fort Donelson, Lew Wallace commanded the Middle Division VIII Army Corps at Monocacy. A lawyer, he served on the military tribunal that tried the Lincoln conspirators and presided at the trial of Henri Wirz for the Andersonville atrocities. A born writer, Wallace is famed for his novel *Ben Hur.*

> From a photograph by Mathew Brady.

Execution of the Lincoln Conspirators, July, 1865. *(above)*

One of three pictures made of the hanging, this one shows the trap just sprung, the bodies swinging in death. Mrs. Surratt, only woman ever hanged in the United States, is seen on the left, her skirts tied about her.

> From a photograph by Mathew Brady.
> (also attributed to Alexander Gardner)

Summary Execution of Captain Henri Wirz, May, 1865. *(below)*

The gallows was busy in 1865. Within sight of the Capitol dome, the noose is being placed around the neck of the infamous commandant of Andersonville Military Prison. Wirz was first soldier to die for war crimes.

> From a photograph by Mathew Brady.

William Worth Belknap, Brigadier General, USA.
Graduate of Princeton College, Belknap served with distinction at the battle of Shiloh, "always in the right place at the right time." Belknap became secretary of war in Grant's cabinet but "unquestioned evidence of malfeasance in office" forced his resignation in 1876.

From a photograph by Mathew Brady.

By 1868, Brady faced some very real financial problems which ended in bankruptcy for the Washington gallery, brought about through mismanagement by his studio manager, James Gibson, while Brady was in New York attending to the business of the New York galleries. Most legal actions brought against him were principally for nonpayment of rent, carpentry services, and photographic supplies. This foreshadowed a very dismal future for the man who had worked so hard all his life.

To save his gallery, Brady went into voluntary bankruptcy, after which the gallery was to be sold at public auction. Brady managed to scrape up enough money to buy back his business for $7,600, the value of the property stipulated by the court, Brady being the only bidder. During the court action, there were accusations and counteraccusations, Gibson blaming Brady for allowing the gallery to run into debt by printing and selling "certain photographs for campaign purposes."

Brady was also blamed by Gibson for making newsworthy photographs of the impeachment trial of President Johnson and of the impeachment managers, and printing their composites for advertising purposes. Brady's fault in all this was apparently ignoring the demands for payment by not opening his mail. Gibson, in fact, had, without Brady's knowledge, mortgaged the studio as a Brady

President James Abram Garfield.

Last president of the United States born in a log cabin, Garfield fought at Shiloh. Inaugurated in March, 1881, he was, according to the *Milwaukee Sentinel* "exceptionally clean for a man who has been for twenty years in active politics." Shot in July, 1881, by a disgruntled office-seeker, he died eleven weeks later.

From a photograph by Mathew Brady.

partner. Before the court could take action on this fraud, Gibson left town for points west.

Brady now continued his operations on a less lavish scale, reducing the size of his studio in the building at 627 Pennsylvania Avenue, over Zadoc D. Gilman's drug store. Brady now began to petition both the Fortieth and Forty-first Congresses to buy his collection of plates of personalities and war views. While the Joint Committee on the Library (Library of Congress) listened and pondered the matter with interest, there were no recommendations.

Meanwhile, in 1870, in New York, Brady's gallery was having the same problems of inadequate income and financing. And after placing a photographer, Andrew Burgess, as manager in Washington, Brady left for New York to do what he could to save the gallery there. His photographic empire was about to topple. Brady, a life-long Democrat, was a personal friend of William Marcy "Boss" Tweed, Mayor of New York. Boss Tweed and the members of his ring in Tammany Hall had been robbing the city blind; and despite his adroit political manipulations, and payments to corrupt judges, the Committee of Seventy was about to close in on Tweed and his cohorts. For Brady, his friend's problems couldn't have come at a worse time. Until now, it seems that Brady had been protected by the Tweed court, which held back judg-

The Aging Mathew B. Brady, a Year Before His Death in January, 1896.

Living in a rooming house at 127 East Tenth Street in New York City, alone and penniless, the great photographer spent much of his time in the rear of Colonel Knox's store, reminiscing with his friend. When Knox asked him about the lost pictures, Brady answered: "No one will ever know what they cost me; some of them almost cost me my life."
From a photograph taken in the Washington gallery, Author's collection.

Three Writers Famous in Their Time.

Left to right: George Alfred Townsend, war correspondent and novelist; Samuel Langhorne Clemens, novelist and lecturer; and Ned House, war correspondent and drama critic.
From a photograph by Mathew Brady.

ments against him. And with Tweed's imminent arrest, all pending judgments would have to be paid—judgments which amounted to several thousands of dollars.

Edward Dickerson, a New York attorney, managed to get Brady into bankruptcy court, where it came out that while Brady's indebtedness amounted to $25,000, the combined value of both the Washington and New York galleries amounted to less than $12,000. On January 2, 1873 Brady was declared bankrupt. To save himself from property seizure, Brady entered into a conspiracy with Matthew T. Brennan, Sheriff of New York, a close friend of his and Boss Tweed's, to seize his properties before the United States Marshall could act to satisfy the judgment. The job was accomplished, and the U.S. Marshall frustrated; and Brady removed himself to Washington once again, this time as a permanent resident.

But Washington proved no sinecure. He was still faced with the claims of ninety-four creditors. All he could do

was to promise them their money when the United States government bought his remaining collection of negatives for illustrating the *Official Records of the War of the Rebellion*. At about this time, he began to drink heavily.

During this time, business at the Washington gallery proceeded at a very slow pace, while Brady petitioned Congress for relief. The *New York Herald* noted: "Mr. Brady, the well-known photographer, is again endeavoring to secure passage of a bill to authorize purchase of the War Gallery." Another newspaper suggested, "Surely this is a purchase the Government ought to make."

Finally on March 3, 1871, following recommendations of Secretary of War William W. Belknap, the War Department purchased Brady's collection of negatives, by paying the storage bill for them, but without title, the money coming from funds accumulated from the Provost Marshall's Office. Yet, not until April 15, 1875, following the financial panic of 1873, did Congress come to Brady's

relief in the Sundry Appropriations Bill for $25,000, at the request of James A. Garfield of Ohio.

The money paid Brady settled matters with his creditors, and he started all over again. *The National Republican* noted that "Mr. Brady has refitted his gallery at 625 Pennsylvania Avenue, and has thoroughly reestablished himself in the photographic business." During the next five years business was poor and competition keen; by 1880 the old photographer was finally forced to close his gallery forever.

For the next fifteen years of his life, Brady worked for other photographers, and with the death of his wife, Julia, and his own ill health, despondency all but engulfed him. A street accident, involving a runaway horse-drawn streetcar, put him in the hospital. When he was able, Brady returned to New York City, the scene of his former triumphs. His age, poor health, and eyesight now began to tell on him, and he spent a lot of his time in the store of

his old friend Colonel E. M. Knox, the hatter. "The old man liked to think back to the past," recalled Colonel Knox.

Not long thereafter, Brady found himself in New York Hospital, where he languished for almost a year. There was an attempt on the part of some of his loyal friends and members of the Seventh Regiment of New York to give him a testimonial dinner and a showing of his pictures at Carnegie Hall. But this, too, never came to pass, mainly for lack of money, and Brady being too ill to attend.

On January 16, 1896, Mathew B. Brady, the great Washington and New York photographer, who had pictorially recorded the great and near great of his era, died in the alms ward of New York Hospital, alone except for his friends William Riley and Wilson MacDonald. He and his wife are buried in the Congressional Cemetery in Washington, D.C.

George Alfred Townsend's Memorial to the Civil War Correspondents.

"Gath," as he was known to his readers and fellow journalists, built this memorial and dedicated it to all the Civil War correspondents, photographers, and combat artists who covered the war with him. Mathew Brady's name is listed prominently among them. Dedicated October 17, 1896, ten months after Brady's death, the memorial still stands at Gapland, Maryland, Townsend's home. His own mausoleum, also nearby, bears the inscription, "Good Night, Gath."

From a photograph by the author.

Index

Page numbers in **boldface** refer to illustrations.